VAN GOGH'S FINALE

VAN GOGH'S FINALE

Auvers and the Artist's Rise to Fame

Updated edition

Martin Bailey

FRANCES
LINCOLN

Quarto

The author would like to acknowledge with grateful thanks the research and translation assistance of Onelia Cardettini.

First published in 2013 by Frances Lincoln
an imprint of the Quarto Group
One Triptych Place, London, SE1 9SH
United Kingdom
T (0)20 7700 6700
www.Quarto.com

This edition published in 2024, and is an updated version of the original 2021 Frances Lincoln edition

A catalogue record for this book is available from the British Library.

ISBN 978-1-8360-0314-4
EISBN 978-1-8360-0315-1

10 9 8 7 6 5 4 3 2

Publisher: Philip Cooper
Editor: Izzy Toner
Typesetter: Typo•glyphix
Cover Design: Paileen Currie and Isabel Eeles
Production Manager: Rohana Yusof

Printed and bound in UK

CONTENTS

Preface 7

Prologue: Interlude in Paris 17

PART I: 74 PAINTINGS IN 70 DAYS 24

1. First Impressions 25

2. The Eclectic Doctor 35

3. Nests 44

4. Into the Landscape 47

5. Portrait of Dr Gachet 52

6. Family Visit 60

7. Vast Wheatfields 68

8. Bouquets 72

9. Portraits 77

10. Gauguin's Tropical Dream 82

11. Day Trip to Paris 86

12. Double Squares 92

13. Last Picture 97

PART II: THE END 102

14. Shot 103

15. Final Hours 107

16. Funeral 113

17. Suicide or Murder 122

18. Theo's Tragedy 135

PART III: FAME & FORTUNES 142

19. Birth of a Legend 143

20. Father and Son 152

21. Fake? 171

22. Hidden Portrait 181

23. Pilgrims to the Inn 187

24. Today 195

On the Trail of Van Gogh 202

Chronology 205

Endnotes 208

Bibliography 233

Index 237

Acknowledgements 246

Picture Credits 249

PREFACE

All his life Van Gogh was constantly on the move, shuttling from place to place, in search of somewhere new to take his art to a higher level. But it is his final resting spot – the village of Auvers-sur-Oise, 30 kilometres north-west of Paris – that today offers us the deepest insight into his life and work. He arrived there on 20 May 1890, after travelling north from the asylum of Saint-Paul-de-Mausole. This cloistered retreat on the outskirts of the small town of Saint-Rémy-de-Provence had been his home for a year, following the breakdown he suffered in Arles when he mutilated his ear. Vincent left the asylum for Auvers full of optimism, hoping that he had recovered. Freed from the constraints of institutional living, he relished the prospect of moving his art forward in a fresh environment. Set just below wooded slopes, Auvers straggles along the valley of the River Oise. More than 130 years later, it still retains much of its distinctive character, in its back lanes and fields.

Today it takes about an hour to reach Auvers from Paris by train, roughly the same time that it took Van Gogh back in 1890. Travellers alight at what was an imposing station for a village, its exterior little changed from the artist's time. From there it is five minutes' walk along the main street to the Auberge Ravoux, the inn where he stayed (fig. 1). A congenial café right up until the 1980s, it has been sensitively restored as a visitor centre, retaining much of the atmosphere of the artist's time.

Climbing the 34 steps to Van Gogh's bedroom one inevitably thinks of the last time that Vincent struggled up this staircase. Having shot

himself while in the wheatfields, he staggered back to the auberge with a bullet lodged in his chest, an astonishing feat of endurance. Doctors were quickly summoned, but little could be done for him.

The garret room now lies bare, furnished only with a simple wooden chair with a straw seat (fig. 2). This represents a homage to the still life painting (now at London's National Gallery) he had made in Arles of his own chair.[1] For Van Gogh, empty chairs symbolically represented their previous occupants. Here, in this tiny room, the fatally injured Van Gogh calmly lay in bed and smoked his pipe, awaiting death, with his beloved brother Theo by his side.

Dominique-Charles Janssens, who acquired the auberge some 35 years ago, made a decision to keep the bedroom as a simple space: 'Visitors come and furnish the empty room with their own memories. They come not for Van Gogh the painter, but for the human being who suffered.'[2]

From the auberge, it is a 15-minute walk to the cemetery. The route along a back road first leads to the church – an edifice (plate 20)

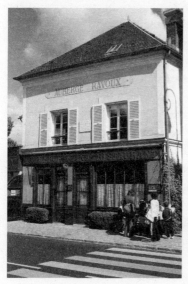

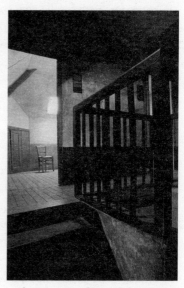

fig. 1 Auberge Ravoux, Auvers

fig. 2 View towards Van Gogh's room, Auberge Ravoux

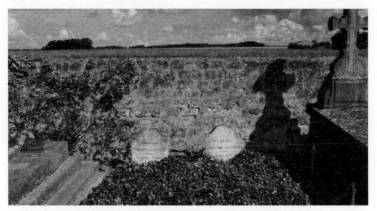

fig. 3 Graves of Vincent and Theo at Auvers, with the fields beyond

portrayed so gloriously by Van Gogh under a cobalt blue sky. Just beyond the church the road winds uphill a short distance, alongside the wheatfields that proved such an inspiration. It was just under a kilometre away, across these fields, that the fatal shot was fired.

For many the grave has become a place of pilgrimage (fig. 3). Visitors flock to what is the most visited French cemetery after Père Lachaise in Paris. It is an emotional experience to gaze at the simple headstones for Vincent and Theo, buried side by side and covered by a single blanket of ivy, one of the artist's favourite plants. For some, the grave has a particularly deep personal meaning: a few people even bring a small quantity of the ashes of their departed loved ones to discreetly scatter into the ivy.

For me, the most memorable moment in my quest to explore Vincent's final days was holding the gun that had ended his life. When I heard that the weapon was being put up for sale in 2019 I travelled to Paris just before its unveiling. I met the auctioneer Rémy Le Fur in his premises, which were crammed from floor to ceiling with objects coming up for sale, ranging from bric-à-brac to major artworks.

Le Fur disappeared into a back room and brought out a white cardboard box. On opening the lid I saw the rusted Lefaucheux revolver

resting incongruously in layers of pristine tissue paper. The late 19th-century gun was more severely corroded than I had expected, but this suggested that it had lain on the ground or just beneath the surface for decades. The wooden section of the grip was missing, having long since rotted away. Tellingly, the safety trigger was

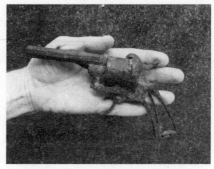

fig. 4 The corroded Lefaucheux revolver which probably killed Van Gogh, held in the hand of the author

unlocked, so it had probably been fired shortly before being abandoned.

Picking up the rusted revolver I was instantly struck by how small and light it was (fig. 4). Cradling it in my hand, it was agonizing to imagine Vincent's state of mind when he pulled the trigger. Choosing his words carefully, Le Fur told me that it was 'probably the gun that Van Gogh used to kill himself', although it is unlikely that we will ever be certain.[3] The Van Gogh Museum has been slightly more cautious, and when exhibiting the revolver it had stated that there is 'a strong possibility' that it was indeed the weapon.[4]

Le Fur told me that in around 1960 an unnamed farmer had dug up the gun while ploughing a field on the outskirts of Auvers. It was now being sold by an anonymous owner. In 2020 I managed to track down details of the story and identify the original finder. He was Claude Aubert, a respected farmer who worked just beyond the northern wall of the château of Auvers.[5]

Tradition has it that Van Gogh's shooting took place at the back of the château and the gun had clearly lain there for decades. Aubert therefore quickly realized that this rusted revolver could indeed be the weapon that had killed the artist. It never occurred to him that the gun had any financial value and he gave it to his friends Roger and

Micheline Tagliana, who ran the auberge where Van Gogh had once stayed. For them, it was merely a curio, occasionally brought out for friends or visitors with a special interest. Aubert died in 1989, having gained nothing financially and won no plaudits for his discovery, which suggests to me that he had been totally honest about the find.

The 1960 discovery went unpublicized and the weapon was later inherited by the innkeepers' daughter, Régine. For decades she kept it securely hidden in a drawer, before eventually deciding to sell it. By this time there was much more international interest in Van Gogh. Without the provenance the rusted gun would have been worth nothing, but with the Van Gogh connection Le Fur auctioned it on Régine's behalf for €162,500, selling it to an anonymous buyer.[6]

The emergence of the gun came during a long-running debate over the circumstances of Van Gogh's death. Although it had always been widely assumed that it was suicide, two American writers argued in 2011 that a local teenager, René Secrétan, had pulled the trigger.[7] Publication of the highly detailed biography, by Steven Naifeh and Gregory White Smith, caused a sensation.

I never accepted their revisionist theory, and for me the subsequent emergence of the gun makes it even less plausible. If Secrétan had shot the artist, why would he have simply abandoned the weapon in an open field that was regularly ploughed? Had he wanted to hide the evidence, surely he would have buried it deeper or hidden it in dense vegetation.

* * *

While researching Van Gogh's stay in Auvers, I became increasingly convinced of the importance of the role played by Dr Paul Gachet, a physician, artist and collector. It was he who kept an eye on Vincent and was later responsible for treating him after the shooting. Dr Gachet was equally interested in medicine and the arts – although at times he hardly had enough time to devote to them both. His artistic friends

reputedly regarded him as a good doctor and an amateur artist; his medical colleagues saw him as a good painter and a mediocre doctor.[8]

The art critic Georges Rivière described Dr Gachet as 'certainly one of the most curious personalities of the 19th century', adding that both the doctor and Van Gogh were 'a bit mad, but they were nonetheless friends'.[9] Another writer had noted that the doctor was 'one of the liveliest and most sympathetically original of men'.[10] Van Gogh's own assessment of him was that he was rather eccentric.[11]

Thanks to newly available archival material at the New York-based Wildenstein Plattner Institute, we now know more about this extraordinary man. Although this material was used to great effect by Anne Distel and her colleagues in the excellent catalogue of the Gachet exhibition held in Paris, New York and Amsterdam in 1999, it is now freely available to researchers, a most welcome initiative.

Dr Gachet was a close friend of the Impressionists and their followers, particularly Camille Pissarro and Paul Cézanne, both of whom had lived close by in the 1870s. Other artists whom he knew included Pierre-Auguste Renoir, Claude Monet, Alfred Sisley and Edouard Manet. Thanks to these contacts, Dr Gachet became one of the greatest early collectors of Impressionism, often receiving paintings in return for his medical advice. He was also an amateur artist himself, working mainly as a printmaker. With his unusually broad interests, including music and literature, he was a key figure in the Société des Eclectiques (Society of Eclectics), an elite group of progressive men in the arts who socialized at monthly dinners in Paris.

But what has gone unremarked in the Van Gogh literature is the macabre side to Dr Gachet's interests, linked to his medical background and his interest in phrenology – the 19th-century theory that the shape of a person's skull revealed something of their personality. This led him to assemble a collection of plaster casts of heads of executed criminals. These bizarre objects, made immediately after guillotining when the neck swells up, have an exceptionally gruesome appearance. Several of Dr Gachet's casts later ended up in the Science Museum in London.[12]

Dr Gachet's interest in phrenology throws new light on a little-known incident that occurred in 1905, when Vincent's remains had to be moved to another grave in the Auvers cemetery. During the exhumation, the doctor picked up the artist's skull, observing that it was '*large*' (his son italicized the word, for emphasis). Although anxious to study the skull, decorum meant that Dr Gachet reluctantly handed it over to his son, who gently placed it at the end of the coffin in the new grave. Gachet Jr later commented that it was like a scene 'from *Hamlet*'.[13]

I was equally surprised to learn that Dr Gachet had apparently been a proselytising member of the Société d'Autopsie Mutuelle (Society for Mutual Autopsy).[14] This extraordinary group of secular and free-thinking intellectuals wanted their own corpses – and particularly their brains – to be dissected and analysed by their medically trained peers, in the hope that it would help shed light on the process of creativity. Among members whose heads were studied was the former French prime minister Léon Gambetta, who had died in 1882, with an entire book being published after an examination of his brain.[15]

Dr Gachet's membership of the Société d'Autopsie Mutuelle has escaped attention in the Van Gogh literature, although it is alluded to in two books on other artists. In 1921 Rivière noted in his study on Renoir that the doctor advocated 'cremation, free love and many other things that seemed new and subversive, because he was a man of progress'. Rivière then added that Dr Gachet had a mania for recruiting on behalf of the Société d'Autopsie Mutuelle and on several occasions 'he asked Renoir to join'.[16] In a book on Cézanne, Rivière again discussed the doctor's propaganda for mutual autopsy, commenting that neither Manet, Edgar Degas nor any of his other artist friends had joined.[17]

Decades later the doctor's son devoted several pages in one of his books to a discussion of the Société d'Autopsie Mutuelle. Although generally critical of Rivière and certainly not explicitly confirming that his father was a member, his silence on whether his father had joined suggests that he had in fact done so. If the doctor had not been a member, his son would presumably either have omitted to mention the matter or else included a

denial. On a later occasion, another Cézanne specialist referred to Dr Gachet's membership of the Société d'Autopsie Mutuelle in a study. Gachet Jr had been invited to read the draft text for possible errors, but did not comment on this issue.[18]

JUILLET 1890

27 DIMANCHE. S. Pantaléon 208-157

Suicide de Van Gogh

fig. 5 Dr Gachet's diary entry for 27 July 1890,
Archive E. W. Kornfeld, Bern

There is no evidence that Dr Gachet conducted autopsies on behalf of the society, although he certainly knew how to undertake such procedures. Early in his training he understandably found this unsettling, and his son explained that this was why he took up smoking a pipe, which apparently put him at ease while dissecting human corpses.[19]

But what bearing does this have on Van Gogh? I do not suggest that Dr Gachet tried to recruit him for the Société d'Autopsie Mutuelle or that he conducted a formal autopsy on Vincent's body. But I nevertheless believe it quite possible that the doctor removed the bullet from the artist's chest after his death. From what we know of Dr Gachet's boundless curiosity it seems that he would have had a professional interest in understanding what had occurred. More importantly, both he and Theo might have felt it would be respectful to allow Vincent to rest in peace without the presence of the deadly projectile.

The doctor's membership of the society and his experience of undertaking autopsies means that by this time he would not have felt squeamish about opening up the chest to remove the bullet, not even on the corpse of a friend. There is a further reason for believing that the bullet may have been removed: 15 years later, when Vincent's bones were exhumed for moving to another grave (and the *Hamlet*-like scene took place), there is no suggestion that the bullet was found.

These rather morbid details are relevant when considering whether Van Gogh died from his own hand or if someone else was involved. Dr Gachet obviously closely inspected the wound while Van Gogh

was alive, but if he had also removed the bullet shortly after death then it should have been quite clear to him whether the shot had been fired from centimetres or metres away. The doctor was certainly well accustomed to dealing with gun wounds: he had served as a military surgeon during the Franco-Prussian war and had also formulated his own antiseptic liquid for treating battle injuries. Dr Gachet was undoubtedly convinced that Van Gogh's death was suicide, as he starkly recorded in his diary entry for 27 July 1890 – reproduced here for the first time in an English-language publication (fig. 5).[20]

In my view, the argument that someone else pulled the trigger is simply wrong. There are quite enough legends surrounding Van Gogh without adding another. Vincent took the decision to end his life. This explains why the longest chapter of this book deals with the controversial issue of how he died.[21]

* * *

Van Gogh's remarkable life has always excited just as much interest as his pathbreaking art, but it is his amazing achievements as a painter that drives the fascination. His sojourn in Auvers turned out to be the most productive of his entire career: he painted at the furious rate of just over a picture a day during his 70 days.[22]

Although Van Gogh completed around a dozen portraits and a similar number of flower still lifes, what he excelled in were landscapes. *Church at Auvers* (plate 20) is one of his most powerful paintings, with its striking use of colour. His panoramic wheatfields capture the vast openness of the plateau above the village, under a variety of skies. Towards the end of Van Gogh's stay he began a series of 'double-square' canvases, a full metre wide, capturing views of the countryside. These striking works helped pave the way for the development of Expressionism in the 20th century.

This book completes a trilogy covering the extraordinary last years of Van Gogh's life in France, where he produced his greatest work. *Studio of the South: Van Gogh in Provence* (published in 2016) explores

his turbulent 15 months in Arles, living in the Yellow House. It was there that his collaboration with Paul Gauguin came to a tragic end with the mutilation of his ear. *Starry Night: Van Gogh at the Asylum* (published in 2018) covers his year behind the walls of a mental institution just outside Saint-Rémy. Art helped him survive in this most challenging of environments.

Van Gogh's Finale: Auvers and the Artist's Rise to Fame finishes the story. The book is presented in three parts. The first and longest section deals with Vincent's ten weeks in Auvers, celebrating his amazing achievements. The second part provides a detailed account of the events surrounding his death, which was so quickly followed by that of his beloved brother Theo. The last part looks at Van Gogh's legacy and rise to fame, with a strong focus on his Auvers period. A man who failed to sell his work in his own lifetime would soon become one of the most well-known artists of all time.

INTERLUDE IN PARIS

*'In Paris it was a great joy for me to see Theo again
and to meet Jo and the little one'*[1]

It was an emotionally charged moment when Vincent first set eyes on his brother Theo's wife Johanna (Jo) and their young child. He stepped into their Parisian apartment and as Jo later recalled: 'Theo drew him into the room where our little boy's cradle was; he had been named after Vincent. Silently the two brothers looked at the quietly sleeping baby – both had tears in their eyes.'[2] The artist's nephew, named Vincent Willem in his honour, was only just over three months old.

The previous day Vincent had been discharged from a mental asylum and now, following an overnight train journey from Provence, he was about to embark on an independent life. It was a courageous venture after all that had occurred. He planned to stop in Paris for a few days with Theo and his family before moving on to Auvers-sur-Oise.

Van Gogh's recent sufferings had begun during the evening of 23 December 1888, in Arles. While living and working with his fellow artist Gauguin he suffered a mental crisis, which led him to sever most of his left ear. This traumatic incident brought an abrupt end to their collaboration in the Yellow House, with Gauguin quickly fleeing back to Paris.[3]

Although Van Gogh's physical wounds healed surprisingly quickly, he was mentally scarred and suffered several further crises and periods of hospitalization over the coming weeks. Eventually realizing that

it would be difficult to live independently, he reluctantly accepted advice to retreat to a mental asylum. He agreed to go to Saint-Paul-de-Mausole, a small institution established in a former monastery on the outskirts of Saint-Rémy, 25 kilometres from Arles.

Vincent moved into the asylum on 8 May 1889. But as the months passed, he understandably became increasingly frustrated with institutional life and being surrounded by many inmates who were in an even worse mental condition than himself.[4] By September he was writing to Theo to say he was anxious to return 'to the north'.[5]

Theo then turned to Camille Pissarro for advice, asking whether Vincent might possibly be able to stay with his family in the village of Eragny-sur-Epte, 70 kilometres north west of Paris. While living in Paris a few years earlier Vincent had met Camille, whom he admired, and had also got to know his son Lucien. It is fascinating to speculate how Vincent's painting might have evolved if he had ended up lodging with the Impressionist master and perhaps even sharing his studio.

At this time Theo (fig. 6) was the manager of the Boussod & Valadon gallery in Rue Montmartre, where Pissarro sold his work. Pissarro was due to have an exhibition there, in February 1890, so it would have been prudent for him to try to help Theo. But he must have been aghast at the prospect of welcoming someone from a mental asylum into his home, so he diplomatically explained that his wife was too busy with their children to look after a lodger. Theo passed on the response to Vincent, commenting that Pissarro 'doesn't have much to say at home, where his wife wears the trousers'. Fortunately Pissarro came up with an alternative: he 'knows someone in Auvers, who's a doctor and does painting in his free moments' – an art-lover 'who has been in touch with all the Impressionists'.[6] This remarkable individual was Dr Paul Gachet.

During the winter months the Auvers plan remained on hold, mainly because Vincent's condition had temporarily deteriorated so he needed to remain in the asylum. But by the early spring of 1890 he was beginning to recover and had become increasingly desperate

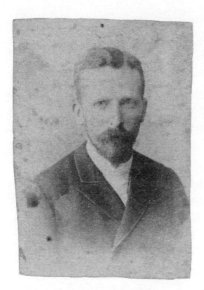
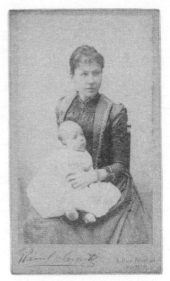

fig. 6 Theo van Gogh, 1889,
photograph by Woodbury & Page,
Amsterdam,11 x 8 cm,
Van Gogh Museum archive

fig. 7 Jo and Vincent Willem van
Gogh-Bonger (the artist's nephew),
April 1890, photograph by
Raoul Saisset, Paris, 11 x 6 cm,
Van Gogh Museum archive

to leave. Theo met Dr Gachet, who worked in Paris part of the week, to seek his advice. The doctor also shied away from offering lodging, instead pointing out that the village had several suitable inns. He would be quite willing to offer informal medical advice and keep a friendly eye on Vincent. Seemingly an ideal arrangement, it was quickly agreed.

On 16 May 1890, the day of Vincent's departure from the asylum, Dr Théophile Peyron completed his medical notes. Van Gogh had suffered several attacks during his year as a patient, each lasting a few weeks, although in the intervals between them he was 'perfectly calm and lucid, and passionately devotes himself to painting'. But at this time little was understood about mental illnesses and treatment was

rudimentary. Dr Peyron wrote 'cured' at the end of the medical record.[7]

It has usually been assumed Dr Peyron was unduly optimistic in pronouncing Van Gogh cured, but the asylum records reveal that remarkably few patients were placed in this category. In 1874, when there had been 32 male patients, only two were regarded as having even 'some hope' of being cured.[8] This suggests that Dr Peyron's verdict may well indicate that he genuinely believed that Van Gogh had recovered. This judgement would have given both Theo and Dr Gachet a false sense of security about Vincent's condition.

That morning Van Gogh passed through the gate of the walled asylum for the last time, accompanied by an orderly. They took the narrow-gauge railway from Saint-Rémy to Tarascon, where Vincent was escorted onto the night train for Paris. Theo had wanted the orderly to take him all the way, but his brother had refused: 'Is it fair to have me accompanied like a dangerous animal? No thank you, I protest.'[9]

During the overnight journey Van Gogh must have pondered on the challenges that lay ahead. More immediately, in just a few hours, he would be reunited with his brother and meet his new wife Jo (fig. 7) and their young baby. After a year in cloistered seclusion, this prospect must have seemed exciting, but also daunting for someone who had led such an isolated existence.

Theo was equally worried. Jo later recalled: 'That night Theo could not sleep for anxiety lest something happen to Vincent on the way; he had only just recovered from a long and serious attack, and had refused to be accompanied by anyone. How thankful we were when it was at last time for Theo to go to the station!'[10]

Vincent's train arrived at the Gare de Lyon early in the morning. The emotional reunion took place on the platform, their first proper encounter in more than two years. Although Theo had visited him in the Arles hospital on Christmas Day 1888, just after the ear incident, Vincent had then been in an extremely weak condition, possibly even on the verge of death. As Theo approached the station he must have dreaded the prospect of seeing his brother's scarred, mutilated ear.

After meeting, Theo hired a carriage to take them back to his apartment at 8 Cité Pigalle, just below the hill of Montmartre. Vincent knew Paris well from his stay there between 1886 and 1888, but the bustle of a major railway station and the drive through the crowded boulevards must have come as a shock after a year behind a walled former monastery deep in the Provençal countryside.

Jo was relieved to hear their carriage enter the courtyard. She looked down from a window: 'Two merry faces nodded to me, two hands waved – a moment later Vincent stood before me.' She was pleasantly surprised: 'I had expected a sick man, but here was a sturdy, broad-shouldered man, with a healthy colour, a smile on his face, and with a very resolute appearance.' Her immediate thought was that 'he looked much stronger than Theo.'[11] Initially, all seemed to go well. Vincent later reported back to his sister Wil that 'Jo is full of both good sense and goodwill.'[12] Theo was relieved at his brother's condition, although he did sound a note of caution: 'He has never looked so healthy, and in the way he talks he is also quite normal. Even so he feels that those attacks may return and is afraid of that.'[13]

After his first night Vincent rose early on Saturday morning to examine some of the paintings that he had earlier sent to his brother from Provence. The vibrant *Almond Blossom*, painted in February at the asylum, had pride of place above the piano in the salon. Hanging nearby were the marvellous Arles landscape, *The Harvest*; a stunning portrait of an *Arlésienne*; and a spectacular triptych of Provençal fruit trees in blossom. *The Potato Eaters* hung above the mantelpiece in the dining room.[14]

There was only space for a few of Theo's favourites on the walls. Dozens of other paintings were stored under the beds and a sofa, to the 'great despair' of their maid, as well as in a cupboard in the spare room.[15] That first morning Vincent took out all the pictures – spreading them on the floor and studying them with 'great attention'.[16] He must have then appreciated quite how his art had developed during his stay in Provence.

On the Sunday Theo took Vincent to see the inaugural show of the revitalized Société Nationale des Beaux-Arts, which showed progressive contemporary paintings. This was the first art exhibition that Vincent had seen for over two years. He was particularly struck by a large symbolist landscape with classical figures by Pierre Puvis de Chavannes, *Inter Artes et Naturam* (Between Art and Nature).[17]

The brothers must also have visited a vast exhibition of prints from Japan at the Ecole des Beaux-Arts. Vincent loved Japanese prints, which were a major influence on his own art. He admired the bold way that their artists cropped images for dramatic effect, with their strong colours proving an inspiration. He empathized with their love of nature and their obsession for spring blossom. Before his arrival Vincent had written that he was 'very much looking forward to seeing the Japanese prints' in Paris.[18] The show was organized by Siegfried Bing, the dealer who had sold him over 600 prints in 1886–87.

That evening Jo's brother, Andries Bonger, came for supper. Andries and Theo had been friends for years, so Vincent knew him well from his earlier stay. Afterwards Andries reported back to his parents that Vincent seemed cheerful and 'looks better than ever, and has put on weight'.[19]

On Monday Theo had to return to work at the Boussod & Valadon gallery. It was an extremely busy time for him, since that week he was opening an exhibition of works by Jean-François Raffaëlli, an associate of the Impressionists. This would be the gallery's first show with electric lighting. It is unclear whether Vincent visited his brother's gallery.[20] Presumably the appearance of someone with a mutilated ear who had just arrived from a mental asylum would have proved highly embarrassing for Theo. To add to the complications, Vincent had been sacked by the company when he worked for them in London and Paris in the mid-1870s, mainly on the grounds that he was awkward at dealing with customers.

Vincent did, however, pay a visit to Père (Father) Julien Tanguy (plate 2), a paint seller and lover of avant-garde art. For two years Theo

had sent Vincent supplies from Tanguy, who also rented out a small attic room above his shop for storing Van Gogh's growing stock of pictures. Although Vincent was pleased to see his friend again and view his earlier paintings, he was horrified by conditions there, describing the storeroom as a 'bedbug-infested hole'.[21]

Jo later claimed that Vincent had been 'cheerful and lively all the time' during his stay, but this was far from the whole story. His year at the asylum was apparently 'not mentioned', suggesting that it was something of a taboo topic, although Vincent and Theo may well have had private discussions.[22] Vincent had initially talked of staying in Paris for a while, perhaps even doing some painting, but he abruptly left on the Tuesday morning – after just three full days. He missed seeing the Salon, the most important art exhibition of the year, and failed to meet his closest Parisian artist friends.

Jo insisted that it was city life that had been the problem, saying that 'Vincent soon perceived that the bustle of Paris did him no good, and he longed to set to work again'.[23] He himself made a similar point: 'I really felt in Paris that all the noise there wasn't what I need.'[24] But one wonders whether the two brothers may have found it difficult to reconnect after their lives had taken such different directions. In a letter that Vincent wrote a few days later, but never actually sent, he was more explicit about the difficulties. He admitted to leaving Paris 'in confusion', hoping 'that it might be possible to see each other soon with more rested minds'.[25]

After Theo returned from work on the Monday evening Vincent announced his intention of leaving the following morning. Theo accepted his abrupt decision, penning a rather formal letter to Dr Gachet for his brother to hand over: 'As he [Vincent] does not wish to tire himself too much in Paris, he has decided to leave for Auvers and to go and see you. You will see that at present he is very well. I should be much obliged to you if you would look after him, and give him advice on a possible place to live.'[26]

PART I

74 PAINTINGS
IN 70 DAYS

CHAPTER ONE

FIRST IMPRESSIONS

*'Auvers… it's the heart of the countryside, distinctive
and picturesque'*[1]

Early in the morning on 20 May 1890 Vincent set off to catch the train for Auvers, insisting to Theo and Jo that he would travel solo. As the train rushed through the newly industrial outskirts, before fields and eventually trees lined the tracks, he must have thought once again about the new life which was opening up for him. Finally the route crossed the River Oise to arrive in Auvers (fig. 8 [2]).

Vincent strode off to meet Dr Gachet, handing over the letter of introduction that Theo had written the previous evening. The immediate task was to find accommodation and the doctor recommended the Auberge Saint-Aubin, an inn on the main road just below his house.[3] But board and lodging there cost 6.50 francs a day – much too expensive for Vincent, who was expecting a daily allowance of 5 francs from

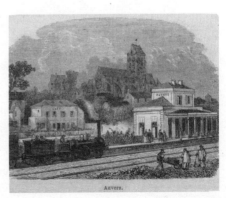

fig. 8 Railway station, Auvers, 1872, print

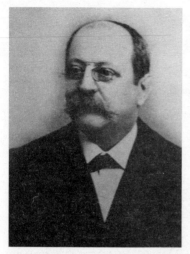

fig. 9 Arthur and Louise Ravoux, 1890s, photographs, Institut Van Gogh, Auvers

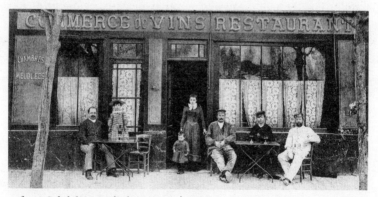

fig. 10 Café de la Mairie (Auberge Ravoux), with Arthur Ravoux and his young daughter Germaine on the left and his older daughter Adeline in the doorway (the infant and the three men cannot be identified), 1891–93, Institut Van Gogh, Auvers

Theo. The two brothers had long had an arrangement: Theo provided regular payments and in return Vincent gave him nearly all the paintings he produced.

Instead, Vincent headed for the Café de la Mairie, a more modest inn right in the centre of the village in Rue de la Gare (now Rue du Général de Gaulle), just opposite the town hall. The price was a more manageable 3.50 francs a day – 1 franc for the room and the remainder for meals. Just four months earlier the auberge had been taken over by a congenial couple, Arthur Ravoux and his wife Louise[4], so it was informally known as the Auberge Ravoux (fig. 9 [5]).It is always said that they just had two daughters, 12-year-old Adeline and 2-year-old Germaine. However, they had also had two other children, a son Victor and a daughter Léonie, but they died in infancy.[6]

When Van Gogh arrived at the auberge it is likely that he would have first seen a few tables outside on the pavement, from where customers could enjoy a drink and watch the world go by. The café itself was more discreetly situated behind net curtains. Above the doorway was the prominent sign 'Commerce de Vins/Restaurant', advertising that Ravoux also sold wine from premises at the side. Most importantly for Van Gogh, a 'Chambres Meublées' notice indicated that there were furnished rooms to let (fig. 10 [7]).

The Ravouxs led Van Gogh to the available room, up the staircase at the back. Tucked away on the attic floor, it measured just seven square metres, making it even smaller than his former monastic cell in the mental asylum in Provence.[8] Rudimentary furniture – probably just a single bed, a small table and a chair – stood on the bare floorboards. Van Gogh would have immediately noted that there was no proper window, just a small skylight in the sloping roof. This must have been particularly annoying for an artist, for whom good light is essential. However, as the auberge was then frequented by painters, a room had been set aside in a building at the back to serve as a makeshift studio and storeroom. And fortunately by late May it was usually warm enough to work outside.

Although cramped, considering the price Van Gogh could hardly complain – and he was well accustomed to unsuitable rooms. Two years earlier, when commenting on the fate of the Impressionists, he

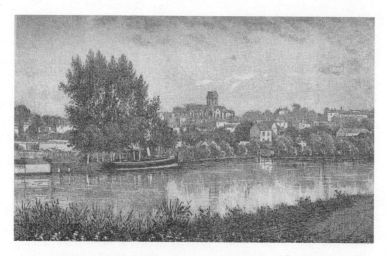

fig. 11 Auguste Deroy, View of Auvers from the Oise, *c*.1893, etching

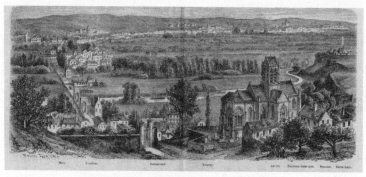

fig. 12 Félix Thorigny, Panorama of the Oise Valley from just
above the church of Auvers, 1868, print

observed that even though a few artists had made successful careers,
'the majority of them are poor souls who live in coffee houses, lodge
in cheap inns, live from one day to the next'.[9]

After unpacking his necessities, Van Gogh was impatient to explore
his new surroundings. Across from the auberge was the imposing
mairie (town hall), with its belfry and large clock. A few weeks later Van

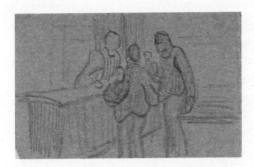

fig. 13 *People in a Café*,
May–June 1890, pencil
on paper, 9 x 13 cm, Van
Gogh Museum, Amsterdam
(Vincent van Gogh
Foundation) (F1654r)

Gogh would make a painting of the building, decked out with French
tricolours on the facade for the 14 July national day celebrations. In his
picture a garland of lanterns hangs between the trees for the festivities
(plate 3).

Adjacent to the town hall and directly opposite the auberge was the
market place, where cattle were sold on Thursdays. This busy area was
lined by several shops, a *tabac* (tobacco sales), the post office and the
Café de la Poste, all conveniently close at hand. Although Auvers was a
straggling village, the artist was in its lively heart.

On his first afternoon Van Gogh, a keen walker, almost certainly
strolled down to the River Oise, which flowed towards the town of
Pontoise and later entered the Seine. Riverside scenes were much
favoured by artists who were attracted to Auvers (fig. 11).[10, 11] He
probably also visited the church, which was positioned on a nearby rise
from where one could look out over the roofs of the village centre and
towards the outlying hamlets and beyond.

A panoramic print depicting the scene from just above the church,
near the cemetery, gives an impression of the view (fig. 12 [12]).The
station, with its double row of three windows, is just visible in the
print, down below, just to the left of the tree trunk in the centre of the
foreground. The *mairie* and the auberge lie beneath the church, but are
hidden in this view. The Oise dominates the valley, with the road bridge
linking Auvers with the neighbouring village of Méry-sur-Oise. Down
in the valley, the road leads towards Pontoise to the right.

Vincent was becoming increasingly confident that Auvers would prove to be an ideal place to work, with its thatched farmhouses clustered in hamlets along the valley. The total length of the commune of Auvers was a very considerable 7 kilometres. Its population then totalled 2,000, with 600 people living around the *mairie* and the church, but with the majority in outlying farms. 'We're far enough from Paris for it to be the real countryside', Vincent wrote to Theo and Jo.[13]

Returning after his afternoon's expedition, Van Gogh settled down for the evening, savouring his first supper and a glass or two of wine. The ground-floor café quickly became the place where he would spend many hours after work, closely observing life around him, mulling over his day's production and planning for the following one. Social contact with the customers, fellow lodgers and villagers must have seemed both challenging and exhilarating after a year of isolation in the asylum. On one occasion Van Gogh made a quick sketch of a bar scene, almost certainly done unobserved in the auberge (fig. 13 [14]).

One wonders what the Ravouxs and their customers made of their new arrival, a foreigner who was very conspicuously missing an ear. Although Van Gogh was known for his direct manner, he would hardly have volunteered what had occurred on that terrible night in Arles just before Christmas 1888. But news that he had left a mental asylum less than a week earlier may well have emerged – and, if so, would then quickly have become the subject of village gossip. Fortunately, the Ravouxs were welcoming and solicitous.

That first evening Vincent wrote to Theo and Jo, quite likely from his café table. Brimming with enthusiasm, he was looking forward to setting off in the morning with his easel, paints and brushes. Vincent described his impressions of Auvers. It was, he wrote, much changed since the time of Daubigny.[15] This was a reference to Charles-François Daubigny, a landscape painter who had regularly come to work in Auvers from the 1840s (fig. 15) and then built a house in 1862, where he lived until his death in 1878. Daubigny, one of the most celebrated 19th-century French landscape artists, had long been admired by Van Gogh.

fig. 14 An unidentified artist in Rue Daubigny, Auvers, c.1905, postcard

fig. 15 Charles-François Daubigny, *The Track on the Plain of Auvers*, 1843, oil on canvas, 33 x 55 cm, private collection, Switzerland

Vincent was already aware of recent changes at Auvers: 'There are many villas and various modern and middle-class dwellings, very jolly, sunny and covered with flowers.' Auvers comprised two communities, which lived side by side: farming families, who had been there for generations and led simple lives, and incomers from Paris, who enjoyed rural tranquility and easy access by train. These visitors included numerous painters, who were turning Auvers into an informal artists' colony (fig. 14).[16]

Those following in Daubigny's footsteps included two of the key Impressionists. Camille Pissarro moved to nearby Pontoise in 1866, where he remained for the next 17 years, and he would sometimes walk to Auvers to paint. His *Rue Rémy, Auvers* is a typical Auvers scene, very close to where Dr Gachet lived. The top of the chimney of the doctor's house can just be made out, poking up above the thatched roof in the centre of the painting (fig. 16).

fig. 16 Camille Pissarro, *Rue Rémy, Auvers*, 1873, oil on canvas, 65 x 81 cm, private collection

Cézanne lived in Auvers from 1872–74, only a minute's walk from Dr Gachet around the corner, and he later often returned for short visits up until 1882.[17] His painting *The House of Dr Gachet at Auvers* (fig. 17) was also done from a nearby location. Both the Pissarro and Cézanne pictures are early Impressionist works, loosely painted to capture the shimmering effects of light and the village's tranquil rural atmosphere. Van Gogh was relishing the opportunity to follow in their tracks, although he adopted an even more radical artistic approach.

After supper Vincent climbed the stairs to his room, exhausted after the long day. He settled in, and it may well have been then that he pinned some Japanese prints on his bedroom walls, to make it feel his own. On either side of the bed he hung two works, one of a mother and child and the other of a courtesan with her assistant. Throughout his

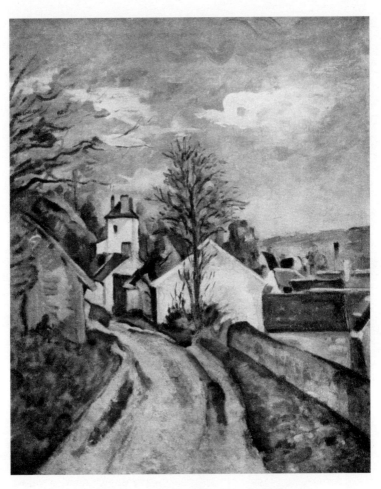

fig. 17 Paul Cézanne, *The House of Dr Gachet at Auvers*, c.1873,
oil on canvas, 46 x 38 cm,
Musée d'Orsay, Paris

life he had always pinned prints of artworks he admired on his walls, a habit which annoyed a succession of landlords.[18]

Following the overnight journey from Provence and the emotionally draining stay in Paris, he must have enjoyed lying in what would become his own bed. Emerging from the suffering he had endured during his final months in Arles and his year in the asylum, he hoped that a fresh environment would cure him of his demons – and help develop his skills. In his first letter from Auvers, he optimistically told Theo and Jo that it might even be possible to sell his landscape paintings: 'There would be a chance of recouping some of the costs of my stay.'[19]

THE ECLECTIC DOCTOR

*'I've found in Dr Gachet a ready-made friend and
something like a new brother'*[1]

Van Gogh was obviously quite mystified by his first meeting with Dr Paul Ferdinand Gachet. He 'gave me the impression of being rather eccentric', Vincent wrote to Theo on the day of his arrival. He added that 'his doctor's experience must keep him balanced himself while combating the nervous ailment from which it seems to me he's certainly suffering at least as seriously as I am'.[2] As so often, Vincent saw his own problems reflected in others. Nevertheless, Dr Gachet was clearly a most unusual character.[3]

Two days later, when calling on the doctor, Van Gogh was disappointed to find that he was away working in Paris. At this point Vincent became agitated, writing in an unsent letter to his brother: 'We must IN NO WAY count on Dr Gachet. In the first place he's iller than I… when one blind man leads another blind man, do they not both fall into the ditch?'[4]

Fortunately, Dr Gachet had redeemed himself on his return by inviting Van Gogh for Sunday lunch. That evening Vincent reported back to Theo that his host was 'as discouraged in his profession of country doctor as I with my painting'. Lightheartedly, he added that he would 'gladly swap profession for profession'.[5] Although Dr Gachet might have ended up becoming a skilled artist, it is more difficult to envisage Van Gogh taking up medicine.

That Sunday, 25 May, was the 15th anniversary of the death of the doctor's wife Blanche, which may explain his initially sombre mood. Perhaps he was hoping that the presence of the Dutch artist at the lunch table would prove a welcome diversion. As the meal progressed the two men quickly found they had much in common, with Vincent later telling Theo that 'I'll end up being friends with him'.[6] Social contact would have been difficult in the asylum, so he must have been pleased to strike up a friendship once again.

The two men also discussed Van Gogh's medical condition. Dr Gachet was reassuring, as Vincent recounted: 'If melancholy or something else were to become too strong for me to bear, he could well do something again to lessen its intensity... I mustn't be embarrassed to be open with him.'[7] Although it sounds as if the doctor had a specific drug in mind, he appears never to have prescribed anything and at that time there was little that could be done for mental disorders.

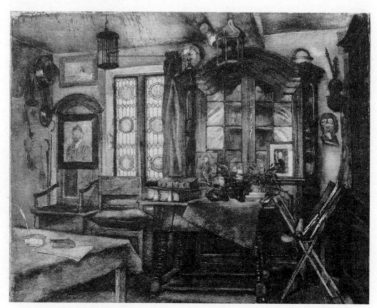

fig. 18 Léopold Robin, *Dr Gachet's Salon*, 1903, watercolour, location unknown

Vincent remained optimistic, believing that his condition was 'an illness of the south that I caught', so a return to northern France would 'dispel all that'.[8] Dr Gachet's advice was exactly what he wanted to hear: 'Work a great deal, boldly, and not think at all about what I've had.'[9] Painting would stave off any potential mental problems.

The extraordinary home of Dr Gachet and his two children was in the upper part of the village, with a panoramic view over the valley. A delightful description of the house was recorded by the doctor's cousin Marguerite Poradovska, who visited in 1891. It was 'the house of wisdom, of the artist, of philosophy' and on the walls there were 'pictures of the Impressionists: Cézanne, Van Gogh, etc'. Animating the scene, 'near the fireplace, the doctor smokes his pipe, between his dog and some black cats'.[10]

An invitation to the Gachet household would have been quite an experience. Vincent described it as 'full of old things, dark, dark, dark, with the exception of a few sketches by Impressionists'.[11] This has usually been interpreted as meaning that it was crammed with antique oak furniture – but he might also have been referring to some of its more unusual and macabre objects.

A watercolour of a corner of the large salon (fig. 18 [12]), painted just 13 years later, conveys something of the assemblage. A birdcage and a lantern hang from the ceiling, while a violin, a landscape painting with a windmill and copper pans dot the walls. Six Florentine Renaissance stained glass roundels decorate the window. Dr Gachet would sit at the large table to write, his quill and inkwell at the ready (fig. 19). Ancient books are casually strewn on the smaller table, next to a print-

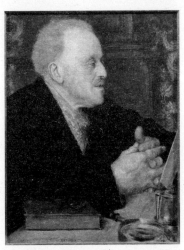

fig. 19 Norbert Goeneutte, *Portrait of Dr Paul Gachet*, 1891, oil on canvas, 35 x 27 cm, Musée d'Orsay, Paris

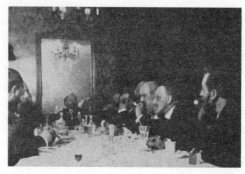

fig. 20 A dinner of the Société des Eclectiques, Paris, with Dr Gachet (second from right), early 1890s, photograph

stand, while a globe is perched above the cabinet. Scattered around are sculptures, fabrics, curios and much, much more.

Arrayed in the glass-fronted cabinet are the Delft and Sèvres vases which appear in the flower still lifes painted by both Cézanne and Van Gogh. Van Gogh's 1889 *Self-portrait with Swirling Background* (plate 1), hangs incongruously on the back of an ecclesiastical seat – suggestive of the artist's empty chair. Just out of sight in the watercolour of the salon was the piano, which would appear in Van Gogh's painting of the doctor's daughter Marguerite (plate 30). There would also have been the doctor's medical equipment, surgical instruments, jars of medicines and the curious devices that he used for electrotherapy. Theo's widow Jo, who visited Dr Gachet in 1905, two years after the watercolour was painted, described his home as 'like the workshop of an alchemist of the Middle Ages'.[13]

The interior decoration may have been extraordinary, but even more remarkable was the character of its host (fig. 19). Dr Gachet radiated boundless energy and an insatiable curiosity, with wide interests spanning the sciences and the arts. By this time he was president of the Société des Eclectiques, which assembled a fascinating array of men for dinner and conversation.

The avant-garde Eclectiques met on the first Monday of every month in a different Parisian restaurant, grouping around a table 'a few friends who care less about fine dishes than about sharing good humour and discussing plays, books and paintings that are in vogue' (fig. 20).[14, 15] That was their formal purpose, but Gachet's son put it

more bluntly: 'You eat, drink, smoke, you tell stories; you make jokes about serious things; you take nonsense seriously.'[16]

As Pissarro had advised Theo, 61-year-old Dr Gachet would be the ideal person to keep a friendly eye on Vincent. Born in Lille, he had studied medicine in Paris and Montpellier. His thesis was on melancholia, in which he wrote that all 'the big criminals, the big poets, the big artists' were mostly melancholic.[17] He then worked for a short period at the Parisian mental hospital of Salpêtrière. In 1859 he began to practise conventional medicine and homeopathy in Paris, as well as putting his faith in phrenology, physiognomy, graphology, chiromancy and electrotherapy – fringe medical ideas, which during the 20th century would become largely discredited.

Seeking an escape from the city, in 1872 Dr Gachet had bought his Auvers home – a villa which had earlier served as a girls' school. From then on he worked in Paris half the week, staying in his apartment there, and spending the rest of the time at leisure in Auvers.[18] His wife Blanche died three years after they bought the Auvers house. At the time of Van Gogh's arrival he was living with his 20-year-old daughter Marguerite, 16-year-old son Paul Louis (Gachet Jr) and housekeeper Louise Chevalier – who was very close to the family and may have once been the doctor's lover.[19]

It was in his Auvers home that Dr Gachet indulged in his greatest passion: the visual arts. A self-taught amateur artist, he mostly etched, signing his prints with the pseudonym Paul van Ryssel, a name he took from his birthplace of Lille (Ryssel in Flemish). He also often included his own personal symbol in his prints, a duck. With his own printing press in the attic, he eventually produced just over a hundred etchings. He also occasionally painted, exhibiting three times in the 1890s at the Société des Artistes Indépendants. The doctor even tried his hand at being an art critic, writing under the pseudonym *Bleu-de-ciel* (Sky Blue). His nine lengthy articles on the 1870 Salon exhibition had appeared in a progressive publication entitled *Le Vélocipède Illustré* (The Illustrated Bicycle), which covered cycling, the sciences and the arts.[20]

LEFT fig. 21 Death head of the guillotined murderer Arsène-Raymond Lescure, 1855, owned by Dr Gachet, plaster, 29 cm high, Wellcome Collection, London (on long-term loan to Science Museum, London)

RIGHT fig. 22 *Méditation* (dinner invitation for the Société des Eclectiques, 7 August 1876), print, 10 x 12 cm

But it was as a collector rather than as an artist that Dr Gachet would eventually achieve renown. His tastes were broad and he owned old masters that included a pair of 16th-century paintings attributed to Giuseppe Arcimboldo, with heads composed of pieces of fruit. His collection of prints, ranging over 400 years, numbered well over a thousand.

However, most of his collection was late 19th century, with a marked emphasis on the avant-garde. His strongest holdings were of Pissarro, Cézanne and their contemporary Armand Guillaumin, although he also had works by Renoir, Monet and Sisley. Many of his Impressionist paintings had been acquired directly from the artists, mostly as gifts or in exchange for medical services.

While the avant-garde Impressionist paintings may have horrified his more conventional friends, what really struck terror into visitors was a row of plaster casts of the heads of guillotined criminals. Two are of Pierre Lacenaire and his accomplice Pierre Avril, who were both executed for murder in 1836. Lacenaire's end was particularly

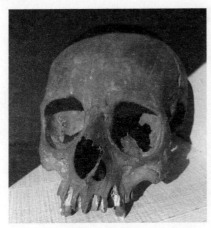

fig. 23 Skull from the collection of Dr Gachet, Maison du docteur Gachet, Auvers

gruesome, since he first had to watch Avril being guillotined. When his turn came, the blade began to drop, but it then got stuck halfway. Lacenaire twisted his head to look up, and a few seconds later the blade was hauled up again and then accomplished its grisly task. Dr Gachet's three other death heads were of Joseph Norbert (guillotined in 1843), Arsène-Raymond Lescure (1855) (fig. 21) and Martin Dumollard (1862). The Norbert head is inscribed with penciled phrenological marks, presumably added by the doctor himself.[21]

Dr Gachet must have found these casts inspirational, since he etched a disturbing image of five severed heads for an invitation for a dinner of the Société des Eclectiques, entitling it *Punishment, Guillotine*.[22] The doctor had earlier shown the casts to Cézanne, who deemed them to be 'exciting'.[23] Van Gogh almost certainly saw them, too – since they were displayed in the studio.

The doctor was also the proud possessor of a collection of human bones. At the back of his house a cliff rises towards an ancient cemetery and as the rock face gradually erodes, bones occasionally tumble down into the garden. The doctor may also have acquired specimens from hospital morgues or his medical colleagues. In the 1860s he used some of these bones for teaching an anatomy course for artists.

It was skulls, in particular, that fired Dr Gachet's imagination. He featured one on the invitation he etched for another dinner of the Eclectiques (fig. 22) and it might well be the cranium that appears

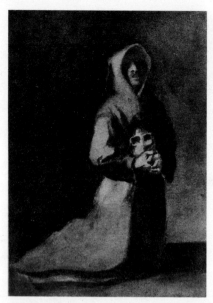

fig. 24 Amand Gautier, *Dr Paul Gachet in the Pose of St Francis of Assisi in Prayer, in the manner of Francisco de Zurbarán*, c.1860, watercolour, 29 x 21 cm, location unknown

in a portrait painted by his son (fig. 74). Indeed it could even be the very skull that survives and is now on display in his house (fig. 23). Further evidence of Dr Gachet's interest in this morbid subject matter is a painting that his artist friend Amand Gautier did of the doctor posing as St Francis of Assisi contemplating a cranium, inspired by a painting by the Spanish artist Francisco de Zurbarán (fig. 24).[24, 25]

Presumably Van Gogh regarded the plaster heads and human skulls as just another manifestation of Dr Gachet's eccentric personality. The men soon got on well and two days after their first Sunday lunch, Vincent returned to paint in the doctor's garden. The result was an exuberant landscape, looking towards the valley from near the front door (plate 4). The doctor loved the view, often saying that this was the reason why he had bought the house.

In *Dr Gachet's Garden* the scene is dominated by a large, spiky yucca plant and, further back, a pair of large thuyas, reminiscent of Van Gogh's Provençal cypresses.[26] A scattering of orange marigolds echoes the colour of the garden wall, creating a dramatic backdrop to the greenery and slicing the composition in two. Dr Gachet's son later recalled that the artist had completed the picture in less than three hours.[27]

Working in the doctor's garden gave Vincent great pleasure, but he found the lunches cooked by the housekeeper Chevalier heavy. As he complained

to Theo: 'However agreeable it is to do a painting there, it's a chore for me to dine and lunch there for the excellent man goes to the trouble of making dinners in which there are 4 or 5 courses, which is as abominable for him as it is for me.' Vincent much preferred two courses, which he described as the 'modern' and healthy way to eat.[28]

Within a fortnight of Van Gogh's arrival he was already 'firm friends' with the doctor. But Vincent remained worried about Dr Gachet's mental condition, probably quite unnecessarily: 'He certainly appears to me as ill and confused as you or I, and he's older and a few years ago he lost his wife, but he's very much a doctor, and his profession and his faith keep him going.'[29]

CHAPTER THREE

NESTS

'Auvers is really beautiful – among other things many old thatched roofs, which are becoming rare'[1]

As Van Gogh set out to explore Auvers he was immediately struck by its traditional farm cottages. Many then still retained their steep roofs (such as in fig. 25), although some were 'falling into ruin'. Not surprisingly, he lost no time in starting to paint them: 'There are roofs of mossy thatch which are superb, and of which I'll certainly do something.'[2]

These picturesque dwellings, constructed from natural materials, blended in harmoniously with the gentle, rural landscape. No doubt they reminded Vincent of his native Brabant, in the south of the Netherlands, where peasants still lived in somewhat similar huts. He had long fondly regarded the rustic dwellings of Brabant, with their smoking chimneys, as symbolizing a cosy, family life. While at the asylum he had written: 'The most wonderful thing that I know in terms of architecture is the cottage with a mossy thatched roof, with its blackened hearth.'[3]

When Vincent had been developing as an artist in his parents' village of Nuenen, five years before his arrival in Auvers, he closely observed the traditional cottages, describing them as 'people's nests'.[4] These vivid memories of the Dutch farming community remained with him throughout his life. While in a fragile mental condition at the asylum, just a few weeks before his departure, he had drawn

fig. 25 A farm at Chaponval, Auvers,
c.1910, postcard

and painted his reminiscences of the Brabant huts with their characteristic steeply angled roofs. Writing about these paintings, the critic Albert Aurier also saw them in human terms, referring to Van Gogh's 'squatting houses, passionately writhing, as if they were beings who rejoice, who suffer, who think'.[5] Aurier had understood how, for Vincent, these simple homes were representative of their inhabitants' lives.

During Van Gogh's first few days in Auvers the weather was unseasonably hot. As the chestnut trees blossomed, the vines grew quickly and wheat rose in the fields, he felt joyous about his decision to return to the north. On the Wednesday morning, after his first breakfast at the auberge, he immediately set off for work, shouldering his painting equipment. When be returned in the evening he reported back to Theo and Jo with a certain satisfaction: 'I don't say that my work is good, but it's the least bad that I can do.' By Saturday he was able to write: 'I've been very well the past few days, I'm working hard and have four painted studies and two drawings.'[6]

Thatched Cottages and Houses (plate 5) was probably one of Van Gogh's first canvases, painted in the hamlet of Chaponval, just beyond Dr Gachet's house.[7] 'Now I have a study of old thatched roofs with a field of peas in flower and some wheat in the foreground, hilly background,' he wrote.[8] Waves of vegetation cascade down the hillside, enlivened by a scattering of white flowers. A cluster of farmhouses nestles beneath the plateau that stretches north of the Oise valley. Smoke wafts up from one of the houses, while those lower down have modern terracotta roofs. Just a narrow band of sky is visible, with a single cloud emerging on the horizon.

A few days later Vincent painted *Cottages at Cordeville* (plate 6) depicting another hamlet to the east.[9] By the side of the main cottage there is a terraced vegetable garden, with other buildings huddling together. Despite the agitated sky, which appears to revolve around the central, circular cloud, the sunny scene is one of rural tranquility.

Farmhouse (plate 7) is strikingly different, a small work, painted very quickly.[10] A pair of women are in the garden in front of the cottage, which is dominated by an undulating thatched roof. The foreground is particularly sketchy and the painting was probably intended as a study for a larger and more finished picture that was never completed.

Houses at Auvers (plate 8) is one of Van Gogh's finest depictions of the village, focussing on a short row of farmhouses in Le Four.[11] In the left foreground is another cottage, with its steeply sloping thatch, and a woman walks along the lane, enlivening the scene. It is painted in a rich patchwork of greens and blue, with the contrasting terracotta roof attracting the viewer's eye towards the centre of the composition.

As Van Gogh strolled around Auvers, seeking out subjects, he may well have envied the families living in these traditional homes. For his entire adult life he had moved from place to place, never putting down roots. Altogether he lived in over 20 cities, towns and villages, usually in impersonal lodgings – and often far from family and friends. Although the interiors of these old thatched farmhouses in Auvers were actually extremely basic, on balmy late spring days they must have appeared as symbols of an idyllic rural life.

CHAPTER FOUR

INTO THE LANDSCAPE

'Nature is very, very beautiful here'[1]

After a year at the asylum it was hugely liberating for Van Gogh to be able to freely explore the countryside. As he anticipated, Auvers had a very different feel from the dramatic, sun-soaked olive groves and parched hills of Provence. This greener, temperate landscape follows the course of the majestic Oise, with farmhouses encircled by vegetable plots on gently rising slopes. A short walk up beyond these houses lies the Vexin plateau, with vast wheatfields stretching towards the horizon.

In May dawn breaks very early and Van Gogh would usually wake at around 5am, enthusiastically heading off laden with his equipment. In his first few days he had completed *Old Vineyard with Peasant Woman*, swiftly rendered with watercolour and diluted oil paint (plate 9).[2] The vibrant, coiling vines, captured in blue swirls, add a sense of movement to the composition. A pair of chickens can just be made out beneath the vines, while on the right a plump farming woman with a basket walks past. The lively scene is set off with patches of orange (now faded to brown) on the terracotta roofs, providing a contrast to the blues. This joyful work reflects the emotions of the artist embarking on a fresh phase in his life.

Van Gogh quickly went on to make an oil painting of the same farm, viewed from a different spot. In *Vineyard and Houses* (plate 10), he once again captured the twisting vines, writhing above their gnarled

stems. As the farm was only a few minutes' walk from the auberge, it is possible that Ravoux bought its wine to serve to his customers.

Soon Van Gogh was hard at work on what was to be one of his finest spring landscapes. *Vineyards with a View of Auvers* (plate 11) shows green vines rippling down a steep slope, in an almost abstract pattern.[3] This twisted mass is framed on the left by contrasting red poppies, with only a strip of sky visible above the horizon. A string of cottages in Chaponval sweeps across the hillside, their gable ends emphasized in white, while several red-tiled roofs echo the poppies' striking hue. Dr Gachet's tall white house, with a light blue pointed roof, can just be made out in the far distance at the end of the row of buildings in the upper-left corner.

It is fascinating to compare Van Gogh's painting with Cézanne's *Auvers, Panoramic View* (fig. 26), completed about 15 years earlier from a nearby spot. Cézanne stood slightly higher up the hillside, allowing a wider view of Chaponval. He uses the houses as blocks to build up a pattern, edged by bands of greenery. Dr Gachet's house also appears in the distance as the high white building with two large chimneys in the upper left. Dr Gachet owned the Cézanne painting, so it is likely that Van Gogh would have known it. Indeed Vincent may well have painted *Vineyards with a View of Auvers* as an homage to an artist whose work he held in high esteem.

fig. 26 Paul Cézanne, *Auvers, Panoramic View*, 1873–75, oil on canvas, 65 x 81 cm, Art Institute of Chicago

While most of Van Gogh's Auvers landscapes were inspired by scenes in the outlying hamlets, he found one subject just a minute from his door. *Stairway at Auvers* (plate 12) depicts Rue de la Sansonne, which runs along the side of the auberge. The sunken lane rises and then meets a flight of steps. Van Gogh animated the painting with figures: two pairs of girls and women walk away, an elderly man with a stick descends the steps and another person, now barely discernible, leans against the right bank.[4] The colours are particularly vivid, with the scene set under a tiny sliver of deep blue sky, contrasting with the red-tiled roof beneath. Sinuous lines, energetic brushwork and vivid colours make this an especially powerful work.

Van Gogh was to take his imagination in another exciting direction in *Poppy Field* (plate 13), a composition that verges on the abstract, with colours set out in horizontal bands.[5] Although prosaically described by the artist as 'a field of poppies in some lucerne', it is an impressive work, with luminous red flowers smothering the crop. The distant clump of stylized trees enlivens the composition and leads the eye upwards to a restless sky.

The Oise had been the favourite subject of Daubigny, who often worked from a boat that he had converted into a floating studio. But although Van Gogh was a great admirer of Daubigny and the river flowed only a few minutes' walk from his auberge, the Dutchman only once painted a scene that so entranced visiting Parisians. With the arrival of the railway the village had become a popular destination for weekend visitors, many of whom were attracted by the delightful river (fig. 27).

The majority of Van Gogh's Auvers landscapes are devoid of people and some, like *Stairway at Auvers*, have small figures, but human interest comes centre stage in his only close-up riverscape, *Bank of the Oise at Auvers* (plate 14). Two women enjoy a summer's day out, with one having boarded a boat and the other following.[6] The man could be their companion, but he is more likely simply renting out the skiffs. The rowing craft, reflected in the rich blue river, show Van Gogh's delight

in the use of colour, animated by parallel strokes for the shimmering water and chevron-shaped patterns for the foliage.

The Oise at Auvers (plate 15) also includes the river, although the emphasis here is on the gently rolling small fields.[7] Van Gogh worked with gouache and diluted oil paint to create a tranquil portrayal of rural life. The patchwork of meadows dominates the foreground, with cattle in the right-hand field. Behind the trees the wrought-iron roadbridge, completed just six months before Van Gogh's arrival, blends harmoniously into this tranquil scene.[8]

On the far side of the river sit the outlying buildings of Méry, with the village centre a kilometre further away. Surprisingly, Van Gogh rarely painted from the Méry side of the river. In *The Oise at Auvers* two industrial chimneys are visible: one on the left and the other tucked behind the poplars in the centre of the composition (these chimneys can also be seen in fig. 12).

Landscape with Train (plate 16) was painted from the steep hillside just above Dr Gachet's house, looking down towards the main road. A small carriage, reflected on the wet road, heads towards the centre of Auvers. The houses on the right include the Auberge Saint-Aubin,

fig. 27 Boats at Chaponval, *c*.1910, postcard

the more expensive inn initially recommended by Dr Gachet. The very long train, with passenger carriages at the front, represents yet another intrusion of the modern world. But the focus of the picture is the richly patterned fields, receding towards the river. The Oise lies just beyond the railway line, obscured by a billowing trail of smoke. Van Gogh wrote that he had been working quickly, 'trying to express the desperately swift passage of things in modern life'.[9]

Vincent gave a detailed description of the picture to his sister Wil: 'Yesterday in the rain I painted a large landscape viewed from a height in which there are fields as far as the eye can see, different types of greenery, a dark green field of potatoes, between the regular plants the lush, violet earth, a field of peas in flower whitening to the side, a field of pink-flowered lucerne with a small figure of a reaper, a field of long, ripe grass, fawn in hue, then wheatfields, poplars'. There were 'blue hills on the horizon', and at the bottom of the valley 'a train is passing, leaving behind it an immense trail of white smoke in the greenery.'[10] It is difficult to believe he actually painted in the rain, but presumably he was on the spot, recalling a slightly earlier downpour.

Van Gogh shifts the focus of his attention from the fields to farmhouses in *View of Auvers* (plate 17), one of his finest depictions of the village. The cluster of small buildings, huddling together, dominates the central band of the square composition, with roofs alternating in contrasting blues and oranges. The foreground is a mass of swirling vegetation rendered in thick impasto, with the fields rising up the hillside in smoothly painted swathes. Van Gogh has captured the sky with just a few strokes of blue, leaving much of the white surface of the prepared canvas to represent clouds. *View of Auvers* may well represent the artist's vision of the village, rather than a specific location, an intimate landscape reflecting his delight in his surroundings.[11]

PORTRAIT OF DR GACHET

'I've done the portrait of Mr Gachet with an expression of melancholy'[1]

Van Gogh's *Portrait of Dr Gachet* (plate 18) is among the artist's most powerful paintings. This expressionist work captures his friend in a pensive moment, probing his complex personality. Dr Gachet rests his head on his right hand, as he leans across the composition. Strong brushwork radiates from the doctor's face, imparting great energy to the image.

Despite some initial hesitations, Vincent reported to Theo that he and Dr Gachet were now firm friends. This had developed in just a matter of days, so it was an unexpected pleasure. Vincent soon wrote to his sister Wil, saying that 'I'll go and spend one or two days a week at his house working in his garden.'[2] By early June he had already completed two pictures there, the dramatically coloured *Dr Gachet's Garden* (plate 4) and the more subdued image of the doctor's daughter among white roses and vines (fig. 28).

On Tuesday 3 June Dr Gachet agreed that Vincent could paint his portrait. Van Gogh usually found it difficult to get people to pose, so he must have been delighted with the opportunity and got down to work immediately. Dr Gachet seems to have enjoyed being a sitter and may have possessed a streak of vanity, since a number of his artist friends portrayed him.[3] He must also have been curious to see how Van Gogh would tackle the task.

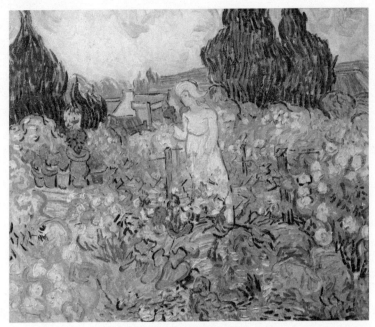

fig. 28 *Marguerite Gachet in the Garden*, May–June 1890, oil on canvas, 46 x 56 cm, Musée d'Orsay, Paris (F756)

Dr Gachet took a seat outside at the long red table where the two men would dine. Van Gogh may well have suggested the contemplative pose, a traditional image of melancholy. This would have reflected both the subject of Dr Gachet's medical thesis and Van Gogh's probably erroneous perception of the doctor's psychological condition.

Van Gogh's composition also echoes that of *The Arlésienne*, a portrait that he had painted three months earlier of his Arles friend Marie Ginoux, who is similarly posed resting her head on a hand and with a pair of books on an adjacent table. Van Gogh had brought a version of *The Arlésienne* to Auvers, where it had been admired by the doctor.[4]

In the first version of *Portrait of Dr Gachet* two yellow-covered novels lie on the table. Their spines reveal that both are 1860s books by the Goncourt Brothers, modern naturalist writers. *Germinie Lacerteux*,

the lower volume, tells the story of a downtrodden servant girl who suffers hardship and melancholia. *Manette Salomon* is a grim tale about a sensitive artist and his model. The choice of titles reveals more about Van Gogh's tastes than those of the doctor. Vincent had depicted *Germinie Lacerteux* in a still life three years earlier and he lent Dr Gachet a copy of the book.[5] He also gave the doctor Edmond de Goncourt's *La Fille Elisa*, the tale of a woman who went mad when she was forced into prostitution and then murdered a man after he raped her.

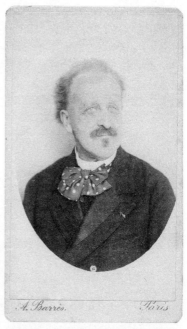

fig. 29 Dr Paul Gachet, 1894, photograph by Alphonse Barrès, Paris, Wildenstein Plattner Institute, New York

Along with the books in the painting is a glass with two sprigs of flowering foxglove (*Digitalis*). Dr Gachet, a keen practitioner of homeopathy, probably grew this plant, which increases the flow of blood and was then used for treating heart disease. Van Gogh is likely to have picked the flowers in his garden.

The background of the portrait is formed of three wavy bands of various blues. This may well be a symbolic representation of the view from the doctor's garden, which enjoyed an extensive vista. The three bands might suggest the landscape reaching down to the Oise, the slope on the far side of the river climbing towards the horizon and finally the sky.

Van Gogh masterfully captured the doctor's singular facial features. Photographs suggest that he did indeed have a wide forehead, an aquiline nose and a protruding chin (fig. 29).[6] The thick hands in Van Gogh's

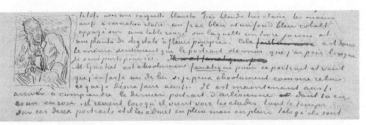

fig. 30 Sketch of first version of *Portrait of Dr Gachet* in letter from Vincent to Theo,
3 June 1890 (Letter 877), Van Gogh Museum archive

painting appear accurate, since it is a feature that French painter Norbert
Goeneutte would later emphasize in his portrait (fig. 19).[7] Van Gogh also
caught the doctor's distinctive saffron-coloured hair – in the village he
was nicknamed 'Docteur Safran'.[8]

Dr Gachet sports his favourite cap with a leather peak, masking his
receding hairline. He wears a striking blue coat, rather formal garb and
uncomfortably hot for a warm June afternoon. It is said to have been
the one he wore as a medical officer during the Franco-Prussian war in
1870.[9] Just visible in his lapel buttonhole is a small dash of red, probably
an award rosette.[10] Lines radiating from the doctor's penetrating eyes
are suggestive of a furrowed forehead.

Writing to Theo, Vincent included a tiny sketch (fig. 30) of the
painting, describing its key features: 'The head with a white cap, very
fair, very light, the hands also in light carnation, a blue frock coat and
a cobalt blue background, leaning on a red table on which are a yellow
book and a foxglove plant with purple flowers.'[11] The colours of the cap
and skin tones have darkened and the red in the purple foxgloves has
faded, leaving them light blue.

Vincent later wrote to his sister Wil about the portrait, saying that
he had not aimed for 'photographic resemblance'. The doctor was
portrayed as a melancholic. He made a similar point in an unsent letter
to Gauguin, explaining that he had set out to convey 'the deeply sad
expression of our time'. In the portrait, something of Van Gogh's own
character emerges, reflecting his own melancholy. Revealingly, he said

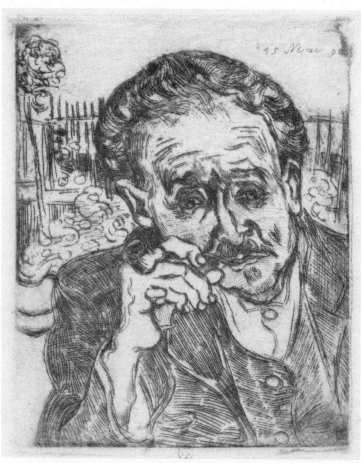

fig. 31 *Portrait of Dr Gachet (The Man with the Pipe)*, June 1890, etching on paper,
18 x 15 cm, version at National Gallery of Art, Washington, DC (F1664)

of Dr Gachet that 'we resemble each other physically, and morally too',
adding that the doctor is 'very nervous and very bizarre'.[12]

Van Gogh compared the portrait of the doctor to his own *Self-
portrait with Swirling Background* (plate 1), which he had brought to

Auvers, explaining that they had 'the same sentiment'.[13] Superficially the two portraits have little in common, other than sharing a blue colouration and strong brushwork. But Van Gogh was referring to his attempt to convey what he saw as the emotions of the sitter. There is little evidence that Dr Gachet actually suffered from melancholia (despite the constant challenges of being a medical practitioner), but Van Gogh, who habitually projected his own emotions onto others, believed that he did.

The portrait painted from life in Dr Gachet's garden was intended to be passed on to Theo, so the doctor seems to have asked whether he could also have a copy. Delighted to oblige, Vincent set to work on a second version back at the auberge and returned to the doctor's house on 7 June to complete the final touches. The two men then repaired to the garden, lit their pipes and contentedly enjoyed a beer.[14]

In the second version (plate 19), painted for Dr Gachet, Van Gogh introduced significant changes, making it more of a reinterpretation than a copy. The still life element on the table has been simplified: the books have been omitted, as has the glass, with the sprig of foxglove simply placed on the table top. This may well have reflected the doctor's wishes, wanting to stress his homeopathic rather than literary interests. In the second version the corner of the table is redder, larger and more prominent, almost appearing to lunge towards the doctor rather threateningly, and the blue background has been simplified into just two bands.

The faces are also slightly different.[15] In the original portrait the facial expression definitely suggests anxiety, whereas in the second version it is more contemplative, again possibly reflecting the doctor's wishes. Although Gachet's son understandably declared the one done for his father as 'well superior'[16], the first version represents a greater artistic achievement. Portraitists rarely produce their best work when heeding the suggestions of their sitters.

A week after handing over the second version of the portrait another memorable encounter occurred. The doctor's son later recalled:

'After an outdoor lunch in the courtyard, once the men's pipes were lit, Vincent was handed an *etching needle* and a varnished copper; he enthusiastically took his new friend *as the subject*.'[17]

Although Van Gogh had never previously etched, under the doctor's guidance in less than half an hour he had completed a portrait of his host smoking in the garden (fig. 31). The two men rushed upstairs to Gachet's studio, where they went through the process of getting the acid to bite into the copper. That afternoon they printed at least 14 impressions, experimenting with various coloured inks and different methods of wiping the plate. Subsequently Dr Gachet printed more and others were later made by his son, with altogether around 70 copies surviving.[18]

There has been much discussion about the date of the print, which was etched in reverse onto the copper plate in the upper right corner. At first sight it appears to read 15 *May*, but Van Gogh only arrived in Auvers five days later. Another explanation, suggested by Gachet Jr, is that the print was made on 25 May, with the 2 wrongly appearing as a 1. However, it is more likely that the 15 is correct and the absent-minded etcher (perhaps after a few glasses of lunchtime wine) inscribed May rather than June, which seems to be the correct month.[19]

Van Gogh's painted and etched portraits of Dr Gachet share superficial compositional similarities. Both were done in the garden and the doctor's head is at a similar angle, with his cheek resting on his right hand. But in the print, the artist zoomed in on the head, depicting the doctor without his cap but with his ubiquitous pipe. The difficulties of drawing in reverse for an etching, a new technique for Van Gogh, may explain the slightly distorted form of the face.

Gachet Jr later reported that Van Gogh was thrilled with the etching and 'talked only of continuing engraving, especially to reproduce some of his canvases.'[20] Vincent considered the idea of making etched versions of his more successful paintings from Provence: 'I really hope to do a few etchings of subjects from the south, let's say 6, since I can print them free of charge at Mr Gachet's.'[21] In an unsent letter to

Gauguin he wrote that he hoped to etch *Road with Cypress and Star* and in a sketchbook he included rough drawings of two Sunflower still lifes, suggesting that he also had these in mind as a suitable subject for prints.[22] But this never happened, and the etching of Dr Gachet remained the only one he ever made. As for the two painted portraits, Van Gogh rightly described them as 'modern heads that one will go on looking at for a long time'.[23]

FAMILY VISIT

'Now the colour is probably more expressive,
more sumptuous'[1]

The day after sitting for his first portrait, Dr Gachet headed to Paris for his regular medical work. At Vincent's urging, he took the opportunity to drop in at the Boussod & Valadon gallery to talk with Theo. They had met only once before, in late March, when they had discussed Vincent's proposed move to Auvers. This time there were customers present when Dr Gachet arrived, so their conversation needed to be kept brief.

Theo was obviously anxious to hear the doctor's assessment of his brother's condition, since it had been barely six weeks earlier that he had recovered from a mental attack at the asylum. Dr Gachet's response was surprisingly optimistic, so Theo reported back to Vincent that 'he thought you cured and that he saw no need at all for it to recur.'[2]

Presumably the doctor told Theo that his brother had just painted his portrait, and how much it had pleased him. They ended their short encounter with Dr Gachet inviting Theo and his family to Auvers for Sunday lunch. Travelling with an infant was complicated (fig. 36), Jo was not in the best of health and Theo was very busy at work, so it was hardly the best moment. But it would obviously have been difficult not to accept – and Theo was curious to see his brother's surroundings.

Four days later, on 8 June, Theo and Jo with the baby (fig. 35) boarded a train for their first family visit to Auvers. They alighted at

the Chaponval halt (fig. 33), which was slightly closer to Dr Gachet's house than the main Auvers station, to be greeted by Vincent and their host.[3] Years later Jo recalled that her brother-in-law had 'brought a bird's nest as a plaything for his little nephew and namesake'.[4] They all made their way up to the house, arriving in good time for lunch.

Once settled in the garden (fig. 32), Vincent 'insisted upon carrying the baby himself and had no rest until he had shown him all the animals' – and he 'introduced his little namesake to the animal world'. It may seem difficult to imagine Vincent enjoying young children, but in the afternoon he pretended to be a loudly crowing cock, which 'made

fig. 32 Dr Gachet's house, 1950s, postcard

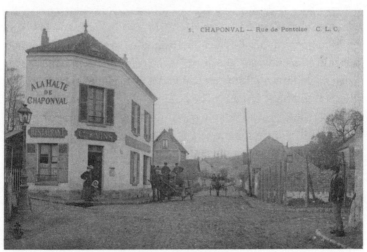

fig. 33 A la Halte de Chaponval, the restaurant next to the railway stop, c.1905, postcard

the baby red in the face with fear and made him cry'. Vincent then 'cried laughingly', reassuring his nephew: 'The cock crows cock-a-doodle-doo.'[5]

Dr Gachet maintained a veritable menagerie: a troupe of at least eight cats, three dogs, a pair of peacocks, a tortoise, a goat named Henriette and numerous hens, rabbits, ducks and pigeons.[6] He was a dedicated animal-lover and a life member of the Société Protectrice des Animaux. Frequently choosing animals as the subject of his art, he had a penchant for swine: he even showed a painting entitled *The Pig* at the 1902 exhibition of the Société des Artistes Indépendants.[7]

The weather was lovely, so Dr Gachet's daughter Marguerite helped his housekeeper Chevalier arrange lunch for them under the trees. They all sat at the long red table where a few days earlier the doctor had posed for his portrait (plate 18). After the meal the men went inside to view some of the doctor's collection, including the Impressionists. Theo would have been particularly interested in his Pissarro works, since he handled the artist at Boussod & Valadon. But the picture that enjoyed the closest scrutiny must have been the doctor's own version of Vincent's *Portrait of Dr Gachet* (plate 19), with its paint still wet.

After lunch they all left for a walk, presumably stopping at the auberge to see Vincent's room – and his other recent paintings. Vincent was no doubt keen to show his brother another picture completed that week, the dramatic *Church at Auvers* (plate 20). It was a striking work, and must have made an impression on Theo.

Vincent set this monumental edifice beneath a deep blue sky, not dissimilar to the backgrounds in the portraits of Gachet. Although he came from a Protestant family and had long ago abandoned organized Christianity, the radiant Catholic church building seems to exude spirituality, soaring heavenward.

He described the picture to his sister Wil: 'I have a larger painting of the village church – an effect in which the building appears purplish against a sky of a deep and simple blue of pure cobalt, the stained-glass windows

look like ultramarine blue patches, the roof is violet and in part orange.'[8]

The church of Our Lady of the Assumption stands not far from the auberge and its hillside location means that it would have been visible from many of the places where Van Gogh worked, so he knew it well. But it still seems a surprising choice of subject. Although an important Romanesque monument dating back to the 12th century and much frequented by visitors, Van Gogh had little interest in

fig. 34 Church of Our Lady of the Assumption, Auvers, 1915, photograph, Archives Départementales du Val d'Oise, Pontoise

imposing architecture. He may well have entered the church out of curiosity early in his stay, but its stone interior is unadorned and the few religious paintings would hardly have caught his eye.[9]

The artist set up his easel outside and facing the apse, which thrusts forward from beneath the bell tower. Comparison with a 1915 photograph (fig. 34) shows that he depicted the scene with reasonable accuracy, although the building is rendered with sinuous lines, bringing the structure to life rather than conveying it as static architecture. The shadow from the apse suggests an afternoon view.

The diverging paths running along the sides of the building are painted with powerful, agitated brushwork in what were originally pinkish tones. Today, after the red pigment has faded, they have become a less dramatic beige. Spring flowers grow on the lush, fresh grass. A woman scurries past, adding movement to a timeless scene, and beyond her the roofs of two houses are visible among the trees. To

the right of the church, the building with the red-brown roof (which still survives) is the parish office.

The picture derives much of its impact from the sky, a blend of shades of blue that grows deeper towards the top. It might appear to be stormy weather, although the shadow cast by the apse confirms that it is a bright, sunny day. The windows, in a similar deep blue, almost suggest that one can look through the building towards the sky. The small areas of terracotta tiling provide a powerful contrast with the blues.[10]

There are striking parallels between this Auvers painting and Vincent's depictions six years earlier of the church in the Brabant village of Nuenen, where his father served as the parson. Conscious of the link, Vincent told his sister that his latest picture was 'almost the same thing as the studies I did in Nuenen of the old tower and the cemetery.'[11] Although similar in composition, the huge differences between the Nuenen and Auvers paintings emphasize the dramatic development of Van Gogh's style in just six years – moving from the sombre tones of his Dutch years to the exuberant palette and strong brushwork of his later French period. As Vincent put it to Wil, his colouring had become more expressive.[12]

After having seen the painting, it is likely that Theo and Jo would have been taken to the church itself, to enjoy the view that Vincent had captured and the panorama of the Oise valley (fig. 12). In the late afternoon they strolled to the station to catch the train back to Paris.

On the surface the Sunday visit had proved a success and was fondly remembered. In 1912, more than two decades later, Gachet Jr recalled it in a letter to Jo: 'I well remember the Sunday when you had come with your husband: after lunch, in the courtyard, Vincent had taken your son in his arms and he ran after the ducks – the uncle and the nephew, laughing one after the other.'[13] And a year later Jo described the occasion as 'so peacefully quiet, so happy.'[14]

A few days after their trip Vincent wrote to Theo and Jo, saying that it left him with 'very pleasant' memories. Wishing that Theo and his family would spend their holidays in Auvers, he added: 'I hope that

fig. 35 Vincent Willem van
Gogh, the artist's nephew,
1890, photograph by Raoul
Saisset, Paris, 11 x 6 cm,
Van Gogh Museum archive

fig. 36 *Baby in a Pram*, May–June 1890,
pencil on paper, 21 x 24 cm, Van Gogh Museum,
Amsterdam (Vincent van Gogh Foundation) (F1610r)

we'll see each other again often.'[15] However, there cannot have been much opportunity for Theo and Vincent to have much time for any intimate discussions, and the presence of a four-month-old infant must have made sustained conversation difficult (fig. 35).

Theo and his family all had medical ailments at the time: the baby was not getting enough milk, Jo was sleeping badly and Theo had a constant cough. A few days earlier Vincent had sought advice on their behalf, but Dr Gachet had been rather uninformative: the parents should simply continue with their normal diet, including '2 litres of beer a day.'[16] Theo took this latter advice to heart, since Jo's household accounts record that they spent nearly 15 francs on beer in mid-June – equivalent to two weeks' rent for Vincent's room at the auberge.[17]

Following the family visit, Vincent continued to see Dr Gachet regularly for the rest of June. A few days later he told his Arles friends Marie and Joseph Ginoux that the doctor had advised him that 'one must throw oneself fully into work and distract oneself in that way' –

more advice that he would have wanted to hear. Vincent added that the doctor 'knows a lot about painting, and likes mine very much, he encourages me a great deal, and two [or] three times a week he comes to spend a few hours with me to see what I'm doing.'[18]

Dr Gachet invited Vincent to return for lunch on 22 June. This represented quite an honour, since it was to celebrate the birthday the previous day of both his children, Paul and Marguerite, who turned 17 and 21. Dr Gachet, like Vincent an admirer of Japanese art, produced delightful placecards for the meal, once again served outside on the red table (fig. 37).[19, 20]

By now Dr Gachet and Van Gogh had developed a relationship that was very much that of friends, rather than of doctor and patient. There is no evidence that Dr Gachet gave Van Gogh any treatment or more than the most general medical advice. His philosophy was that

fig. 37 Lunch placecard with Japanese motif, inscribed by Dr Gachet, 22 June 1890, Archive E. W. Kornfeld, Bern

although one should keep melancholic patients under surveillance, it was important to make them feel free to make their own decisions.[21] Although he was on hand in Auvers for half the week, for the rest of the time he remained out of touch in Paris – and urgent help would not necessarily be available. For his part, Van Gogh wanted to believe that his earlier problems had gone away, so he was quite content to accept Dr Gachet's optimistic reassurances.

CHAPTER SEVEN

VAST WHEATFIELDS

'I'm wholly absorbed in the vast expanse of wheatfields
against the hills, large as a sea'[1]

While in Provence Van Gogh had become entranced by wheatfields, capturing them in all seasons, in varied weathers and in differing lights. Wheat held a deeply symbolic significance for him: farmers would sow seeds in autumn, the shoots would sprout towards the end of the winter, the fields would turn green in spring, and finally the crop would ripen to a burnished gold – ready for reaping. The harvest represented a time of plenty, although it temporarily left the fields bare and empty. And so the cycle would continue, year after year.

In Provence, Van Gogh had viewed his own work as an artist in similar terms to that of the farmers: 'I plough on my canvases as they do in their fields.'[2] In Arles, throughout 1888, he completed more than 20 paintings of wheatfields, before going on to produce another 14 the following year at the asylum. Wheat was an equally important crop in Auvers, so it was natural that Van Gogh threw himself into its artistic challenges. He arrived at the perfect time to explore the theme – when the wheat was growing tall and would soon be turning a golden hue.

Van Gogh's first Auvers wheatfield was painted in a hamlet just beyond Dr Gachet's house. *Les Vessenots* (plate 21) depicts the fields in varied shades of green with scattered yellow flowers, leading towards a cluster of farm buildings.[3] Rippling brushstrokes create an undulating

rhythm and the bright red roof draws the eye into the composition. In the distance a barely discernible cart and driver head towards the farm along a track. Beyond the buildings more fields rise above the valley to the plateau above.

As with so many of Van Gogh's Auvers landscapes, the horizon sits at the very top of the painting, leaving only a sliver of sky, enlivened by fluffy clouds. *Les Vessenots*, probably painted a week or two after Van Gogh's arrival, revels in his unalloyed joy at discovering the Auvers landscape – with its small farms dotted along the fertile valley.

In *Wheatfield* (plate 22) the crop swamps the composition. Vincent described the painting as 'a green field of wheat which extends up to a white villa surrounded by a white wall with a single tree'.[4] It captures the movement of the green shoots with ripening ears, bending under their weight in a breeze. In the distance a substantial building and an outhouse are squashed beneath a tiny layer of sky, lending a claustrophobic feel to the composition.

Green Wheatfields (plate 23) has a decorative quality. The field, painted with surging brushwork in a range of greens, blues and yellows, spreads over half the composition. The lush colours of the fast-growing crop, patterned with flowers, suggest a June date. A track at the right side of the field breaks up the composition, imparting depth to the picture under a sunny, but turbulent sky.

Van Gogh zooms in on the crop in *Ears of Wheat* (plate 24), creating a picture seething with rhythmical brushstrokes. He included a tiny, rough sketch of it in an unsent letter to Gauguin, adding his description: 'Studies of wheat … nothing but ears, blue-green stems, long leaves like ribbons, green and pink by reflection, yellowing ears lightly bordered with pale pink due to the dusty flowering.'[5] The patterned effect is almost like a tapestry.

Van Gogh went on to write, rather poetically, that the young wheat vibrates and makes one think of 'the soft sound of the ears swaying in the breeze'.[6] Three flowers, probably bindweed, animate the lower part of the composition, although Van Gogh's original red pigment

has deteriorated, leaving them nearly white. In the upper-left corner another faded bloom can just be made out – a single blue cornflower.

While some wheat was cultivated down in the Oise valley, most of it came from much larger fields spread out across the plateau above, on the undulating Vexin plain, which had relatively little human habitation. Several of Van Gogh's most powerful Auvers landscapes, painted in July, capture these panoramic views. The atmosphere in these expansive works is quite different from the homely rustic scenes down in the farming hamlets.

Van Gogh described two of his plateau landscapes as 'wheat after the rain', including small sketches of them in a letter to Theo.[7] *Plain near Auvers* shows endless fields beneath curling clouds, painted with thick impasto (plate 25). The vivacious foreground, composed of short strokes at varying angles, gives the impression of a windy day with changeable weather. Three poppies near the lower-right corner catch the eye, while white flowers dot the foreground crop. Hovering above the foreground, a flick of dark paint defines a bird, presumably a crow, with another just discernible to the left. In the fields beyond are isolated signs of local life: a farming hut, a row of recently harvested stacks and a tree-lined track.[8]

Wheatfields after the Rain (plate 50) is a similar scene, but with a slightly threatening atmosphere. Its main subject is the patchwork of fields, some still green and others already turning a rich golden brown. The fields head off at an angle, then veer off in another direction before reaching the horizon. Around the centre of the composition two darker green fields converge, producing a chevron effect at their meeting point. On the right, three exaggeratedly tall trees reach upwards. White clouds ascend above patches of dark blue, suggestive of a receding storm.

Much has been read into these late landscapes as a result of Van Gogh's comment that 'they're immense stretches of wheatfields under turbulent skies, and I made a point of trying to express sadness, extreme loneliness'.[9] This outpouring of emotion in mid-July suggests that he was feeling increasingly abandoned, lacking support from family and friends.

Yet as soon as Vincent had written the words 'extreme sadness', he immediately pulled back. In a complete about-turn, in the very same paragraph, he went on to add that 'these canvases will tell you what I can't say in words, what I consider healthy and fortifying about the countryside'.[10] Vincent may have been trying to reassure Theo and Jo about his mental state, although the letter suggests contradictory feelings and confusion.

The Fields (plate 26) is a further exploration of a turbulent sky. This time the wheat is a swathe of gold, suggesting that it was painted in early July, shortly before the harvest. Poppies have proliferated, smothering the crop with scarlet spots. It is unclear whether the sky is sunny deep blue with wafting white clouds or dark and stormy with lower clouds, but arguably the ambiguity is deliberate.[11]

In a letter written to Vincent's mother and sister Wil, he described the colours of his latest landscapes: 'Delicate yellow, delicate pale green, delicate purple of a ploughed and weeded piece of land, regularly speckled with the green of flowering potato plants, all under a sky with delicate blue, white, pink, violet tones.'[12]

But not all the scenes are filled with foreboding. *Wheatfields with Reaper*[13] (plate 27) is a late work from mid-July, since the crop is being harvested, with stacked sheaves. The view shows the fields on the plateau, looking back towards the village and its church, with the hills beyond on the other side of the Oise. Unusually among Van Gogh's Auvers wheatfields, it includes the figure of the reaper with a sickle, nearing completion of his task – a reminder of the cycle of life.

CHAPTER EIGHT

BOUQUETS

'[Gachet's house] is full, full like an antique dealer's … there would always be what I need there for arranging flowers or still lifes'[1]

It is important 'to see the flowers growing', Vincent wrote to his mother and sister Wil from Auvers.[2] His love of nature and delight in colour meant that he revelled in painting floral still lifes. Fortuitously, he had arrived in Auvers in the middle of spring, the perfect time. The hamlets and fields were ablaze with colour.

Encouraged by Dr Gachet, who readily offered his garden and an easel, Van Gogh got down to work. Although Vincent frowned on the clutter in the doctor's house, he could see one 'good aspect': there were plenty of vessels for still lifes in the cabinet in the salon (fig. 18). He also took inspiration from paintings hanging on the walls, singling out 'two fine bouquets' by Cézanne.[3]

Floral paintings had long been important to Van Gogh. Coming from the Netherlands, he had been brought up appreciating the strong tradition of a genre that dates back to the 17th-century. Vincent also hoped that such works would be particularly marketable for domestic interiors. During his two years in Paris, in 1886–88, he had painted over 50 flower still lifes, an experience that taught him much about the handling of colour.[4] It was in Arles that he made his iconic series of *Sunflowers*.[5] At the asylum his happiest hours were spent in its walled

garden and just a week or two before his departure he had completed four striking still lifes of irises and roses.[6]

The extraordinary *Blossoming Chestnut Branches* (plate 28) was the first Auvers still life.[7] Van Gogh had long admired chestnut trees, describing them as 'magnificent' while living in London some 16 years earlier.[8] Blossoming in May, they appeared at their finest on his arrival in Auvers. He carefully selected several branches, which he then laid out on the doctor's red table.

At first sight the composition seems to be simply a grouping of flowering twigs, since the eye just takes in the blossom, painted with thick impasto. But a closer examination reveals that the arrangement is more complicated. The partial outline of a pinkish-red pot can just be made out near the edge of the table, in the centre of the composition. Blue shadows cast by the leaves on the table blur the distinction with the background. The elements of the composition appear interwoven, creating an abstract, decorative and disorienting effect, with the blossom seemingly hovering. Yet what really animates this vigorous picture is the brushwork, particularly the parallel strokes of blue, which make the background pulse with movement and the petals emerge like billowing clouds. This highly exuberant work is quite unlike traditional flower paintings: *Blossoming Chestnut Branches* could hardly be less 'still' – and more full of life.

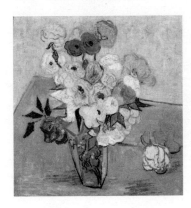

fig. 38 *Japanese Vase with Roses,*
June 1890, oil on canvas, 52 x 52 cm,
Musée d'Orsay, Paris (F764)

Another still life done in Dr Gachet's garden is *Japanese Vase with Roses* (fig. 38). The 19th-century hexagonal ceramic vase is decorated with traditional motifs of blossom and a small bird. As Van Gogh loved Japanese decorative art, he must have been delighted to discover this particular vessel among Dr Gachet's curios. The vase still survives (fig. 80) and is now in the Musée d'Orsay. The painting's unusual perspective reflects the style of Japanese prints, which were so admired by Van Gogh. While in Auvers he had at least 20 prints with him in the auberge.[9]

Vincent's furious pace of work meant that by mid-June he had run out of canvas. He therefore improvised by painting *Wild Flowers and Thistles* (fig. 39) on a most unconventional material: a dish towel fabric with red stripes.[10] This linen may well have come from the restaurant at his auberge. Van Gogh described the picture as 'a bouquet of wild plants, thistles, ears of wheat, leaves of different types of greenery'. Rather unconventionally he has focussed on three large leaves, which take up much of the right half of the composition, describing them as 'one almost red, the other very green, the other yellowing'.[11] Presumably he had been on a walk by hedgerows and through wheatfields, collecting blooms and leaves along the way.

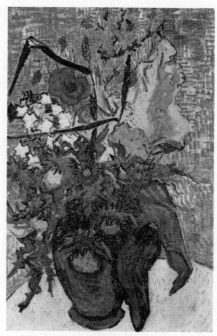

Fig. 39 *Wild Flowers and Thistles,* June 1890,
oil on linen towelling, 66 x 45 cm,
private collection (F763)

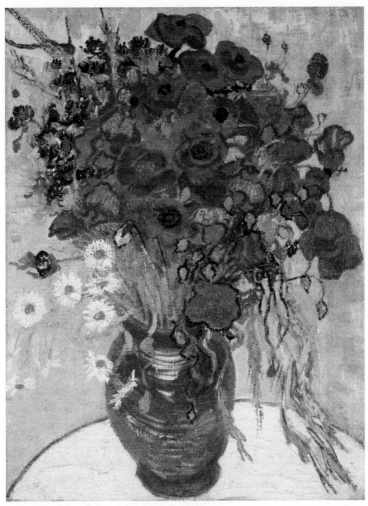

fig. 40 *Poppies and Daisies,* June 1890, oil on linen towelling, 66 x 51 cm, private collection, Beijing (F280)

Poppies and Daisies (fig. 40), also painted on linen towelling at almost the same time, includes the same round table and large brown pot that feature in *Wild Flowers and Thistles*. With the poppies exploding out of the complementary greenish background, this is the most vibrant of his Auvers bouquets. Blue cornflowers, mixed with a few ears of wheat, animate the upper-left corner. The floral arrangement fans out, unrealistically dense and taking over nearly all the upper part of the composition. Although the blooms could hardly be fresher or more vigorous, it depicts a transitory beauty – albeit one that can be captured and then endures in paint.

CHAPTER NINE

PORTRAITS

'What I'm most passionate about, much much more than all the rest in my profession – is the portrait, the modern portrait'[1]

Van Gogh had a vision of the modern portrait – it should, he believed, be done 'by way of colour'. He was not seeking photographic verisimilitude, but something more profound, using the 'modern taste for colour' to express the character of the sitter.[2] He must have discussed these ideas with Dr Gachet while painting his portrait (plate 18).

The doctor was Van Gogh's first sitter in Auvers. Having produced what he felt was a successful image of a well-connected villager, he then looked forward to further opportunities, perhaps even paid commissions. 'To have clients for portraits one must be able to show different ones that one has done,' he explained to Theo. To his sister Wil he wrote that potential buyers might see his work in Dr Gachet's house and 'he'll find me a few interesting models to do'.[3]

Vincent went on to tell Theo that he hoped that 'certain canvases will one day find collectors', although he was not overly optimistic. He felt that the high prices that had recently been paid for works by successful artists, such as Jean-François Millet, actually made it more difficult for struggling painters such as himself – even reducing the chances of 'merely recouping one's painting expenses'. Alluding to these rising sums for a tiny number of

favoured painters, Vincent concluded: 'It's enough to make one dizzy.'[4]

Despite a lack of commissions, Van Gogh pressed ahead. *Child with Orange* (plate 31) was an attempt to exploit colour: the large fruit, bursting out from tiny fingers, makes dramatic use of complementary hues.[5] The blonde, rosy-cheeked child is sitting among meadow flowers. Although her identity is uncertain, she might be Germaine Ravoux, the innkeeper's two-year-old daughter, or perhaps the child of a neighbour.[6] While working on the painting Vincent's thoughts must have turned to his young nephew.

Fig. 41 Adeline Ravoux, as a teenager, early 1890s, photograph, Van Gogh Museum archive

Around the same time Van Gogh made a pair of portraits of a daughter of the Ravoux couple. The girl is assumed to be Adeline, then aged 12, although surprisingly he recorded her age as four years older in a letter to Theo. Vincent presented the first portrait to her and kept the second version for Theo (plate 29).[7] On 24 June Vincent wrote to his brother: 'This week I've done a portrait of a young girl of 16 or so, in blue against a blue background, the daughter of the people where I'm lodging. I gave her that portrait but I've done a variant for you.'[8]

The two portraits of Adeline show her from her lap up, her head in profile – looking straight ahead, displaying little emotion. With her hair tied back with a long ribbon, she wears a light blue dress with a high collar and a white bodice. The hands and particularly her lower arms are elongated, as in many of Van Gogh's portraits. A glimpse of the orangey-brown back of the chair adds a burst of contrasting colour against the blues.

For many decades the identity of the sitter was referred to simply as 'the woman in blue'. Adeline's name only emerged when she was

tracked down in the 1950s, admitted to being the sitter and recounted her reminiscences about Van Gogh – more than 60 years after their encounter.[9] Adeline recalled: 'He did my portrait one afternoon in one sitting. As I posed, he did not speak a single word to me; he smoked his pipe continually ... Dressed in blue, I sat in a chair. A blue ribbon tied back my hair, and since I have blue eyes and he used blue for the background of the portrait, it became a *Symphony in Blue*.'[10] As for the result, she said, 'I was not very pleased, it was even a disappointment – I didn't think that it looked like me.'[11] A photograph captures Adeline's appearance a few years later (fig. 41).[12]

That same month Van Gogh also made two pictures of Dr Gachet's 20-year-old daughter. *Marguerite Gachet in the Garden* (fig. 28) is not a portrait, but simply a figure in a landscape, amid a profusion of white roses. A few weeks later Van Gogh proceeded with a much more ambitious project.

Marguerite Gachet at the Piano (plate 30) was partly inspired by an etching that Dr Gachet had made in 1873 of his wife Blanche at the keyboard (fig. 42). Blanche had been a talented amateur musician and after her death the piano remained in the family's salon.[13] Dr Gachet was also musical and even composed a piece he entitled in English *Night*, in memory of one of his first black cats.[14]

Marguerite had continued the family's musical tradition, taking up the piano. For the portrait Van Gogh used an unusual format, a 'double-square' canvas that was a metre high. Dr Gachet's son later recorded that it had been painted in two days: 'Standing at his easel, Vincent stepped back, advanced, moved away, approached, stooped, one knee on the ground, rose, bowed almost without stopping.'[15] He had apparently forgotten to bring his palette, so the doctor lent him one of his. This paint-splattered relic was preserved and donated to the Louvre in 1951.

Van Gogh spent the first day completing most of the figure. His preliminary drawing survives and a tiny speck of the green background paint on it suggests that the sketch was close at hand while he was working on the painting.[16] Marguerite's elongated fingers strike the

fig. 42 Paul van Ryssel
(Dr Paul Gachet),
*Madame Gachet at the
Piano*, September 1873,
etching,
18 x 14 cm

keys as she concentrates on the music. It is not so much a portrait of her
as an individual, but more a timeless depiction of a musician engrossed
in a melody. A photograph taken four years later records Marguerite's
appearance (fig. 43).[17]

Vincent hoped that Marguerite would pose for him again, this time
playing the 'little organ', her harmonium.[18] It has long been assumed
that this never happened, but a note by Gachet Jr has recently emerged
suggesting that Van Gogh may have at least made a preliminary sketch.
However, when the drawing became damaged, he apparently scrunched
it up into a ball and abandoned the project.[19]

There is also an intriguing suggestion of a lost Auvers portrait. Félix
Vernier, the elderly village schoolmaster, was a friend of Dr Gachet and
the school lay just across the road from the auberge. Anton Hirschig,
another Dutch lodger at the auberge, painted Vernier's portrait in mid-
July and it is quite possible that Van Gogh might have joined the sitting.

But if Van Gogh did complete a portrait, it has gone missing (it could have been given to Vernier, who died two years later).[20]

fig. 43 Marguerite Gachet, 1894, photograph, Wildenstein Plattner Institute, New York

Two of Van Gogh's finest Auvers portraits are of a woman he described as a 'country girl' or 'peasant woman.'[21] In *Girl in White* (plate 32), the slim woman is portrayed in one of Van Gogh's favourite landscape settings – a wheatfield speckled with poppies, shortly before the harvest. Van Gogh had recently written about the decorative effect of wheat, pointing out that this 'very alive and yet tranquil background' would provide a perfect setting for portraits.[22] Although depicted in a field, the elegant woman in white hardly comes over as a country girl.

The other picture, *Girl against a Background of Wheat* (plate 33), probably portrays the same model, this time in a blue dress with vibrant orange spots and an apron, her head also crowned in the same straw hat.[23] In both paintings the young woman turns to the side, her eyes avoiding our gaze. In this second work, an ambitiously large painting, Van Gogh has truly achieved his aim of producing a 'modern portrait'. Well over a century later she is very much alive for us, making it even more frustrating that her identity has been lost.

CHAPTER TEN

GAUGUIN'S TROPICAL DREAM

'If he [Gauguin] went to Madagascar I'd be able to follow him there ... the future is very much in the tropics for painting'[1]

Gauguin (fig. 44) was just as restless as Van Gogh, always seeking to move on. By 1890 he was pursuing the idea of establishing a 'Studio of the Tropics', a follow-up to the short-lived 'Studio in the South' in Arles.[2] Early that year he had proposed setting off for Tonkin (northern Vietnam), but by the spring he was focussing his attention on the island of Madagascar. At one point Van Gogh, writing from Auvers, actually suggested that he might join Gauguin on the Indian Ocean adventure, agreeing that the future of painting lay 'very much in the tropics'. Vincent told his brother that if his friend reached Madagascar then he would follow, since artists 'should go there in twos or threes'.[3]

The relationship between the two artists was complex and sometimes volatile. After their first meeting in December 1887 in Paris they exchanged paintings and Theo gradually began to sell Gauguin's work at Boussod & Valadon. The following month Gauguin travelled to Pont-Aven, an artists' colony in Brittany, while Van Gogh set off a few weeks later in a different direction, heading south to Arles.

On renting the Yellow House in May, Van Gogh was keen to share his home with a fellow artist. He immediately invited Gauguin, but his colleague prevaricated, no doubt worrying that Vincent would prove an awkward companion. Van Gogh strongly encouraged him to come, both in letters and by sending him a dedicated self-portrait (plate 34). Slightly reluctantly Gauguin agreed, finally arriving in Arles on 23 October 1888.

Initially things went reasonably well: the two men set up their easels side by side and after work they would have long discussions about art over drinks. But as the weeks rolled by, tensions developed, with Gauguin eventually threatening to return to Paris. Neither artist would have been easy to live with. Van Gogh could be argumentative and was a poor housekeeper. Gauguin was self-centred and domineering; his swaggering and egocentric manner comes over in a 1889 self-portrait, where he depicts himself with a halo, serpent and apple (plate 35).

Just two months after Gauguin's arrival the terrible denouement occurred: during the evening of 23 December Van Gogh severely mutilated his ear (plate 36). He had felt abandoned by Gauguin, whose threats to leave were endangering their shared studio. Just a few hours before the self-mutilation Vincent received news that Theo had become engaged, leading him to fear that he would face further abandonment – this time by his brother, whose emotional and financial resources would be focussed on his new wife.[4]

Van Gogh was hospitalized the following morning and Gauguin quickly fled to Paris. From then onwards the two men kept in contact by correspondence and, despite the previous tensions, Van Gogh naively hankered after further collaboration. 'I still tell myself that G. and I will perhaps work together again', Vincent had confided in Theo from the asylum.[5]

Just before leaving the asylum Van Gogh had written to tell Gauguin of his plan to return to 'the north', although without specifying his destination.[6] When Van Gogh stopped briefly in Paris he failed to contact

his friend, presumably fearful that a meeting would prove disturbing. And when Gauguin eventually learned about Van Gogh's arrival in Auvers, in mid-June, he was just about to leave Paris for Brittany.

Gauguin must have been intrigued to learn that Van Gogh was now staying in an area that he knew well. From 1879 to 1882 Gauguin had frequently visited Pissarro, who was then living in Pontoise. Gauguin would paint in the Oise valley, sometimes in Auvers itself.[7] When Gauguin was told that Van Gogh was in contact with Dr Gachet, he responded that although they had never met, 'I've often heard Père Pissarro speak of him.'[8]

fig. 44 Paul Gauguin, 1891, photograph by
Louis-Maurice Boutet de Monvel,
Musée Départemental Maurice Denis,
Saint-Germaine-en-Laye

In June 1890, Gauguin announced highly ambitious travel plans. He started by asking, 'do you remember our conversations of old in Arles when it was a question of founding the studio of the tropics?' His latest goal was Madagascar: 'I'll turn a little earthen and wooden hut into a comfortable house with my ten fingers; I'll plant all things for food there myself, hens, cows, etc... In Madagascar I'm sure of having the calm necessary for good work.'[9]

Van Gogh seems to have responded, since a draft for a letter has survived. He planned to apologize that his stay in Paris had been very brief: 'I judged it wise for my head to clear off to the countryside – otherwise I would have swiftly run round to your place.' Rather

surprisingly, Van Gogh added that since his arrival in Auvers, 'I've thought about you every day.'[10]

Vincent went on to suggest that he might follow Gauguin to the Breton fishing village of Le Pouldu: 'It's highly likely that – if you allow me – I'll come for a month to join you there to do a seascape or two.'[11] The thought of once again living with Vincent clearly unnerved Gauguin. But the situation was complicated, since Theo had become his dealer and had succeeded in selling two of his paintings[12], so he needed to tread carefully.

Gauguin responded that 'your idea of coming to Brittany at Le Pouldu seems excellent', before immediately shooting it down. With the only transport there being a hired horse-and-cart, 'for a sick man who needs a doctor, it's sometimes risky'. Gauguin added that in any case he would not be staying long in Brittany, since he hoped to depart for Madagascar at the beginning of September: 'I dream of it every day'. His concluding words would hardly have encouraged Van Gogh: 'the savage will return to savagery.'[13]

Van Gogh realized that Gauguin was politely rebuffing him. Furthermore, if Gauguin was putting him off coming to Le Pouldu, he certainly would hardly welcome him as a companion on a long and arduous expedition to the tropics. Gauguin was once again abandoning his friend.

The Madagascar dream never came off, partly because of a lack of money. But a year later, in April 1891, Gauguin succeeded with yet another plan – to set off for Tahiti (fig. 44). A few weeks after his arrival in the South Seas he settled in a coastal village outside the capital Papeete and a native-style bamboo hut in Mataiea became his 'Studio of the Tropics'. But despite plunging into this exhilarating new environment, Gauguin would never forget the intense weeks he had shared with Van Gogh in the Yellow House.

DAY TRIP TO PARIS

*'I'd very much like to come and see you, and what
holds me back is the thought that I'd be even more
powerless than you are in the given state of distress'*[1]

On Sunday 6 July 1890 Vincent left the Oise valley for the first time, to
visit Theo and his family in Paris.[2] It was a last-minute decision, taken
after he had received a worrying letter from his brother, who was facing
a series of problems.[3] Vincent caught an early train and on arriving he
would have been delighted to once again meet his nephew, now just
over four months old. He must also have been pleased to see some of
his earlier paintings.

A series of friends dropped by to see him at Theo's. The critic Albert
Aurier (fig. 47), who in January had published the first substantial
review of his work, was the first to arrive. Vincent had been curiously
ambivalent about Aurier's enthusiastic comments, somehow feeling
they were undeserved. However, Vincent was grateful and a few weeks
before his departure from the asylum he had asked Theo to give Aurier
a Saint-Rémy landscape, *Cypresses*.[4]

Next to arrive was an old friend, Henri de Toulouse-Lautrec, whom
Vincent had got to know in Paris in 1886 (fig. 45). During the Sunday
visit he 'made many jokes with Vincent about an undertaker's man they
had met on the stairs.'[5] Although Toulouse-Lautrec had a legendary
sense of humour (fig. 46), it is surprising that Vincent enjoyed a morbid

joke at a difficult moment.[6] Toulouse-Lautrec stayed on for lunch. Apparently by coincidence, he had just finished a painting of a female pianist, which turned out to be an uncannily similar composition to Van Gogh's portrait of Marguerite Gachet (plate 30). Toulouse-Lautrec showed him *Mademoiselle Dihau at the Piano*, which Vincent found 'quite astonishing, it moved me.'[7]

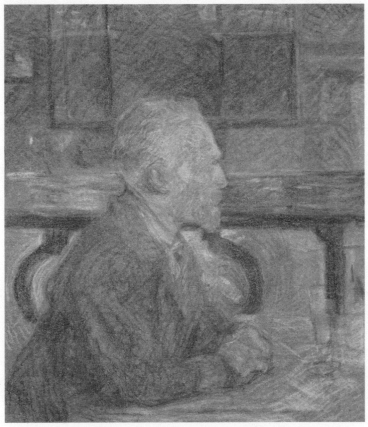

fig. 45 Henri de Toulouse-Lautrec, *Portrait of Vincent van Gogh*, 1887, pastel on paper, 54 x 46 cm, Van Gogh Museum, Amsterdam (Vincent van Gogh Foundation)

Third on the visitor list was the sculptor Sara de Swart, a friend of Jo who was living in Paris. After returning to Auvers, Vincent wrote that he 'thought that Dutch lady had a great deal of talent'.[8] Although now largely forgotten, she was well-connected in Parisian artistic circles. Theo presumably thought that his brother would enjoy the guests, but Vincent probably found their presence overwhelming, being no longer accustomed to the capital's hectic social life.

That afternoon, after the guests had departed, Jo's brother Andries Bonger joined them to discuss a number of pressing concerns. The circumstances were difficult, as Jo later admitted: 'We were exhausted by a serious illness of the baby; Theo was again considering the old plan of leaving Goupil [by then renamed Boussod & Valadon] and setting up in business for himself; Vincent was not satisfied with the place where the pictures were kept; and our removal to a larger apartment was talked of – so those were days of much worry and anxiety.'[9]

Everyone seemed to have medical problems. The baby was weak: Jo still had insufficient milk, the infant had a bad reaction to cow's milk and there were early teething problems. Only a week before, their doctor had to reassure Jo that 'you won't lose the child', suggesting that the parents must have been extremely worried.[10] By this time the infant

fig. 46 Henri de Toulouse-Lautrec paints himself, c.1890, 'double' photograph by Maurice Guibert

fig. 47 Albert Aurier, c.1890, photograph

was taking fresh donkey's milk, with the animal being milked in the courtyard below.

Jo was exhausted from sleepless nights looking after the baby and also suffered from postnatal loss of blood. In mid-June she had stayed in bed for a week and may also have been suffering from what we now would recognize as postnatal depression. A few days before Vincent's visit Jo was finally sleeping better, although still 'moaning' during the night.[11] Theo continued to suffer from a long-term cough, along with other medical problems. A few weeks earlier Jo had told her sister Mien that he 'looks very bad, shivers constantly and has little appetite'.[12]

To add to these stresses, Theo faced work problems and felt that he was not being properly rewarded. As manager of the Boussod & Valadon branch in Boulevard Montmartre, he put in long hours. However, the gallery directors offered little support, while criticizing him for showing avant-garde work by Gauguin, Pissarro and Degas. A few months later Etienne Boussod complained that Theo had 'accumulated appalling things by modern painters which are the dishonour of the firm'.[13]

Theo was being squeezed financially, since he not only provided Vincent with a regular allowance, but also partially supported their mother and now had a wife and child to support. He agonized over whether to issue an ultimatum to his bosses: raise my salary or I will leave and set up my own gallery. Theo was uncharacteristically angry and resentful, complaining to Vincent that 'those rats Boussod & Valadon treat me as if I'd just started working for them and keep me on a leash'.[14]

The day after the visit Theo went ahead and confronted the gallery directors, so the issue must have been much discussed during Vincent's visit. Vincent was equally indignant about Theo's treatment (it had been the same company that had sacked him as a young art dealer some 14 years earlier), but he was financially completely dependent on his brother. Both Vincent and Jo feared that it would be risky for Theo to go it alone.

To add to their worries, Theo and Jo were considering moving to another apartment in the same building. They were then living on the

third floor, but a slightly larger one was becoming available on the first floor. More space would have been useful for their child, while also providing extra storage for Vincent's paintings. A provisional decision was made during the Sunday visit to move, but this was followed by further indecision.[15] Although some of Vincent's pictures were stored under the beds in the apartment, most were kept with Père Tanguy, who ran the nearby art supplies shop where Theo had hired a small attic room. Vincent had been disturbed to see the bedbug-infested premises during his earlier visit to Paris in May.

Finally, there were discussions over whether Theo, Jo and the infant should spend their summer holidays in Auvers – or go to the Netherlands to visit their families. Vincent was desperately keen for them to come to Auvers, but Theo and Jo were under pressure to return to Holland, since their relatives wanted to greet the new arrival. In the end they decided on the Netherlands, leaving a week after Vincent's day in Paris.

Not surprisingly, the family discussions on that Sunday afternoon became very fraught. Although their artist friend Armand Guillaumin had been due to call, Vincent made a sudden decision to rush off to the station. As Jo later commented: 'It became too much for Vincent, so he ... hurried back to Auvers – overtired and excited.'[16] It must have seemed a repetition of what had occurred on his previous visit after leaving the asylum.

On the train back to Auvers Vincent turned over all the family problems in his mind. They were not only troubling, but in some cases opened up conflicts with his brother. For the next few days he deliberated over how to smooth things over, drafting a note for Theo and Jo that he never actually sent: 'We're all a little dazed ... You surprise me a little, seeming to want to force the situation, being in disagreement. Can I do anything about it – perhaps not – but have I done something wrong?'[17] Although the precise meaning of these words remains unclear, the Paris visit had clearly been emotionally disturbing.

Jo eased the situation by getting in first with a conciliatory note. Greatly relieved, Vincent responded that her letter was 'like a gospel for me, a deliverance from anguish which I was caused by the rather difficult and laborious hours for us all'.[18] Vincent continued that his life felt 'attacked at the very root'. He then added: 'Once back here I too still felt very saddened, and had continued to feel the storm that threatens you also weighing upon me ... I feared ... that I was a danger to you, living at your expense – but Jo's letter clearly proves to me that you really feel that for my part I am working and suffering like you.'[19] He felt guilty at failing to sell his work and being a burden on Theo.

Vincent's reaction to these problems was to channel his energy into his art, advice that he had also received from Dr Gachet. Working at a frenetic speed and with great emotion, he completed three large landscapes in three days.[20] The act of painting these 'immense stretches of wheatfields' helped calm him by absorbing his emotions (plates 37 and 45).[21]

DOUBLE SQUARES

*'I have a canvas one metre long by only 50 centimetres
high, of fields of wheat, and one that makes a pendant
of undergrowth'*[1]

A month after his arrival in Auvers Van Gogh made the bold decision to
paint some of his most important works on 'double-square' canvases,
each a full metre wide. These are among his largest paintings and the
format is particularly appropriate for the panoramic views he had in
mind. He was probably partly inspired by the example of Daubigny,
who produced wide landscapes, although not precisely of these
dimensions. For Van Gogh's desired format, he took a 2 metre-wide
roll of canvas which he received on 17 June, cutting the individual
pieces to size.

Landscape at Twilight (plate 38) is among the earliest of the series.
The greenery is suggestive of late spring rather than summer, and it was
probably painted around 20 June. Vincent described it as 'an evening
effect – two completely dark pear trees against yellowing sky with
wheatfields, and in the violet background the château encased in the
dark greenery.'[2]

The 17th-century château, the most imposing secular building in
Auvers, stands on a wooded hillside overlooking the Oise valley. In the
painting the path on the left leads the eye to a solitary farmhouse with a
terracotta roof, contrasting with the dark green mass of a more distant

tree. But what gives the picture its impact is the luminous, golden evening sky. Van Gogh was aiming not for realism, but for dramatic effect.

That same week he completed *Undergrowth with two Figures* (plate 39), with a couple strolling through a forest carpeted with flowers, the trees neatly arranged in rows. Van Gogh described the picture as 'undergrowth, violet trunks of poplars which cross the landscape perpendicularly like columns', set above a 'flowery meadow, white, pink, yellow, green, long russet grasses and flowers'.[3] The red pigment has now faded, so petals that were once pink are now nearly white. Meadow flowers such as these would hardly thrive under a dense forest canopy, emphasizing that this is an imaginary scene.

Only after finishing most of the picture did Van Gogh add the strolling lovers – faceless, dwarfed by the trees and seemingly as immobile as their surroundings. The dark background, contrasting with the bright meadow, could either be imprisoning or protecting this ethereal couple.

The Plain of Auvers (plate 40) returns to Van Gogh's favourite subject – the wheatfields – rendered in a colour scheme he described as 'soft green, yellow and green-blue.'[4] The eye is drawn to the central field, emphasized in violet with wavy lines representing rows of a crop. To the left, there is a wheatstack, with large scarlet poppies scattered around. Three towering trees to the right lead towards the horizon, lending a sense of distance. As with so many of his Auvers works, Van Gogh has left only a narrow band of sky, painted in a deep turquoise.

All of his double-squares were landscapes with one exception, the portrait of *Marguerite Gachet at the Piano* (plate 30). Van Gogh had the surprising idea of hanging his painting of the doctor's daughter next to *The Plain of Auvers*. The vertical portrait and horizontal landscape obviously have nothing in common in terms of subject matter, but what interested him were the colour contrasts between the paintings. As he explained, the portrait 'looks very good with another horizontal one of wheatfields, thus – one canvas being vertical and pink, the other pale green and green-yellow, complementing the pink.'[5] Once again, Van

Gogh's red pigment has suffered over the years, with Marguerite's rosy dress now largely faded to a bluish white.

The first version of *Daubigny's Garden* (plate 41) represents a vibrant tribute to the artist whom Van Gogh so admired. He mentions Daubigny in over 50 of his surviving letters throughout his life, often referring to him as one of his favourite artists. Six years earlier, when Van Gogh set out to develop his painting skills, he had commented that his hero 'really is very *daring* in colours.'[6] Although Daubigny had died in 1878, his elderly widow Marie lived in the Auvers house they had built. It still survives, with its long grounds running up from the main road, almost opposite the railway station.[7]

Van Gogh had already made a square picture of her garden and part of the house. This study was done when he had run out of canvas, so he used dish towel fabric.[8] It was three weeks later that he returned to the same subject, this time with a double-square canvas, twice the size. The larger one, he wrote, was 'a painting I'd been thinking about ever since I've been here.'[9]

In this much more ambitious composition the garden is depicted from slightly further back, near the road, capturing almost its full length. Beyond the Daubigny house the top of a more distant building, now known as the Villa Ida, can be glimpsed.[10] To the right is the church, presented slightly larger than it actually appears from this spot.

The small figure of an elderly woman, dressed in black, must represent Marie. She walks towards a bench, table and chairs, set in a welcoming glade. Van Gogh included a cat, presumably her pet, slinking across the foreground. Since Dr Gachet had a penchant for black cats, it may also have been a nod to him for making the introduction.

This is the only one of the double-square canvases of which Van Gogh made a copy, so one of the paintings could go to Daubigny's widow. The later version, painted in mid July, was presented to her by Theo after Vincent's sudden death. Sadly, Marie did not have long to enjoy the picture, since she died that December, aged 73.

Four of Van Gogh's other double-square paintings are panoramic wheatfields. *Landscape at Auvers in the Rain* (plate 42) could hardly be more different from Daubigny's idyllic garden, since it depicts the village being pounded by a squall as several crows swoop down towards the viewer. Farmhouses nestle in the valley, with the church tower just visible on the left, close to what appears to be a factory chimney.[11] But the work's most impressive and prominent feature is the diagonal lines of driving rain, which Van Gogh adopted from a striking print by the Japanese artist Utagawa Hiroshige. Three years earlier, in Paris, Van Gogh had painted his own interpretation of Hiroshige's *Sudden Evening Shower on the Great Bridge near Atake*, in which the river scene is drenched with similar slanting lines of pouring rain.[12]

Field with Wheatstacks (plate 43) is one of the artist's most powerful Auvers landscapes, painted with vigorous brushwork that surges across the scene in wave-like strokes. The composition is divided into four areas: green vegetation evoked by Van Gogh's characteristic inverted horseshoe swirls, a pair of large golden stacks (built up into house-like formations), small patches of distant fields and the sky, painted with parallel strokes of blue mixed with white. Unlike some of his late wheatfields under stormy skies, this exuberant picture radiates joy.

Wheatfield under Thunderclouds (plate 37) is a menacing scene, with a panoramic view of endless fields. The darkened sky near the horizon contrasts with a white cloud which hovers above the composition.

In *Sheaves of Wheat* (plate 44) eight or so stacks are arrayed across the canvas, almost reaching the top of the picture. The leaning bundles seem to dance, their flowing motion heightened by the agitated lines of the earth. No horizon appears, imparting a claustrophobic feel to the landscape. Since the crop has been harvested, this must be one of the painter's late double-squares, dating from mid July.

The 13 double-square paintings represent a disparate, yet distinct, group. All are landscapes, except for the vertical *Marguerite Gachet at*

the Piano, but each has its own mood. Some, such as *Undergrowth with two Figures* (plate 39) and *Tree Roots* (plate 48), are enclosed scenes, whereas others present bird's-eye, panoramic views of vast fields and skies, but under differing meteorological conditions.

The double-square canvases can be seen as a summation of Van Gogh's late work, at least in terms of landscapes. They are among his most ambitious paintings from Auvers, all completed within the last four weeks of his stay. Three of them – *Wheatfield with Crows* (plate 45), *Farms near Auvers* (plate 46) and *Tree Roots* (plate 48) – have at different times even been considered to be his very last painting.

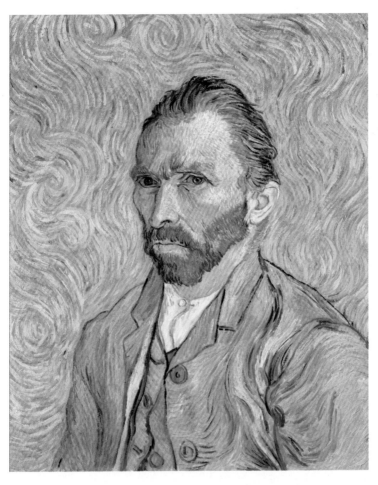

plate 1 *Self-portrait with Swirling Background*, September 1889, oil on canvas, 65 x 54 cm, Musée d'Orsay, Paris (F627)(F790)

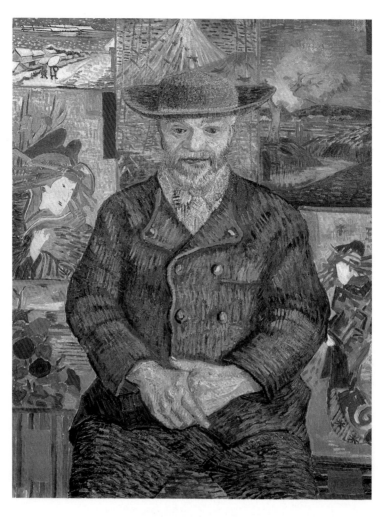

plate 2 *Portrait of Père Tanguy*, autumn 1887, oil on canvas, 92 x 75 cm, Musée Rodin, Paris (F363)

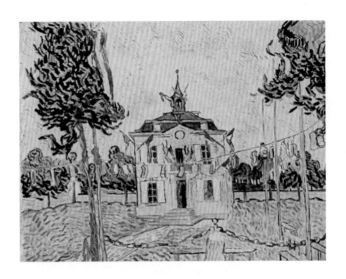

plate 3 *La Mairie* (Town Hall), Auvers, July 1890, oil on canvas, 72 x 93 cm, private collection, Spain (F790)

plate 4 *Dr Gachet's Garden*, May 1890, oil on canvas, 73 x 52 cm, Musée d'Orsay, Paris (F755)

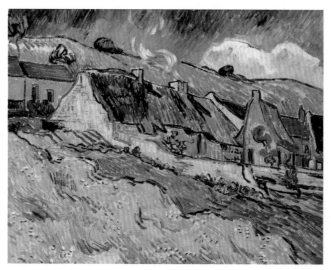

plate 5 *Thatched Cottages and Houses*, May 1890, oil on canvas, 60 x 73 cm,
State Hermitage Museum, St Petersburg (F750)

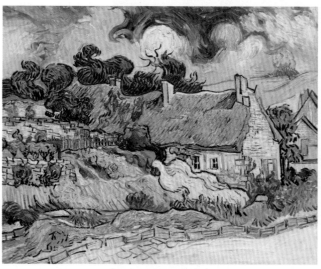

plate 6 *Cottages at Cordeville*, May–June 1890, oil on canvas, 73 x 92 cm,
Musée d'Orsay, Paris (F792)

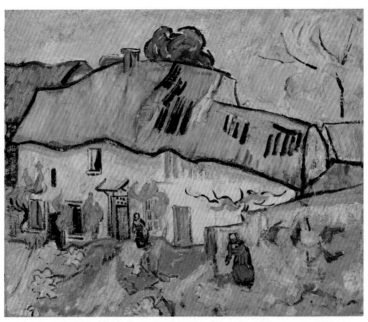

plate 7 *Farmhouse*, May–June 1890, oil on canvas, 39 x 46 cm,
Van Gogh Museum, Amsterdam (Vincent van Gogh Foundation) (F806)

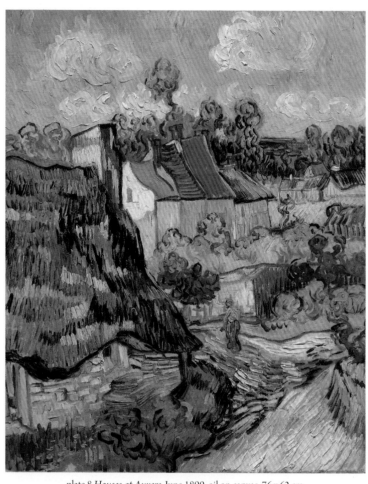

plate 8 *Houses at Auvers,* June 1890, oil on canvas, 76 x 62 cm,
Museum of Fine Arts,
Boston (F805)

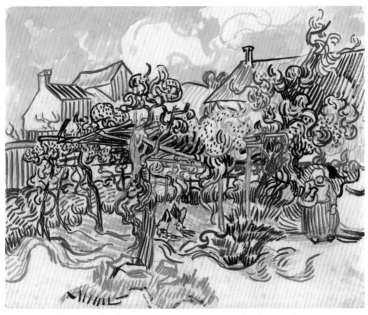

plate 9 *Old Vineyard with Peasant Woman*, May 1890, oil and watercolour on paper, 44 x 54 cm, Van Gogh Museum, Amsterdam (Vincent van Gogh Foundation) (F1624)

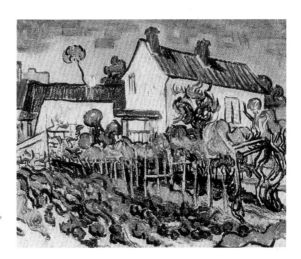

plate 10 *Vineyard and Houses*, May 1890, oil on canvas, 51 x 58 cm, private collection (F794)

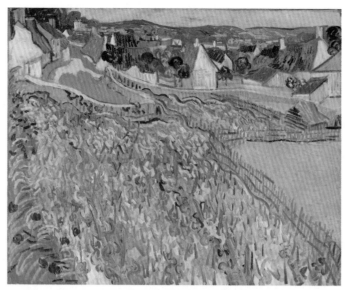

plate 11 *Vineyards with a View of Auvers*, June 1890, oil on canvas, 65 x 80 cm
Saint Louis Art Museum (F762)

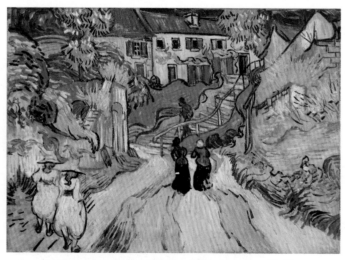

plate 12 *Stairway at Auvers*, May–June 1890, oil on canvas, 50 x 71 cm,
Saint Louis Art Museum (F795)

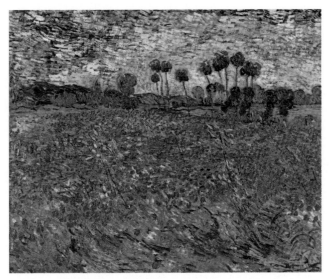

plate 13 *Poppy Field*, June 1890, oil on canvas, 73 x 92 cm, Kunstmuseum
The Hague (on loan from Cultural Heritage Agency of the Netherlands) (F636)

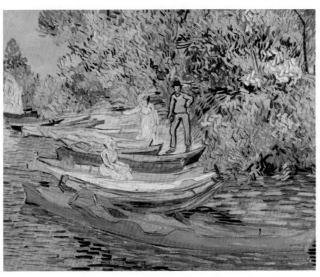

plate 14 *Bank of the Oise at Auvers*, oil on canvas, June 1890, 71 x 94 cm,
Detroit Institute of Art (F798)

plate 15 *The Oise at Auvers*, June 1890, watercolour and oil on paper, 48 x 63 cm, Tate, London (F1639)

plate 16 *Landscape with Train*, June 1890, oil on canvas, 72 x 90 cm, Pushkin State Museum of Fine Arts, Moscow (F760)

plate 17 *View of Auvers*, May-June 1890, oil on canvas,
50 x 53 cm, Van Gogh Museum, Amsterdam
(Vincent van Gogh Foundation) (F799)

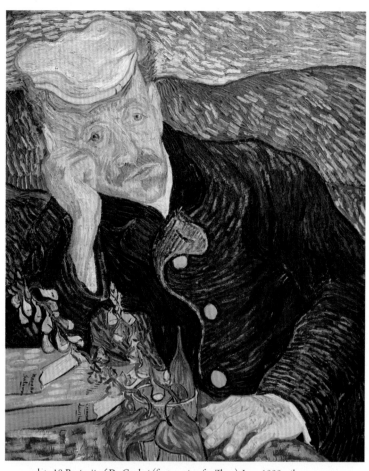

plate 18 *Portrait of Dr Gachet* (first version for Theo), June 1890, oil on canvas,
67 x 56 cm, private collection (F753)

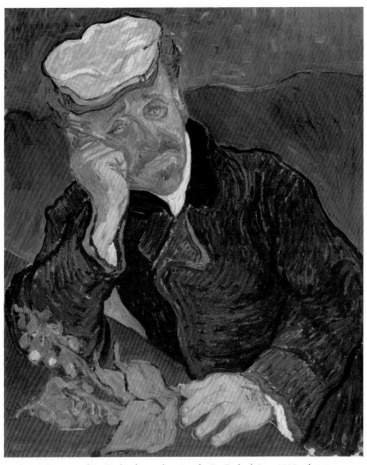

plate 19 *Portrait of Dr Gachet* (second version for Dr Gachet), June 1890, oil on canvas, 68 x 57 cm, Musée d'Orsay, Paris (F754)

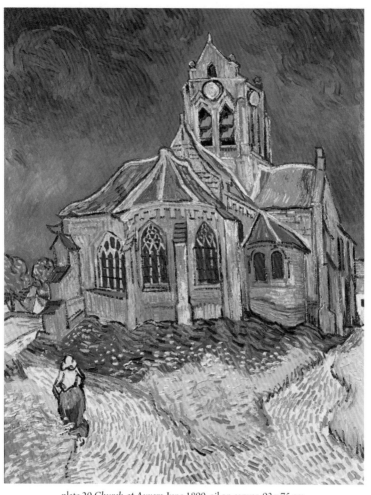

plate 20 *Church at Auvers,* June 1890, oil on canvas, 93 x 75 cm,
Musée d'Orsay, Paris (F789)

plate 21 *Les Vessenots*, June 1890, oil on canvas, 55 x 65 cm,
Museo Nacional Thyssen-Bornemisza, Madrid (F797)

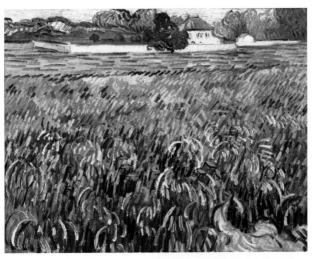

plate 22 *Wheatfield*, June 1890, oil on canvas, 49 x 63 cm,
Phillips Collection, Washington, DC (F804)

plate 23 *Green Wheatfields,* June 1890, oil on canvas, 72 x 91 cm, National Gallery of Art, Washington, DC (F807)

plate 24 *Ears of Wheat,* June 1890, oil on torchon, 64 x 48 cm, Van Gogh Museum, Amsterdam (Vincent van Gogh Foundation) (F767)

CHAPTER THIRTEEN
LAST PICTURE

*'My life, too, is attacked at the very root, my step
also is faltering'*[1]

Art-lovers are often fascinated to know what is a great artist's last picture[2], but in Van Gogh's case there is also a hope that identifying and analysing the work might provide an insight into his state of mind at the very end of his life. What, then, is his 'last' painting?

Wheatfield with Crows (plate 45) has most frequently been cited as the final Van Gogh.[3] This powerful picture can certainly be regarded as unsettling and full of foreboding. A flock of crows hovers menacingly, either swooping towards the viewer or making its escape. The three diverging paths all appear to be going nowhere, ending abruptly after veering away, while the sky could hardly be more turbulent and threatening, with a thunderstorm about to break over the eerily luminous wheat.

Jo interpreted the picture in this way: 'As his last letters and pictures show', the catastrophe approached 'like the ominous black birds that dart through the storm over the wheatfields.'[4] Two other very early writers on Van Gogh took a similar view, regarding the painting in symbolic terms.

Frederik van Eeden, a writer and psychiatrist, saw *Wheatfield with Crows* just a few months after the artist's death. Describing the sky as 'a terrible, deathly blackish blue', for him the picture represented 'an

expression of utter despair.'[5] A few months later Johan de Meester wrote about the 'great dark birds', entitling the painting *The Desolation of the Fields*.[6] But despite these emotive descriptions, neither author referred to it as the artist's last work.

In the early Van Gogh retrospective exhibition held in Amsterdam in 1905, this painting ended the display – suggesting that it was the final picture. Three years later, in a show in Munich and Dresden, the catalogue explicitly described it as the 'last work of the master.'[7]

This idea really took off when the painting was included as the climax of Irving Stone's 1934 novel *Lust for Life* and even more so in the subsequent 1956 film. Kirk Douglas, who plays Van Gogh, stands beside an easel with his version of *Wheatfield with Crows* (fig. 90). As he adds the final touches, a flock of birds suddenly takes off from the field and swirls around his head. Impulsively, he paints the crows into his picture, with thick, black, stabbing strokes. The artist then staggers off, as the camera pans towards a nearby farmer ploughing. We hear the sound of a gun being fired. Not only is the painting presented as his last, but he is working on it right up until a few seconds before the shot rings out.

Wheatfield with Crows, painted quickly with confident brushwork, is undisputedly among Van Gogh's most powerful works. But along with its sinister aspects, it is also full of life – the ripening and swaying wheat, the soaring birds and the volatile weather. The diverging paths are not unlike those in the much more restful *Church at Auvers* (plate 20). *Wheatfield with Crows* may indeed reflect something of Van Gogh's inner turmoil, but it is certainly not his final work. The crop has yet to be harvested and the artist's correspondence suggests that it is likely to be one of the wheatfields under 'turbulent skies' that he completed just after his difficult 6 July visit to Paris.[8]

The firmest evidence to identify the paintings done in the week or so before Van Gogh's death are those recorded in his last letter, dated 23 July.[9] He included small sketches of four pictures that he was completing: *Thatched Cottages and Figures*[10], *Wheatfields after the*

Rain (plate 50), *Plain near Auvers* (plate 25) and the second version of *Daubigny's Garden* (plate 41 shows the first version). But this was four days before the shooting, so none of these was the very last.

What then was Van Gogh's final work? *Road in Auvers* (plate 47) had earlier been suggested[11], since it could be regarded as unfinished: large patches of sky have been left white. But at Van Gogh's pace of working it would have taken him only a few minutes to fill in the missing areas of blue. This suggests a deliberate decision to leave the white ground layer showing to give the effect of clouds.[12] Conservators have discovered that after the main paint had dried, Van Gogh retouched the canvas, adding yellow flowers in the grass. If he had regarded the sky as unfinished he surely would have completed it along with the blooms. This unusually striking picture is not mentioned in the artist's letters and could have been painted early in his stay.[13]

A more plausible candidate for the last picture is another double-square landscape, *Farms near Auvers* (plate 46).[14] In October 1891, only a year or so after the artist's death, it was exhibited at the Société des Artistes Indépendants in Paris with a catalogue entry describing it as his 'last sketch'.[15] This display was prepared with the help of Jo and Andries Bonger, so they are likely to have provided this key description.

Farms near Auvers represents Van Gogh's most ambitious depiction of the thatched cottages that he so loved.[16] Although nearly all the picture is finished, there are patches that appear incomplete: in the lower-right corner and in the background above the roofs of the houses on the right.[17] These loosely painted areas are curious, since once again they would have taken Van Gogh only a few minutes to complete. However, unlike the sky of *Road in Auvers*, these unfinished areas are slightly distracting. Perhaps Van Gogh painted most of the picture outside and had intended to retouch it back at the auberge – so it could well have been among his last works.

However, Andries Bonger was later much more specific about another painting that he described as having been done in the morning of the shooting: *Tree Roots* (plate 48). A detailed study by the Van Gogh

Museum's senior researcher Louis van Tilborgh and the ecologist Bert Maes cites an 1893 article in a Dutch newspaper by Andries Bonger.[18] Jo's brother wrote that 'the morning before his death [the writer must mean shooting, since Van Gogh died two days later] he had painted an underwood, full of sun and life'. *Tree Roots* is the only picture to really match this description.[19]

Although not mentioned in the essay of Van Tilborgh and Maes, there is further evidence that *Tree Roots* was indeed the last painting. In 1891, two years earlier, the Dutch critic Johan de Meester had written that he had seen 'a *sous bois* [underwood], which was said to be his final painting'. De Meester described it as 'a marvellously opulent piece drawn from a sumptuous and joyous nature, a very good painting'.[20]

When Van Tilborgh and Maes published their findings it was unclear where the artist had pitched his easel. They speculated that it might have been on a chalk face off Rue Gachet, just to the east of the doctor's house. Exposed tree roots also appear along the banks of the Oise, worn away by the water. But the answer came in 2020 with a brilliant discovery by the art historian Wouter van der Veen.[21]

During the 2020 coronavirus pandemic, Van der Veen had more time to pursue his research and was looking through some old postcards of Auvers. A rare early card depicting a cyclist by a slope of trees caught his eye (plate 49). He suddenly realized that part of the slope looked uncannily similar to that in *Tree Roots*.

The postcard fortuitously identifies the road as Rue Daubigny and when Van der Veen was able to visit Auvers he very quickly found the location. To his utter astonishment, he saw that the largest tree stump in both the painting and postcard is still there. A close examination revealed that the images of the painting, the postcard and the present remains of the roots match up.

The site of *Tree Roots* is only three minutes' walk from Van Gogh's auberge, outside 48 Rue Daubigny. Van der Veen believes that the artist painted it during the morning of Sunday 27 July. Although it is a large double-square picture, given his intense rate of work he might have

almost finished it by lunchtime. He would then have gone for a meal and possibly returned in the afternoon, adding some refinements. The day's work virtually completed, Van Gogh carried the painting back to the auberge.

Tree Roots is indisputably an audacious painting. This closely cropped composition shows the lower part of a cluster of pollarded trees, which at that time would have been cut for firewood. With little sense of space or perspective, the roots spread across the canvas in an almost abstract composition. This makes it difficult to determine whether the painting is entirely finished. Although basically complete, Van Gogh may have intended to adjust the colours and retouch certain details back at the auberge.

Whether or not *Tree Roots* reflects something of the artist's mental turbulence is debatable. Knowing that *Tree Roots* was his final picture, it is tempting to see something of the tensions in his mind reflected in its tangled, writhing forms – but it is often distorting to look into Van Gogh's paintings and then read into them his psychological condition. Although there were always problems, Vincent showed no signs of giving up. On 23 July, four days earlier, he had written to Theo that in Auvers 'one can't find anything good in the way of colours' – enclosing a list of paints that he wanted to be sent from Paris.[22] As always, painting was uppermost in his mind.

PART II

THE END

CHAPTER FOURTEEN

SHOT

'Better to die of passion than to die of boredom'.[1]

Just after 7pm on Sunday 27 July 1890 Vincent left the auberge for the very last time.[2] It is often assumed that he set off to work laden down with his equipment, as depicted in the film *Lust for Life* (fig. 90). But for once painting was not on his mind: that evening he carried a gun, not an easel.[3] He intended to end his life – or at least to contemplate that terrible possibility.

With a heavy heart Vincent descended the stairs of the auberge. Problems were overwhelming him. His friend Bernard, presumably reflecting the views of Dr Gachet, later reported that he had made his decision 'completely lucidly'.[4]

How did Van Gogh acquire a revolver? It could well have come from the auberge. Many locals owned such weapons and Arthur Ravoux, as an innkeeper, may have felt it prudent to keep one in a secure place, not far from the bar.[5] A less likely possibility is that the gun came from Dr Gachet's house.[6] It seems implausible that Ravoux or the doctor would have lent a weapon to Van Gogh, considering his recent mental instability – but he might have taken it without their knowledge.[7]

It is also possible that Van Gogh bought his own revolver. According to tradition, the Leboeuf gunshop in the neighbouring town of Pontoise is said to have supplied the gun.[8] New evidence has emerged which shows how simple and relatively inexpensive it would have been to buy

a weapon. A local paper, *Le Progrès de Seine-et-Oise*, carried a Leboeuf advertisement on 2 August 1890 which offered Lefaucheux rifles as well unidentified revolvers and pistols (fig. 48).[9] Augustin Leboeuf, the owner, had originally served his apprenticeship with the Lefaucheux company.[10]

On leaving the auberge, Van Gogh probably headed towards the château, passing close to the area where he had painted *Landscape at Twilight* (plate 38). Indeed it would have been at almost the same time of day that he made that picture. On the fateful evening Van Gogh would have then walked along the road that climbs above the valley and eventually leads to the neighbouring village of Hérouville (the three-lined route in plate 25). Soon after passing the château he turned right onto a track.[11] By this time he had surely made his decision.

Vincent searched for an appropriate spot. Presumably he sought somewhere private, yet not too hidden. He probably wanted his body to be discovered, if only to spare Theo the grief of not knowing what had happened. He found that spot in his beloved wheatfields, just under a kilometre from the auberge.

The place of the shooting has been much debated, but it was most likely just to the north of the château, where the wheatfields begin to unfold across the plateau (fig. 49).[12] Bernard, who attended the funeral, wrote the following day that Vincent had gone 'behind the château', near a wheatstack.[13] Two local newspaper articles support this view. *Le Régional* reported that Van Gogh had set off 'towards the château' and *L'Echo Pontoisien* wrote that the shooting

fig. 48 Leboeuf advertisement for guns, Pontoise, *Le Progrès de Seine-et-Oise*, 2 August 1890

took place in 'the fields' (fig. 60).[14] A further source stating that it was 'behind the wall of the château' comes from a Catholic sister who recorded the memories of her grandfather, Léon Jacquin, who had been 18 at the time of the shooting.[15] The location 'behind the château' is also supported by books on Van Gogh published in the 1920s and later in the 1950s by Adeline Ravoux, the landlord's daughter.[16]

The location may well be depicted in a painting by Gachet Jr (fig. 50), which he inscribed on the reverse: *'De l'endroit où Vincent s'est suicidé'* ('Of the place where Vincent committed suicide'). This was painted in 1904, while his father was still alive, so it presumably reflects Dr Gachet's knowledge. In the picture the stone wall on the right with a distinctive gateway is the northern perimeter of the château grounds, along a lane known as the Chemin des Berthelees.[17] On one side of the lane were the grounds of the château and on the other the wheatfields. A year after completion of the painting Adolphe van Bever wrote that Dr Gachet had said that the shooting took place 'behind the château'.[18] Many decades later Gachet Jr was slightly more specific, writing that it was 'behind the park of the château', 800 metres from the auberge.[19] In the 1990s the wheatfields were replaced by a modern housing estate.

A shot rang out and the bullet pierced Vincent's chest. Probably aimed at his heart, it entered 3 or 4 centimetres below his left nipple, ricocheting off the fifth rib and lodging in the left part of the abdomen, the hypochondrium.[20] Had Vincent been standing, the force of the

fig. 49 Aerial view around the château, with the place where the shooting probably took place indicated (with arrow), mid 20th century, postcard

shot would almost certainly have thrown him to the ground, causing further injuries, so it is more likely that he was sitting on the ground or leaning against a wheatstack.

The bullet missed its target – Van Gogh's heart – and, although gravely wounded, he was still breathing. He could have fired another shot, to conclude what he had set out to do.[21] He might have lain down and awaited death. But he must have been overcome by an urge to survive or perhaps it was pure instinct. Incredibly, he got back on his feet, steadied himself and began to stagger. Moving slowly, he did not stop at any of the isolated farmhouses to seek help, but headed back towards the auberge. Although initially the shock may have deadened the pain, it must have intensified by the minute. The journey would have been an horrific experience, requiring enormous energy and determination. Bernard reported that he fell three times.[22]

Somehow Van Gogh made it back, arriving about an hour or so after he had set out, and an hour before sunset. He laboriously climbed the stairs to his room, pushed open the door and collapsed on the bed. Hearing groans, Arthur Ravoux rushed upstairs, to witness a shocking scene. His lodger was slumped on the bed, his shirt covered with blood. Van Gogh calmly informed his horrified host that he had just shot himself.

fig. 50 Louis van Ryssel (Paul Gachet Jr), *The Place where Vincent van Gogh committed Suicide*, 1904, oil on canvas, 24 x 31 cm, Musée Camille Pissarro, Pontoise

CHAPTER FIFTEEN
FINAL HOURS

'Then I will have to do it again'[1]

Ravoux immediately dispatched messengers to seek medical assistance. Dr Joseph Jean Mazery, another doctor, lived nearby in part of Marie Daubigny's house (plate 41) and arrived quickly. Fortunately the incident occurred during the half of the week that Dr Gachet was in Auvers. That evening he was fishing on the far side of the Oise and, on being summoned, it took a little while to cross the river and collect his emergency medical bag. He reached the auberge at around 9.30pm.

Theo later reported that 'the two doctors were marvellous'. Dr Gachet asked the much younger Dr Mazery, aged 31, for his advice, 'because he didn't trust himself, but nevertheless it was he who did everything'.[2] The wound was small, the size of a large pea, with just a trickle of blood.[3] But having determined the likely trajectory of the bullet in the chest, the two doctors agreed that it would be extremely risky to attempt to remove it. However, with the bullet inside him, Van Gogh's survival might only be a matter of hours or days. It was a difficult decision.

To operate in the auberge, without any facilities, would have been particularly dangerous. It was already twilight and using an oil lamp would have been almost impossible. Dr Gachet also generally avoided surgery and favoured minimal intervention.[4] The nearest hospital was in Pontoise, 6 kilometres away, and transporting Vincent by horse and

Cher Monsieur Vangogh

J'ai tout le regret possible
de venir troubler votre
repos. — Je crois pourtant
de mon devoir de vous
écrire immédiatement
On est venu me chercher
à 9 h. du soir aujourd'hui
dimanche de la part
de votre frère Vincent qui
me demandait de suite.
arrivé près de lui, je
l'ai trouvé très mal.
Il s'est blessé

fig. 51 Letter from Dr Gachet to Theo informing him of the incident,
27 July 1890, Van Gogh Museum archive

cart along a rough road would have been extremely painful and risky. By this time he was in agony and wished to die, so he might well have resisted being moved.

Dr Gachet tried to reassure Vincent, telling him that 'it's serious, but I hope that we will save you'. Vincent responded: 'Failed again? Can I smoke? Give me my pipe.'[5] He was 'lying on his bed but not crying, enduring his condition with courage', according to the doctor's son.[6] Although a survival instinct seems to have kicked in immediately after the shooting, by now he was adamant that he wanted to die. The doctors were hopefully able to provide a painkiller, possibly morphine.

Theo needed to be informed promptly, but Vincent refused to divulge his home address in Paris. Although Dr Gachet should have had this in papers back at his house, by now it was getting late in the evening to send someone by train to Paris and return, so it was decided to wait until the morning.[7]

Dr Gachet penned a note to be handed to Theo when Boussod & Valadon opened, with the envelope marked 'très important' (fig. 51).[8] He broke the terrible news with sensitivity: 'Today, Sunday, at nine o'clock in the evening I was sent for by your brother Vincent, who wanted to see me at once. I went there and found him very ill. He has wounded himself… I believe that it is your duty to come, in case of any complications that might occur…'[9]

Hirschig, a fellow lodger at the auberge, was dispatched to Paris very early in the morning with the doctor's note. Sleeping in the adjacent room to Vincent, they had got to know one another well. Hirschig met Theo in Paris to break the news and pass on the letter. Together they rushed to the station to catch the train back to Auvers. During the journey Theo pressed him for further details, but Hirschig could hardly have hidden what had been omitted by the doctor: Vincent had shot himself.

Meanwhile back at the auberge two gendarmes had arrived, having heard about the shooting. They needed to be confident that no one else had been involved, so Ravoux escorted the officers up to Van Gogh's

room. Annoyed at being disturbed, Vincent bluntly told them: 'I am free to do what I like with my own body.'[10]

On his arrival Theo must have been relieved to find his brother still alive and able to converse. Dr Gachet explained the medical situation. Theo spent the rest of the day at Vincent's bedside, responding to frequent requests for his brother's pipe to be lit (fig. 52). They talked for hours, and Vincent even went to the effort of asking about his young nephew. Theo must have agonized over what it was that had led Vincent to take this terrible action – and whether there was anything more that he could have done to have prevented it.

Jo was away, since she had stayed behind in the Netherlands after their joint family visit. Theo was therefore facing the tragedy very much alone. This was the first time that they had been separated since their marriage just over a year earlier. That afternoon, presumably during a few minutes when his brother may have fallen asleep, he wrote to her, but held back the details: 'This morning a Dutch painter who is also in Auvers brought a letter from Dr Gachet conveying bad news about Vincent and asking me to go there. I dropped everything and went immediately and found him better than I had expected, although he is indeed very ill. I shan't go into detail, it's all too distressing, but I should warn you, dearest, that his life could be in danger.'[11]

Theo's anguish then poured out in the letter: 'Poor fellow, he wasn't granted a lavish share of happiness and he no longer harbours any illusions.' This presumably reflected what Vincent must have just told him. Theo failed to elaborate on the nature of his condition, but Jo must have assumed that it was something similar to what had occurred in Arles: a self-destructive act. Theo concluded: 'Don't worry too much, it was just as desperate before, and the physicians were surprised by his strong constitution.'[12]

The end must have been traumatic. Hirschig recalled that during the final night Vincent 'groaned, groaned heavily'.[13] Theo remained at the bedside that evening, observing his brother's intense pain, but helpless to save him. The newspaper *Le Régional* reported that Van Gogh faced

'excruciating suffering' at the end.[14] Vincent's condition deteriorated quickly. At 1.30am in the morning of 29 July 1890, after 30 hours of agony, his heart stopped.[15]

Later that day Theo wrote to Jo: 'It took a few moments & then it was over & he found the peace he hadn't been able to find on earth.'[16] A few days afterwards he explained to his sister Lies: 'When I was sitting with him…. he said, "Sadness will last forever"… Shortly afterwards, he gasped for breath and a moment later he closed his eyes'. [17]

Dr Gachet also believed that Vincent had 'found rest'.[18] Like Theo, he too must have pondered what more he could have done. He had been entrusted with the responsibility of keeping a watchful eye on Vincent, but as his son admitted, very quickly he became 'more his friend than his doctor'.[19] After an initial consultation on his arrival, Dr Gachet seems to have done little to deal with Vincent's medical and mental condition before the shooting – and the end must have come as a considerable shock to him.

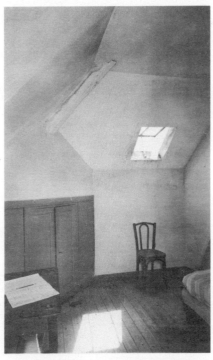

fig. 52 Van Gogh's bedroom, 1950s, postcard, Archive Tagliana, Auvers

Jo, then in Amsterdam, heard about the death not from Theo, but in a joint letter from Vincent's mother and sister Wil, who had just been informed and presumably thought that she had already heard the news.[20] It was most unfortunate that Theo and

Jo happened to be apart at this dreadful time. However, if the shooting had been ten days earlier, the situation would have been even worse, since Theo would have been far from Auvers, in the Netherlands. Jo wrote a heartfelt letter to her husband: 'Words fail me. I am so sad, so profoundly sad, and I can't even put my arms around you and share in your grief.'[21]

CHAPTER SIXTEEN

FUNERAL

'Painters... being dead and buried, speak to a following generation or to several following generations through their works'[1]

Theo sat alone beside the body of his brother as its warmth ebbed away. The 13 hours he had spent with Vincent would have been hugely traumatic and by now he was exhausted, both emotionally and physically. Towards dawn, he made his way downstairs to tell Ravoux the terrible news.

Another messenger was dispatched to Dr Gachet, quite possibly again Hirschig, who had slept only fitfully in the adjacent room. The doctor arrived swiftly and went upstairs to attend to Vincent's body. Hirschig never forgot the distressing scene: 'With the mouth wide open, as if he was still groaning, the doctor closed his eyes and took the blankets off his body and then he lay naked with a small red hole in his side.'[2]

Later that morning Dr Gachet found a stick of charcoal, probably one of Vincent's, and sketched a deathbed portrait (fig. 53), an act of homage which underlines his esteem for him and the bond that the two men had forged during the previous weeks. He had done such a portrait when his young nephew André had died.[3] The sketch of Vincent was executed very rapidly, with just a few, simple strokes, but it still must have been difficult to peer at his friend's face. Dr Gachet made

fig. 53 Paul van Ryssel
(Dr Paul Gachet), *Vincent
van Gogh on his Deathbed*,
29 July 1890, charcoal
on paper, 48 x 41 cm,
Musée d'Orsay, Paris

no attempt to idealize the lifeless features, the mouth downturned and the eyes closed. Vincent appears shaved, giving him a rather different appearance from his bearded self-portraits.[4] Dr Gachet inscribed the name rather formally as V. Van Gogh, adding the date and his monogram PVR (for his pseudonym Paul van Ryssel).

The paper of the deathbed portrait shows the imprint of a regular woven pattern, suggesting that it was placed on the cane seat of a chair when the charcoal was sealed with a fixative.[5] This may well represent a record of the vacant chair beside Van Gogh's bed. Dr Gachet also made a second, smaller version of the drawing for Theo and in 1905 he presented Jo with an oil sketch of the deathbed scene (fig. 54).[6]

Surprisingly, Dr Gachet portrayed the left side of Van Gogh's head showing his mutilated ear. One might have expected him to have drawn the unblemished side, but this may have been logistically difficult due to the position of the bed against a wall in the cramped room. The drawing appears to show the upper part of the mutilated ear relatively intact. Although Dr Gachet may have included more of the ear than

was actually present, his medical background might have made him reluctant to unduly distort reality. There has been much debate in recent years over whether Van Gogh cut off part or all of his ear, but this drawing suggests that at least some of it remained.[7]

Despite the doctor's membership of the Société d'Autopsie Mutuelle, there is no suggestion that he had actually recruited Van Gogh or that any sort of formal autopsy was conducted on the Dutchman's body. However, an important question which has not been adequately addressed is whether Dr Gachet might have cut an incision to remove the bullet.

It is possible that Dr Gachet did extract the bullet, an intervention that would presumably have required Theo's approval. Both men might have regarded the removal of this foreign object as a mark of respect to preserve Vincent's dignity. He could then be buried in a natural

fig. 54 Paul van Ryssel (Dr Paul Gachet), *Vincent van Gogh on his Deathbed*, 1890 or 1905, oil on board, 11 x 17 cm, Van Gogh Museum, Amsterdam (Vincent van Gogh Foundation)

state, rid of the projectile that had caused his death. It might seem a particularly grisly task to open up the body of a deceased friend, but Dr Gachet's membership of the Société d'Autopsie Mutuelle meant that he would not have felt uneasy about such a procedure.

Having left Dr Gachet to deal with the body, Theo needed to quickly make the necessary funeral arrangements, assisted by Ravoux. They first crossed the road to report the death at the *mairie*, the building which Vincent had depicted in festive mode just two weeks earlier (plate 3). The mayor, Alexandre Caffin, met them and together the three men signed the death record at 10am (fig. 55). This recorded the legal details, noting Vincent's profession as 'artiste-peintre'.

The next formality was the request for burial in the Auvers cemetery, which was signed by Dr Mazery. The villagers had originally buried their dead in the churchyard, but in 1859 a new cemetery was established higher up the hill, on the plateau. That afternoon the gravedigger began his task. In the meantime a coffin was ordered from Godard, a merchant near Dr Gachet's house.[8]

Theo arranged the funeral notice, which was quickly printed in Pontoise. At this point he assumed that the service would be held in the Auvers church (plate 20). But problems quickly developed, since the priest, Henri Tessier, refused to allow it because Van Gogh had committed suicide. Although no longer a criminal offence in France, it was still regarded as sinful by the Catholic Church. Van Gogh's background as a Dutch Protestant would not have helped and his links with Dr Gachet, known for his progressive and agnostic views, may possibly have created a further hurdle.

Father Tessier even refused to allow the church hearse to be used for the funeral. Gachet Jr and Hirschig therefore walked to the neighbouring village of Méry to request theirs, which was agreed.[9] The printed funeral notices had to be hastily amended by hand, with mourners being asked to gather at the auberge by 2.30pm the following day (fig. 56).[10] The postal service at that time was faster than today, but even still it made it difficult for those beyond the village to attend Van Gogh's funeral.

fig. 55 Registration of the death of Vincent van Gogh, 29 July 1890, Archives Départementales du Val d'Oise, Pontoise

On the day of the funeral[11], Wednesday 30 July, Vincent's body was laid out in the painters' room, at the back of the auberge. Vincent Levert, the carpenter from next door, lent two trestles for the coffin. The hot weather meant that the burial needed to take place without delay. Hirschig recalled that the coffin 'leaked fluid continuously because the planks hadn't been made close enough and eventually we had to use carbolic'.[12]

Theo bade farewell to his brother's body at 9am and the coffin, surrounded with flowers, was then sealed. Jo, who later received a detailed account from Theo, recorded that there were 'many flowers and wreathes', with Dr Gachet bringing 'a large bunch of sunflowers', which

fig. 56 Funeral notice, with deleted reference to the church, 29 July 1890, Van Gogh Museum archive

were then in season.[13] Bernard also described the scene: a white drape over the coffin, with 'masses of flowers, the sunflowers that he so loved, yellow dahlias, yellow flowers everywhere'. Yellow, he wrote, represented a 'symbol of the light that he dreamed of finding in hearts as in artworks'.[14]

Vincent's artist friends decked out the room with his paintings, many of which were not yet completely dry. Bernard continued with his account: 'On the walls of the room where the body reposed, all his last canvases were nailed, making a sort of halo.'[15] Van Gogh was already being regarded in saintly terms.

Adeline Ravoux recalled many years later: 'The house was in mourning as if for the death of one our own. The door of the café remained open, but the shutters were closed in front.'[16] Mourners began to assemble. Theo wrote to Jo that the 'last hour was hard', just before they set off.[17] A painting done by Bernard three years later may represent a stylized tribute (fig. 57).[18]

fig. 57 Emile Bernard, *Funeral*, 1893, oil on canvas, 73 x 93 cm, private collection

Dr Gachet was naturally one of the first to arrive at the auberge, together with his son Paul.[19] It is unclear whether his daughter Marguerite and housekeeper Chevalier attended or if they were too upset. Levert came with other neighbours to pay their respects. Jo was still with her family in Amsterdam, but her brother Andries travelled from Paris, possibly with his wife Annie.

It has often been said that relatively few people attended Vincent's funeral, but a considerable number of mourners gathered, considering the short notice and the fact that his mother and sisters were in the Netherlands and most of the two brothers' friends lived some distance away in Paris.[20] Père Tanguy was the first Parisian to arrive. So many of Vincent's works had been produced with paints and canvas from his shop and many of the completed pictures were stored in his attic. A few days later Tanguy told Octave Mirbeau about the funeral, causing the critic to reel under 'the so tragic, so sorrowful death'.[21]

Bernard, Vincent's closest French friend, was the next to join the mourners. The following day he reported to the critic Aurier that 'the coffin was already closed, I arrived too late to see him… the innkeeper told us all the details'.[22] Bernard had travelled from Paris with their artist friend Charles Laval.[23] Although Laval had never met Vincent, he had heard much about him from their mutual friend Gauguin.

Auguste Lauzet, a printmaker who worked with Theo, also came. He too had not met Vincent, but knew about his work. Boussod & Valadon had just published Lauzet's lithographs of paintings by Adolphe Monticelli, an artist greatly admired by the two brothers, and Vincent had wondered whether it might even be possible to produce a similar illustrated publication on his own work. Another mourner who might possibly have come from Paris was the young Maurice Denis, who would go on to become a leading symbolist painter.[24] The Pissarros were living in Eragny, 40 kilometres from Auvers. They only heard about the funeral at the last minute: Lucien just caught the train, although his elderly father Camille remained at home.

Theo wrote to Jo that 'there are lots of artists living in Auvers and many of them came'.[25] Léonide Bourges, a friend of Daubigny who had worked in Auvers since the 1870s, arrived to pay her respects. Eugène Murer – a pastry chef, noted collector of Impressionism and amateur artist – claimed many years later to have attended.[26] Ernest Hoschedé, a collector and friend of Dr Gachet, is also said to have been present (Hoschedé's wife Alice was then living with Monet and later married him).[27]

Interestingly, the majority of the artists working in Auvers who attended the funeral were foreigners, suggesting that Van Gogh, as a Dutchman, socialized more with the small international community. Along with Hirschig, three other Dutch painters were among the mourners: Maurits van der Valk, his fiancée Baukje van Mesdag and Siebe Ten Cate.[28]

Auvers played host to a number of US artists and Vincent had written that 'a whole colony of Americans has installed itself' next to his auberge.[29] Two long-standing American painters did attend. Boston-born Charles Sprague Pearce had moved to Auvers in 1884

to paint rural scenes.[30] British-born Robert Wickenden grew up in America, studied art in Paris and had moved to Auvers in 1888. He was present at the funeral and later claimed to have spoken a 'few words' at the graveside.[31]

Two Spanish-speaking artists joined the mourners. Nicolás Martínez Valdivielso, who had moved from his native Cuba and was working in Auvers, stayed in the same road as Dr Gachet.[32] Also at the funeral was Ricardo de Los Ríos.

At 3pm the mourners left the auberge, with Theo 'sobbing painfully' as he accompanied his brother on the last journey.[33] Setting out under a strong sun, they placed the coffin on the Méry hearse – solemnly walking along the main road past the *mairie* where the death had been registered and then by the Daubigny garden. The mourners spoke in hushed voices. As Bernard explained: 'We climbed the hill of Auvers talking about him, about the bold thrust he gave to art, the great projects that he was always planning, about the good that he did every one of us.'[34] The route took them past the church that had refused Van Gogh a Christian burial.

The ceremony was brief, yet emotionally intense. Theo wrote to Jo that 'Dr Gachet spoke beautifully; I said a few words of thanks & then it was over.'[35] Bernard gave what may have been a more accurate account of the doctor's contribution: he 'wept so much that he could only bid him an extremely confused farewell'. Dr Gachet began by describing Vincent as 'an honest man and a great artist', with only two goals: humanity and art.[36] When the doctor broke down and sobbed, the other mourners also shed tears, silently shovelling earth over the coffin.

Only a few years earlier the land where the new cemetery stood would have been used for growing the wheat that so inspired Vincent's art. Just days earlier Vincent had been painting close by on the plateau, with its wide vistas. Now he was laid to rest in what Theo described as 'a sunny spot among the wheatfields'.[37]

CHAPTER SEVENTEEN

SUICIDE OR MURDER

'If I was without your [Theo's] friendship I would be sent back without remorse to suicide, and however cowardly I am, I would end up going there'[1]

Until 2011 it was almost universally assumed that Van Gogh had died by his own hand: his death had always been regarded as suicide.[2] The idea that someone else might have pulled the trigger was first seriously suggested in *Van Gogh: The Life*, a biography by two American authors, Steven Naifeh and Gregory White Smith. In a highly detailed and thoroughly researched book, what caught international attention was their appendix entitled 'A Note on Vincent's Fatal Wounding'.[3]

Naifeh and Smith pointed out that 'for an act of such far-reaching significance and subsequent notoriety, surprisingly little is known about the incident that caused Vincent van Gogh's death'.[4] This is essentially correct – details are sparse and the few witness accounts are on some points contradictory. The two American writers therefore set out to forensically investigate the evidence, relying heavily on a long-forgotten interview given by René Secrétan, a young visitor to Auvers in Van Gogh's time. René spoke about the artist in 1957, a few months after the release of the *Lust for Life* film. A retired banker and businessman, he died later that year at the age of 83.[5]

René and his brother Gaston, as teenagers, had spent the early summer of 1890 near Auvers. They apparently got to know Van Gogh

and occasionally taunted the eccentric artist. In the 1957 interview René recalled that he himself had taken a revolver from Ravoux, which he used for playing cowboy games and shooting squirrels. René claimed that Van Gogh stole the gun, but without suggesting that he himself had any direct involvement in the artist's death.

Naifeh and Smith theorized that René was, however, responsible for the shooting. They also cited the distinguished American art historian John Rewald, who once apparently repeated a rumour that 'young boys shot Vincent accidentally'.[6] The Naifeh and Smith theory was subsequently taken up in slightly different forms in two acclaimed films – the painted-animation *Loving Vincent* (2017) and the artist Julian Schnabel's *At Eternity's Gate* (2018).

The two American biographers did not explicitly claim in their book that it was murder, suggesting instead that it was some sort of accident.[7] But if René had accidentally shot Van Gogh in the chest and seen him fall to the ground in a remote field, he must have assumed that either the artist had been killed instantly or that his life was in imminent danger and without urgent medical assistance he might well not survive. Such negligence would be regarded extremely seriously if it came to the attention of the authorities. If the perpetrator was believed in claiming that it had been an accident, then it would probably be treated as manslaughter involving negligence. If not, then they might well face a murder charge.

But if Van Gogh was accidentally shot by René, why would the victim not have said so, instead of claiming that he had done it himself? Naifeh and Smith argue that Van Gogh 'welcomed death', so the shooting came as something of a wish fulfilment. The artist therefore shielded René by claiming that it was a suicide attempt. Naifeh and Smith summarized the situation: Van Gogh was 'killed accidentally by a couple of boys and he decided to protect them by accepting the blame.'[8] On another occasion, they explained that 'Vincent chose to protect them as a final act of martyrdom'.[9]

It must be extremely unusual, if not unprecedented, for a victim of a shooting by a casual acquaintance to claim that it was a failed suicide

attempt. But if this did happen in the case of Van Gogh, why would the person who had fired the shot have voluntarily agreed to give an interview relating to it more than 65 years later? Until then it had apparently never occurred to anyone that René might have played any role in the artist's death, so he does not appear to have been under the slightest suspicion. Naifeh and Smith suggest that the 1957 interview represented an oblique deathbed confession.

A close reading of the René interview suggests that there is scant evidence of the involvement of the Secrétan brothers in the artist's death. René never implied that he had fired the shot, merely saying that Van Gogh had got hold of a gun that had been in his possession.[10] Crucially, René claimed to have left the Auvers area in the middle of July.[11] If René was truthful, then he had an alibi – and could not have fired the shot. If he either lied about the date of his mid-July departure or forgot that he was still in Auvers on 27 July, then everything else in the interview needs to be questioned. In short, the idea that René fired the shot seems extremely unlikely.

The clearest evidence about the shooting might be forensic evidence about the wound. If the gun had been fired very close to the body then this would be strongly suggestive of suicide, although not absolutely conclusive. But if it was fired from more than a metre away, then obviously someone else must have had their finger on the trigger.

The forensic evidence would almost certainly have to come from the accounts of the two doctors who examined the wound. Dr Mazery has left no medical records, and seemingly no account at all of his contact with Van Gogh.[12] Unfortunately, none of Dr Gachet's original medical records survive and he seems to have given out no detailed information on the artist during his lifetime. What we do have is material from his son, Gachet Jr, which may be at least partly based on written material left by his father, but the difficulty is gauging the accuracy of these later accounts.

For their 1928 book *La Folie de Vincent van Gogh*, Dr Victor Doiteau and Dr Edgar Leroy interviewed Gachet Jr at length. He told them that

the shot was '*trop en dehors*' (too far out) to kill him instantly.[13] Naifeh and Smith believe it means that it was 'too far out' in terms of distance from his body for Vincent to have pulled the trigger.[14] But Louis van Tilborgh and Teio Meedendorp, two specialists at the Van Gogh Museum, interpret this as meaning 'too far out' in terms of a trajectory to his heart, which would have caused almost instant death.[15] Although debatable, this latter explanation seems much more plausible, since in French one would normally say '*trop loin*' to mean too far away in distance.

The nature of the wound might indicate whether the gun had been fired from very close or from some distance away. But, once again, the evidence is far from clear. Doiteau and Leroy, after interviewing Gachet Jr, wrote that the wound was 'a small dark red circle, almost black, surrounded by a purplish halo, and oozing a thin stream of blood'.[16] Gachet Jr himself described the wound in similar terms as 'a dark red hole, surrounded by a double purple and brownish halo'.[17] For such a detailed description, it is quite possible that Gachet Jr had access to some of his father's now lost medical records.

Alain Rohan, a local historian, has undertaken a detailed investigation of the death of Van Gogh.[18] In his book he cites Yves Schuliar[19], then medical head at the Institut de Recherche Criminelle de la Gendarmerie Nationale, who believed that the gun had been fired from an extremely close range, probably less than 3 centimetres. The inner purplish ring would have been caused by the bullet's impact and the brown one by powder burns. The existence of a powder burn suggests that there was no clothing in the way, since a shirt would have trapped much of the powder, so the gun may have been fired beneath a shirt.

Naifeh and Smith disagree with the explanation given by Schuliar. They asked Vincent de Maio, an experienced American forensic expert, who came to very different conclusions to Schuliar. He argued that the inner purplish ring was not caused by the impact of the bullet, but was the result of 'subcutaneous [under the skin surface] bleeding from vessels cut by the bullet and is usually seen in individuals who live a

while'.[20] Its presence therefore reveals nothing about the distance from which the gun was fired. As for the inner brownish ring, this was 'an abrasion ring and seen around virtually all entrance wounds', so again it says nothing about the distance.

De Maio then argued that the most important point is what appears to have been missing from Van Gogh's wound. The black powder used in late 19th-century cartridges was very dirty and would have left soot around the wound if it had been fired within around 50 centimetres of the body. He therefore concluded that 'in all medical probability, Van Gogh did not shoot himself'.[21] There is little agreement among the medical specialists on what the wound tells us.

The other forensic question to be considered is where the bullet entered the body and the trajectory, since this might indicate whether Van Gogh or another party had pulled the trigger. Gachet Jr states that it entered near the heart.[22] But if it was an accident, the chances of it entering the body at such a vulnerable point would presumably be small. This suggests that the gun is more likely to have been fired with an intent to kill, either by Van Gogh or René.

The very limited forensic evidence about the wound has so far failed to resolve the debate. It is therefore necessary to consider the circumstances – and weigh up what seems to be the most plausible explanation. Five main reasons can be cited for believing that it was suicide, not manslaughter or murder.

SUICIDAL TENDENCIES

Van Gogh had suffered a recent history of severe self-harm. In December 1888, just 19 months before his death, he cut off much of his left ear. Although it is unclear whether this was a suicide attempt, his life was certainly in danger. A few hours after receiving the news in Paris, Theo wrote to Jo that 'he is very sick, but he still might recover'.[23] Vincent himself felt that he was unlikely to survive, telling his friend the postman Joseph Roulin, a day after being admitted to hospital, that they 'would meet again in heaven'.[24] Three months later Vincent wrote

to Theo to say that 'I would have preferred to die than to cause and bear so much trouble'.[25]

Although surviving the physical injury to his ear remarkably well, Vincent went on to suffer a series of severe attacks. On several occasions he ingested substances that could have caused serious injury – or death. Signac, on visiting him in Arles in March 1889, reported that Van Gogh had 'wanted to drink a litre of turpentine'.[26] The following month Vincent wrote that without his brother's friendship he would be 'sent without remorse to suicide' – and despite his cowardice he would end his life.[27]

Van Gogh moved to the asylum of Saint-Paul-de-Mausole in May 1889. Two months later its director, Dr Théophile Peyron, reported that his patient had tried 'to poison himself with his brush and paints'.[28] In September, after recovering from an attack, Vincent admitted that he had considered ending his life, but had stepped back from the brink, like someone 'who wants to commit suicide, and finding the water too cold he struggles to catch hold of the bank again'.[29] Dr Peyron confirmed his recovery at the asylum, saying that 'his ideas of suicide have disappeared; there remain only his bad dreams'.[30]

On Christmas Eve 1889, almost a year to the day after the mutilation, Van Gogh suffered a further crisis and again tried to poison himself by eating paint.[31] A month later he wrote to Joseph and Marie Ginoux, friends in Arles, saying that 'I've very often told myself that I'd prefer that there be nothing more and that it was over'.[32]

When departing from the asylum in May 1890 Dr Peyron recorded in Van Gogh's medical notes: 'On several occasions he has attempted to poison himself, either by swallowing colours that he used for painting, or by ingesting paraffin, which he had taken from the boy while he was filling his lamps.'[33] These episodes were later recalled by two witnesses who worked at the asylum, Sister Epiphane and Jean-François Poulet.[34]

This string of incidents shows that Van Gogh undoubtedly had a strong inclination towards self-harm or worse, cutting an artery and

severely mutilating his ear and later ingesting substances that could well have killed him. Neither Vincent nor his doctor shied away from using the word 'suicide'. Of course this does not prove he shot himself, but it does demonstrate that ending his life was something that he seriously considered on quite a number of occasions.

COR'S DEATH AND WIL'S DEPRESSION

Of Vincent's five siblings, two suffered severe mental issues. Cor, the youngest brother (fig. 58 [35]), took his own life. He had been working as a railway engineer in South Africa and after the outbreak of the Boer War fought on the Dutch side. Aged 32, he died on 12 April 1900 near Brandfort, north of Bloemfontein in South Africa. Little is known about the circumstances or the problems he had encountered – but it was classified as suicide. Cor's death certificate gave the cause as 'an accident during his illness (fever)'. A Red Cross register of war deaths was more explicit, recording that 'during fever took his own life'.[36]

Vincent's youngest sister Wil (fig. 59)[37] suffered much more prolonged distress. In 1890 she worked as a nurse and later supported an early feminist organization in the Netherlands. In 1902, at the age of 40, she suffered a mental attack that led to her being sent to the Veldwijk asylum in Ermelo, in the east of the Netherlands. There she was diagnosed with what was then described as early dementia, but may have been schizophrenia.

Wil withdrew from all human contact. The asylum recorded: 'She remains solitary and withdrawn, rarely speaks and generally does not respond to questions… She has refused food for years and has to be fed artificially.'[38] When Wil did speak, it was sometimes to talk of self-mutilation or suicide.[39] She lived in the asylum for 38 years, eventually dying of old age in 1941. It seems quite possible, although not certain, that Cor and Wil shared a genetic affliction whose first victim was their elder brother Vincent.[40]

fig. 58 Cor van Gogh, 1890s,
photograph by Charles Schouten,
The Hague, Van Gogh Museum archive

fig. 59 Wil van Gogh, c.1900,
photograph by Johann Hameter, Leiden,
Van Gogh Museum archive

THEO'S PROBLEMS

The first half of July 1890 had obviously been an extremely disturbing time for Theo, with a number of problems coming to a head, and Vincent was only too aware of them when he visited Paris on 6 July. Theo, Jo and the baby had various medical conditions and they were agonizing over whether to move to another apartment, causing further anxiety.

Theo's row with his bosses at Boussod & Valadon over his salary and their lack of support was much discussed during Vincent's visit. The following day Theo went ahead with an ultimatum, threatening to leave and set up his own gallery. A week later he told Vincent that his bosses had still not responded: 'Those gentlemen have said nothing as regards what they're thinking of doing with me.'[41] Vincent became

increasingly worried about the financial risks of Theo leaving the gallery, both for the sake of his brother, but also for himself. Without a regular allowance from Theo he could not paint – so life would hardly be worth living.

In fact the situation was resolved just a few days later. On 22 July Theo reported what had transpired to his mother and sister Wil: 'Recklessly giving up my position to plunge into uncertainty was a very dangerous matter… I thought about it so much that I was nearly desperate.' Theo had therefore spoken with Etienne Boussod the previous day, saying that he now felt 'it was wiser for me to stay', even without a rise.[42] Boussod agreed that he could keep his job, with a vague promise that if business expanded then his salary might be increased.

Inexplicably, Theo apparently failed to inform Vincent that he had stepped back from his ultimatum and negotiated to remain – news which would have put his brother's mind at rest at a stressful time. On 22 July, the very day that Theo informed their mother and Wil, he also wrote to Vincent, but did not mention his work situation – even though it had been resolved the previous day. It remains a mystery why Theo failed to reassure him that he was staying at Boussod & Valadon. Had he done so, Vincent would have had one less burdensome worry. Instead, on 23 July Vincent wrote with concern about the 'storms' that he feared were threatening his brother's household.[43]

VINCENT'S LAST WORDS

As Vincent lay dying, Dr Gachet tried to comfort him by saying that he hoped to save his life. Vincent responded that 'then it has to be done over again'.[44] Minutes before his final breath Vincent told Theo 'this is how I wanted to go'.[45] And as Theo reported to his sister Lies, 'he himself wanted to die'.[46]

Theo, who sat by Vincent's bedside throughout his final hours, was fully convinced that the shooting was suicide. The two brothers knew each other intimately and had confided in each other at difficult times

throughout their lives. It seems almost inconceivable that Vincent, who was then in an extremely weak condition, would have wanted to mislead or even been capable of lying to his brother – and then simply to protect a casual acquaintance from a manslaughter or murder charge. Had he even attempted to lie, surely Theo, who knew him so well, would have suspected that something was amiss.

If Theo had had even the slightest doubt as to whether it was suicide, he would never have let the matter drop. The death of his brother represented an indescribable loss.[47] Had someone else possibly been responsible, Theo would surely have pursued the matter with the utmost vigour. The obvious course of action would have been to consult Dr Gachet, to seek his medico-legal advice. The doctor himself would presumably have been greatly concerned at any suggestion that his friend might have been shot by someone else and that there could be a murderer at large in the village. Dr Gachet would surely have advised that if there was even a remote doubt about whether it was suicide, the authorities should be promptly informed and a post-mortem examination conducted.

EVERYONE AT THE TIME BELIEVED IT WAS SUICIDE
Dr Gachet undoubtedly believed it was suicide. Within a few hours of the shooting he wrote to Theo, warning him that his brother had 'wounded himself'. He chose his words with care, since he wanted to break the news gently and avoid a sudden shock. But in his diary entry, the doctor wrote clearly and succinctly: 'Suicide de Van Gogh' (fig. 5).[48]

The day after the shooting Dr Gachet spent much of the time with Vincent, talking with him and monitoring his condition. Had there been anything about the wound or the trajectory of the bullet to suggest that it had been fired from a distance, he would have surely have taken the matter further. Dr Gachet saw Vincent's corpse just a few hours after his death and had considerable knowledge of gun wounds from his experience during the Franco-Prussian war. He would have been able to inspect the wound carefully and it seems possible that he

actually removed the bullet. Two weeks later, when writing to Theo, he explicitly used the word 'suicide'.[49]

The two policemen who briefly questioned both Vincent and Ravoux also concluded that it was suicide. Bernard recorded the arrival of 'the gendarmes who came to his bed to reproach him for an act for which he was responsible'.[50] Had the police had any lingering suspicion that it might have been murder or manslaughter, then surely they would have continued their inquiries – including interviewing Dr Gachet and Theo.[51] Likewise, the mayor, Caffin, does not appear to have raised questions when the death was registered. Father Tessier must have been convinced it was suicide, since he refused a church service or the use of the hearse.

Vincent's artist friends who attended the funeral accepted his death as suicide. Bernard spoke at length with Theo, Dr Gachet and Ravoux, writing the following day to tell Aurier that Vincent had 'fired a revolver shot at himself'. He added that 'his suicide was absolutely *calculated*' and undertaken with 'total lucidity'.[52] Bernard could hardly have been more explicit. As a close friend, had he had any doubts after speaking with the three key witnesses, he would surely have expressed himself more tentatively in his letter. Signac and Gauguin, although not present at the funeral, also believed it was suicide.[53]

No testimony from Arthur Ravoux survives, although in the 1950s his daughter Adeline (who was only 12 at the time) did recount her memories, presumably based partly on what her father had told her. 'Vincent shot himself', she said.[54] Another witness to the death was Hirschig, who in 1911 recorded what Van Gogh had told him: 'I wounded myself in the field, I fired the pistol'.[55] Although this was 21 years later, the death of a fellow lodger must have been a traumatic event that would stick in his memory.

Immediate newspaper reports give no indication that it was anything other than suicide (fig. 60).[56] Although using different terminology, they all gave similar messages: 'he tried to commit suicide' (*Le Petit Parisien*, *Le Petit Moniteur Universel* and *Le Régional*), 'he discharged a shot' (*La Petite Presse*) and 'the artist... fired a shot'

(*L'Avenir de Pontoise* and *L'Echo Pontoisien*). Discharging or firing a shot could theoretically have been an accident, but the slightly obtuse terminology was presumably because suicide was regarded as sinful. None of the press reports suggest that anyone else was involved.

So all the key people at the time believed it was suicide: Dr Gachet, the innkeeper Ravoux, the gendarme Rigaumont, the mayor Caffin, the priest Tessier, the friend Bernard, six journalists – and, most importantly, Theo. None of them seem to have had the slightest doubt that Vincent had shot himself.

Suicidal behaviour is complex and can rarely be attributed to a single cause. In Van Gogh's case, there may well be no simple reason why he decided to end his life. After his father's death five years earlier, Vincent had said that 'dying is hard, but living is harder still'.[57] As well as worrying about Theo's problems, Vincent had long suffered from a

fig. 60 Newspaper reports on Van Gogh's death. First column: *Le Petit Parisien* (2 August 1890), *Le Petit Moniteur Universel* (3 August 1890), *L'Avenir de Pontoise* (3 August 1890) and *L'Echo Pontoisien* (7 August 1890). Second column: *Le Régional* (7 August 1890). Third column: *La Petite Presse* (18 August 1890)

fig. 61 Extract of letter from Vincent to Theo and Jo, with added phrase '*de la solitude extrême*' (extreme loneliness), *c.*10 July 1890, Van Gogh Museum archive.

sense of rejection by society, which only increased his dependence on his brother. Van Tilborgh and Meedendorp believe that a key factor behind his suicide was 'Vincent's own idea that he had attained no inner contentment'.[58]

Vincent's feeling of loneliness in the final months suggests that this preyed on his mind. In September 1889, while still at the asylum, he had written to Wil to say that since the ear incident and his subsequent illness 'the feeling of loneliness takes hold of me in the fields in such a fearsome way that I hesitate to go out'. The solution, he explained, was that 'it's only in front of the easel while painting that I feel a little of life'.[59] Two weeks before the shooting, he wrote that in depicting the wheatfields (plate 50) of Auvers he was expressing 'sadness, extreme loneliness' (fig. 61).[60] The day after his mortal wounding Theo wrote in grief: 'He was lonely, and sometimes it was more than he could bear.'[61]

CHAPTER EIGHTEEN

THEO'S TRAGEDY

'My dear brother [Theo]… you have your part in the
very production of certain canvases, which even in
calamity retain their calm'[1]

While sorting out Vincent's bloodstained clothes a paper was found tucked into a pocket, neatly folded three times to make it easier to carry.[2] It was the draft of a letter that he never sent. Although not a conventional 'suicide note', we will never know whether Vincent deliberately carried it with him on his final journey in the expectation that it would be discovered – or if it had been inadvertently left in his clothing. At the top of the document Theo added a pencilled inscription: 'The letter he had on him on 27 July, that horrible day.'[3]

Although certainly not directly explaining why Vincent took his own life, the document points to some of the issues that were troubling him four days before he pulled the trigger. Written on 23 July, it was the early draft for a letter that he posted later that day. The final letter that Theo received was rather different – and much more optimistic.[4]

In the unsent version, Vincent confessed that he was writing in a state of 'crisis'. Thanking Theo for his loyal support, he generously said that his brother effectively played a part in the 'very production' of his paintings. Admitting that he had become obsessed with his vocation, he complained about the injustice of works of dead artists selling for large sums, at the expense of living painters.

On discovering this unsent note in Vincent's room Theo must have agonized over the puzzling final sentence: 'I risk my life for my own work and my reason has half foundered in it – very well – but you're not one of the dealers in men; as far as I know and can judge I think you really act with humanity, but what can one do'. [5] The draft finished (with plenty of space remaining on the paper) without a full stop at the end of the last words. It is unclear whether Vincent had fully expressed his thoughts – or if he had been interrupted by something in mid-sentence.

The sent letter included small sketches of four paintings that he was completing that week – more evidence of his extraordinary productivity. On receiving the letter Theo wrote to Jo: 'If only he could find someone to buy a couple from him, but I'm afraid this could still take a very

fig. 62 Final page of a draft letter from Vincent to Theo (found on Vincent's body, with possible bloodstains), 23 July 1890, Van Gogh Museum archive.

long time.'[6] Most tellingly, the letter that was actually sent included an order for paint, evidence that he had no immediate intention of ending his life. The difference in the two documents, written only a few hours apart, emphasizes Vincent's vulnerability to mood swings.

What has received relatively little attention is the presence of several dark brown stains on the paper of the unsent letter which was found in his pocket (fig. 62). In earlier decades Van Gogh specialists might have been reluctant to allude to these, but they could be blood. So far this remains unconfirmed, but more advanced scientific techniques might yield a more conclusive result. The question would then arise as to whether it might be possible to extract a DNA sample. This may be unlikely, but knowledge of Vincent's DNA could perhaps tell us more about his medical condition and whether he suffered from a genetic disorder.

The burial of his dearly beloved brother must have been a profound shock for Theo. It was only two days before the funeral that he had learned about the shooting and rushed to his bedside. A few hours after the funeral a grief-stricken Theo took the train back to Paris, accompanied by his brother-in-law Andries. It must have been painfully difficult to cope without the support of Jo, who had remained behind in the Netherlands with her family. Theo delayed writing to her, unsure how to sensitively explain what had occurred.

It was not until two days after the funeral that he felt he could break the news: 'Fortunately, he was still alive when I reached Auvers & I didn't leave his side until it was all over. I can't write about it all, but shall be with you soon and I'll tell you everything.'[7] Jo was distraught, writing back to Theo: 'How sorry I was for being impatient with him the last time' and 'Had I only been a bit kinder to him when he was with us!'[8]

On 3 August Theo set off for Holland, to brief his mother Anna and Jo's parents on the family tragedy. He took with him a version of Dr Gachet's deathbed portrait (similar to fig. 53) and later wrote how moved Anna had been by the image of her eldest son, whom she had not seen for nearly five years.

On returning to Paris with Jo in mid-August Theo's top priority was to arrange an exhibition of Vincent's work. Theo was convinced that his brother's achievements had not been recognized. He is reported to have said to a friend: 'I should not be surprised if my brother were one of the great geniuses and will one day be compared to someone like Beethoven.'[9] His first move was to approach Paul Durand-Ruel, one of the few dealers who handled the Impressionists. Durand-Ruel came on 20 August to view a selection of paintings.

That same day, in the evening, Dr Gachet arrived for supper, staying until midnight. The doctor had already sent a condolence letter, expressing great admiration for Vincent's artistic imagination: 'Not a day goes by without my looking at his canvases. I always find a new idea in them.'[10] Jo told her parents about the evening: 'Theo was highly determined that we should give him a very good welcome, because he has been so friendly to Vincent and Theo. The impression Vincent's death made on him is striking – he has not experienced anything like that since the death of his wife.'[11]

Despite some initial interest, Durand-Ruel dropped the idea after viewing the paintings and Theo then fell back on a less ambitious plan. He and Jo had changed their minds yet again and decided to go ahead and move into the slightly larger apartment in the same block. Theo proposed mounting a private exhibition of Vincent's work in the new apartment, just before they moved in properly. Helped by Bernard, he brought back the paintings from Père Tanguy's attic. Not surprisingly, Theo was still suffering intense grief. On 22 September Jo's brother Andries wrote to their parents: 'He was very depressed. The loss of Vincent has affected him terribly.'[12]

The apartment exhibition must have been one of the greatest Van Gogh shows ever mounted, with 'a few hundred' pictures hung in the sitting room, the bedroom and a small storage room.[13] Bernard wrote that with the crowded hang 'the apartment looked like a suite of museum rooms'.[14] But once it was ready in late September it was for invited guests only, with just a few friends and art world contacts

attending. As it turned out, Theo and Jo would never move into the new apartment.

Within days of the exhibition being hung, disaster struck. During the evening of 4 October, Jo's 28th birthday, Theo began to show symptoms of nervous exhaustion. His condition deteriorated extremely rapidly. Six days later Andries wrote in desperation to Dr Gachet for advice: 'Everything irritates him… The memory of his brother haunts him… My sister is exhausted and does not know what to do.'[15]

The situation quickly became much, much worse. Incredible though it seems, according to Camille Pissarro, Theo had 'become violent; his beloved wife and child, he wanted to kill them'.[16] No further details are recorded about the incident, but hospitalization was inevitable. Just eight days after Jo's birthday, Theo was taken to a nursing home and two days later moved to the Maison Emile Blanche, a clinic for the mentally ill. He experienced severe delusions and at one point needed seven men to hold him down.

The diagnosis was dementia paralytica, a terrible condition caused by syphilis, which ultimately leads to coma and death.[17] Jo decided to move her husband to the Medical Institution for the Insane in Utrecht. On 17 November he was put into a straitjacket and, accompanied by two attendants, taken to the Netherlands by train.

On arrival Theo was delirious with a fever and had to be strapped into a bed in a padded cell. Eating was difficult and he frequently vomited and was incontinent. He was barely able to walk and speaking became increasingly difficult. In six weeks he had plunged from living a normal life to being in an absolutely wretched state.

It was shocking for Jo to see her husband suddenly reduced to such a condition. A week after his admittance she visited the Utrecht institution, but Theo pushed over a table and chairs, bringing their short meeting to a stormy close. In early December Jo returned and her arrival precipitated further aggression. Theo's medical report recorded on 9 December that 'the man's condition is in all aspects utterly deplorable & at this moment his chances are poor'.[18] When Jo came

once more just before Christmas she was refused admittance because of his condition and her husband immediately destroyed the flowers that she had brought. Three weeks later Jo returned and although Theo was now calmer, he simply ignored her.

Jo's final visit was on 25 January 1891, after the doctors had summoned her, believing the end was near. Theo died that evening at 11.30pm. Although the doctors suggested an autopsy, Jo withheld permission. Four days later Theo was buried in Utrecht's Soestbergen municipal cemetery, after less than two years of married life. Jo planted ivy on the grave, as Theo had done for Vincent, believing that her husband's decaying flesh would nourish the plant (fig. 63).[19, 20]

An important question, but one that has been very little explored, is whether Theo had been aware that he was suffering from terminal syphilis when Vincent returned from Provence in May.[21] Theo had not been well for many months with a cough and other problems, and had frequently seen a number of doctors.

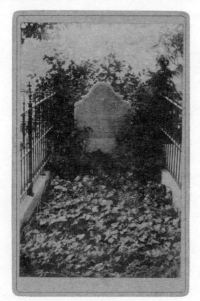

fig. 63 Theo's original grave (1891–1914), Soestbergen Cemetery, Utrecht, photograph, Van Gogh Museum archive

The symptoms of dementia paralytica would normally manifest themselves two or three years before death, so it is very probable that Theo had learned the nature of his condition by May 1890. If so, he would presumably have realized that it was incurable and would inevitably lead to an agonizing conclusion. It was only in the early decades of the 20th century that penicillin provided a straightforward cure.

If Theo knew that he had syphilis, would he have told Vincent? For many years they had shared the intimacies of their lives, including medical problems. It is therefore quite possible that he told Vincent during private discussions when they met briefly in Paris in May or July. Although this too is speculation, Vincent's concern about the imminent loss of his brother might have been one of the factors behind his suicide.

A year after Theo's burial Jo visited her husband's grave in Utrecht. She wrote in her diary: 'A ray of sunlight fell on the roses I had laid there – just such a rose as he gave me when we had been married for one day – It was so quiet and peaceful there; I had wanted to stay and lie there beside him in the cold earth.'[22]

That evening, as she was writing her diary, her thoughts turned to their two-year-old son (fig. 64), who was sleeping nearby: 'The wind howls around the house – I'm glad it's stormy outside, just as it is here inside – but the child lies snug and warm and safe in his cot. Theo, my darling, my own dear husband, I shall take good care of him, look after him well – with all my powers – the thought of you helps me… My darling, my darling – why did you leave us so early?'[23]

fig. 64 Vincent Willem van Gogh (the artist's nephew) aged 2, 1892, photograph by Johannes Hennequin, Amsterdam, Van Gogh Museum archive

PART III

FAME & FORTUNES

BIRTH OF A LEGEND

'In the life of the painter, death may perhaps not be the most difficult thing'[1]

'One of the most moving and extraordinary chapters in the history of modern art' – this is how the art historian Rewald described Van Gogh's spectacular rise to fame.[2] During Vincent's lifetime he managed to sell only one of the thousand paintings he produced.[3] This was an Arles landscape, *The Red Vineyard*, which was bought by the Belgian artist Anna Boch in February 1890.[4]

Vincent's failure to sell means that he is now widely assumed to have remained virtually unknown during his lifetime. But this is not entirely true, at least in his final years. He exhibited at the progressive Société des Artistes Indépendants in Paris: three paintings in 1888, two in 1889 and ten in March 1890. In January 1890 he also showed eight works at the Brussels exhibition of Les Vingt, a similar group in Belgium.

Van Gogh's work is cited in reviews in more than 20 identified newspapers and journals in his last seven months, a record that would delight most up-and-coming artists today.[5] Although many mentions were only a sentence or two, Aurier had penned an enthusiastic six-page critique in the January 1890 issue of *Mercure de France* in which he concluded that Van Gogh is both 'too simple and too subtle' – but he is understood by 'his brothers, the true artists'.[6]

Surprisingly, very few of these articles are mentioned in the brothers' correspondence, so Vincent may well have been unaware of many of them. Vincent also sadly missed the opportunity to see any of the four major exhibitions in which his work featured, since he was in Provence. He therefore never received the encouragement and gratification of viewing his pictures hanging alongside those of his contemporaries.

Van Gogh's tragic death resulted in at least nine obituary notices (as well as seven news reports of his suicide).[7] The condolence letters sent to Theo also demonstrate the respect that he had won from his colleagues. Camille Pissarro described Vincent as representing 'the spirit of an artist', with his death being 'deeply felt by the younger generation'. Monet wrote about the 'terrible loss'. Toulouse-Lautrec recalled 'what a friend he was to me and how eager he was to demonstrate his affection'.[8]

fig. 65 Emile Bernard, portrait of Van Gogh, after a 1887 self-portrait, cover of *Les Hommes d'Aujourd'hui*, July 1891

After Theo's death most loyal friends and colleagues rallied around to promote Vincent's work. Bernard, who had hung the paintings in Theo's apartment, was the greatest supporter. In 1891 he wrote and illustrated a short biographical account for *Les Hommes d'Aujourd'hui* (fig. 65) and a tribute in the Belgian journal *La Plume*.[9] The following year he organized Van Gogh's first one-man exhibition for a dealer, a modest show of 16 works at the Parisian gallery of Le

Barc de Bouteville. Then in 1893 he began to publish what turned out to be a series of thirteen monthly extracts from Van Gogh's letters in *Mercure de France*. Bernard moved to Cairo later that year, staying there until 1904, but after his return he assembled all the correspondence from his friend, which came out in book form in 1911 as *Lettres de Vincent van Gogh*.[10]

fig. 66 Johan Cohen Gosschalk, *Portrait of Jo Bonger*, c.1905, chalk on paper, 45 x 34 cm, Drents Museum, Assen

Gauguin's contribution, however, was very unhelpful. To Theo, he wrote in a condolence note that Vincent was 'a sincere friend… an artist a rare thing in our epoch'.[11] But to Bernard he took a very different line. On hearing news of Vincent's demise, he wrote: 'Sad though this death may be, I am not very grieved. I knew it was coming and I knew how the poor fellow suffered in his struggles with madness. To die at this time is a great happiness for him, for it puts an end to his suffering.'[12]

Two months later Gauguin wrote again to Bernard, saying that although both liking Van Gogh's work, they should not publicly acknowledge it: 'It's completely out of place to remember Vincent and his madness when his brother is in the same situation! Many people say that our painting is madness. That does us harm without doing any good to Vincent.' He opposed Bernard's decision to try to arrange another exhibition, 'it's IDIOTIC.'[13]

By far the most tireless and successful promoter of Vincent's work was Theo's widow Jo (figs. 66 and 67). In her diary, which has only

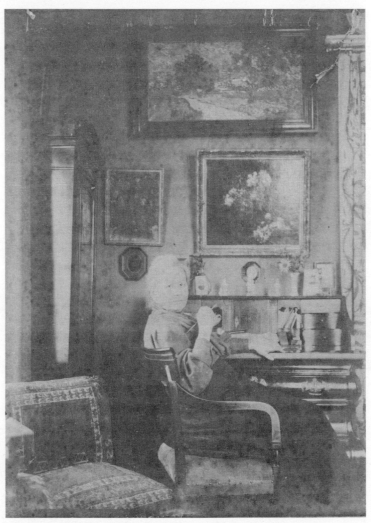

fig. 67 Jo Bonger at her desk, 77 Koninginneweg, Amsterdam, 1910s, photograph, 12 x 9 cm, Van Gogh Museum archive

recently been made available for research, she looked back on married life: 'For a year and a half I was the happiest woman on earth; it was a long, beautiful, wonderful dream, the most beautiful one *can* dream. And following it was all that untold suffering that I cannot touch upon.'[14]

On the first anniversary of Vincent's death, she felt totally bereft. Jo went out for a walk late on what was a dark, rainy, windy evening, recording that 'I saw the lights in other people's houses and I felt so dreadfully lonely and abandoned – how

fig. 68 Poster for Van Gogh exhibition, Stedelijk Museum, Amsterdam, July 1905

often must he have felt like that!' On Theo's death earlier in the year, he had left her two legacies: 'As well as the child, he has left me another task – Vincent's work – getting it seen and appreciated as much as possible – keeping all the treasures that Theo and Vincent had collected intact for the child – that, too, is my work.'[15] It was a labour of love that would dominate the rest of her life.

At Theo's death, Jo inherited around 400 paintings and many hundreds of drawings, representing nearly half of Vincent's surviving oeuvre. In 1891 a group of 200 of the paintings was valued at 2,000 guilders[16], then equivalent to £165. In today's money, this would represent about £21,000, or around £100 for each picture.

Jo realized the importance of lending individual works and helping to organize exhibitions in order to win recognition for Van Gogh. The first show with pictures entirely from her collection was held in 1892 at Amsterdam's Kunstzaal Panorama, with just over 100 works. By far the

most important exhibition she organized was at the Stedelijk Museum in Amsterdam in 1905 (fig. 68). There were 474 works, making it the largest exhibition ever held on the artist right up to the present day. It included 29 paintings from Auvers, nearly 40% of those from this short period. Vincent can never have dreamt that he would achieve such a retrospective in his country's leading museum of contemporary art only 15 years after his death.

During the 1890s Jo also began to sell works. This provided much needed income for herself and her young son, but the gradual dispersion of paintings played a key role in developing Van Gogh's reputation. Most of the pictures were sold through four progressive dealers – Paul Cassirer (Berlin), Ambroise Vollard and Bernheim Jeune (both Paris) and Johannes de Bois (The Hague). By the time of the 1905 retrospective Jo had sold 99 paintings and drawings; she had sold a further 140 at the time of her death in 1925.[17]

A sure sign of recognition came when Van Gogh began to enter public collections. The first two museum pictures were, by chance, acquired in the same month, March 1903 – and both happened to be Auvers paintings.[18] Vienna's Secession group purchased *The Plain of Auvers* (plate 40) for the Belvedere gallery. *Road in Auvers* (plate 47) was bought for Helsinki's Ateneum Art Museum, part of the Finnish National Gallery.

The most important private collector of Van Gogh's work would soon be Helene Kröller-Müller, the daughter of a wealthy German industrialist who married a Dutch businessman. Buying her first Van Gogh in 1908, she had acquired no fewer than 90 paintings and 180 drawings by 1929.[19] Kröller-Müller ended up concentrating on the artist's Dutch period, so only four works date from Auvers.[20] She later set up a museum of modern art, which was opened in 1938 in a remote heathland area in the eastern Netherlands, near Otterlo. Kröller-Müller died the following year and her body was laid out among her favourite Van Goghs (fig. 69).

The publication of Vincent's letters would play a crucial role in the development of his growing fame. Jo had initially studied them to bring her closer to her lost husband and her brother-in-law. She wrote in her

diary in 1892: 'I live utterly with Theo and Vincent in thought, oh, how infinitely fine and tender and loving that relationship was! How they felt for each other – how they understood each other!' By this time only a few articles had been published on Vincent, so she ended her diary entry with a question: 'Who'll write that book about Vincent?'[21]

Although Bernard and others had published small groups of letters over the years, Jo waited until 1914 before releasing a comprehensive three-volume compilation in their original Dutch and French languages.[22] She explained the delay by saying that it would have been 'an injustice to Vincent to create interest in his personality' before 'the work to which he gave his life was recognized and appreciated'.[23]

The first biographers had already made their way to Auvers on the trail to uncover the Van Gogh story. As early as 1900 the French critic Théodore Duret called on Dr Gachet to view the paintings, although his biography on the artist only appeared 16 years later.[24] In 1903 an even more influential art historian, Julius Meier-Graefe, visited the

fig. 69 Helene Kröller-Müller's body laid out in her museum, under her Van Goghs, December 1939, Kröller-Müller Museum, Otterlo

doctor, lunching at the table where Van Gogh had portrayed Gachet. The following year Meier-Graefe included a chapter on the artist in his innovative study of modern art.[25] His later highly successful biography of Van Gogh was published in German in 1921 and translated into English the following year.[26] Meier-Graefe presented a melodramatic view of Vincent's life, stressing his role as an unrecognized genius and setting the tone for countless books by later authors. If anyone was responsible for initiating the legends about Van Gogh, it was this German writer.

In the years up to the First World War, Van Gogh's work played a starring role in a series of remarkable exhibitions, establishing him as a driving force behind the development of Modernism in art. In 1910 Roger Fry held a pathbreaking show at London's Grafton Galleries, which featured nearly 30 Van Goghs, including the first version of *Portrait of Dr Gachet* (plate 18) and *Wheatfield with Crows* (plate 45). Fry could not decide on a title for the exhibition and at the last minute hit upon 'Manet and the Post-Impressionists', inventing the term, based on the fact that his selected artists came after Impressionism. This gave art history the word Post-Impressionism.

Two years later, in Cologne, a larger survey of modern art was staged, organized by the Sonderbund, a union of artists and enthusiasts. Van Gogh was even more of a key figure, represented by no fewer than 130 paintings and drawings. This show played a major role in inspiring German collectors and Expressionist artists. Up until around 1900 the majority of Van Goghs were owned by French and Dutch collectors, but by 1914 German private owners had acquired 120 paintings – compared with just 3 in Britain, 4 in America and 39 in all the rest of the world.[27]

In 1913 New York's International Exhibition of Modern Art, known as the Armory Show, introduced Van Gogh to an American audience. The 19 Van Goghs included major works that made a deep impression on avant-garde US artists and collectors. By the eve of the First World War, Van Gogh was achieving international renown, just under 25 years after his death in Auvers.

A tangible sign of Van Gogh's growing status came when his paintings began to be displayed in gilded frames. He himself had wanted his pictures to be presented in plain wooden frames, but by the early 1900s dealers were attempting to make their Van Goghs more marketable by surrounding them in gold – with collectors soon following suit. Gachet Jr was dismissive of this trend, writing to Jo: 'It is an act of moral barbarism to put golden frames around Vincent's canvases, that simple, humble man.'[28]

FATHER AND SON

'The doctor here has been very kind to me... He has
two children, a girl of 19 and a boy of 16'[1]

Few visitors to Auvers realize that Vincent was not originally buried in the spot where he now lies. The grave was in another part of the cemetery and his remains had to be moved in 1905, when the 15-year rental period for the first plot was due to end.[2] The simple headstone, erected a few days after the funeral, carried the incised words 'Ici repose Vincent van Gogh 1853–1890'. 'Here rests' was particularly poignant, considering Vincent's unsuccessful quest for peace of mind during his lifetime.

Until recently no images were known of Van Gogh's first grave, but a picture has recently surfaced (fig. 70).[3] Painted by Dr Gachet's art student Blanche Derousse, the sepia-coloured watercolour is dominated by shrubbery. A yucca almost hides the stone and a pair of thujas towers above at the side. Although it is unusual for such substantial plants to be grown over a grave, there was more space available in the Auvers cemetery in the 1890s than in later years and the idea was to surround the artist with his beloved nature.

Right from the start Dr Gachet assumed responsibility for the care of Vincent's grave. As soon as the headstone had been laid he planted sunflowers on the plot, a tradition that he and his son maintained right up until the 1950s. The yucca and thujas on the first grave are believed

to have been transplanted from his own flower beds and examples of both shrubs feature prominently in Van Gogh's painting *Dr Gachet's Garden* (plate 4).

As the 1905 deadline for the end of the lease approached Dr Gachet wrote to Jo, suggesting that a permanent grave should be arranged.[4] If it was a double space, then there would be an opportunity to move Theo's remains from Utrecht, to lie beside those of his brother. Although Jo disliked the idea of disturbing Vincent's bones, if it meant that they could be accompanied by those of her husband, this seemed the best solution. Dr Gachet was authorized to proceed.[5]

Jo travelled to Auvers on 9 June 1905, her first trip there for fifteen years (she and Theo had visited the cemetery together in late August or September 1890).[6] It must have been a gruelling experience as she, along with Dr Gachet and his son, watched as the gravedigger reached Vincent's rotted coffin. Gachet Jr later described how the thuja had 'spread its roots' around his torso, 'penetrating the cavities between the ribs'.[7] By chance, this was just where the bullet had entered his chest. The grave-digger had to disentangle the roots from around the rib cage.

The cranium was then exposed, giving Dr Gachet the chance to observe 'the huge skull, the cheekbones and the arch of the eyebrows'. His son commented that 'unknowingly, we reenacted the scene of the gravediggers from *Hamlet*'. The doctor then handed the skull to Gachet Jr, who gently placed it at the end of the new coffin. For Jo's sake, the exhumation needed to be completed swiftly, although Dr Gachet had wanted to 'study the ensemble, and particularly the skull'.[8]

And what about the bullet? It may well have been removed from Vincent's body before the funeral, but if it had remained in his chest, then it would very likely have become dislodged when the thuja root was untangled from the ribs. Gachet Jr does not mention the bullet in his explicit description of the exhumation – this suggests, although it does not prove, that the projectile may indeed have been extracted before the 1890 burial. As for the uprooted thuja, tradition has it that

fig. 70 Blanche Derousse, *Van Gogh's First Grave* (1890-1905), watercolour on paper, 1900-11, Archive E.W. Kornfeld, Bern

fig. 71 Gustave Coquiot, *Graves of the Van Gogh brothers*, 11 December 1921, watercolour, Van Gogh Museum archive

part of the bush was brought back to the Gachet residence, where it had originally started life. Replanted near the front door, it has now grown into a large tree and continues to thrive.

With the move of Vincent's remains, the Gachets suggested incorporating a bronze medallion in a gravestone for the two brothers.[9] For this purpose Gachet Jr produced a sculpted relief, depicting the head of the artist with determined-looking features (fig. 72). Ultimately it was never installed, because Jo felt that a simple double grave with Vincent's original stone and another similar one for Theo would be most appropriate.

Before Dr Gachet's death, his son made a solemn promise that he would continue to care for the Van Gogh grave (fig. 73): 'The hands that had held the skull of Vincent, were they not the most appropriate for this responsibility?'[10] He was therefore ready to assist when Jo wanted to proceed with the transfer of Theo's remains to Auvers. There was, however, a delay due to yet another tragedy that had befallen Jo. In 1901 she remarried, to the Amsterdam artist Johan Cohen Gosschalk. He soon fell ill, being bedridden for his last months and dying in 1912. Jo finally decided to go ahead with moving her first husband's remains

in 1914, fortunately a few months before the outbreak of war. The relatively recent funeral of her second husband must have made the reburial of Theo's bones even more distressing.

Theo's remains were exhumed in Utrecht. Meanwhile, Gachet Jr (fig. 75) arranged for the carving of a matching headstone to be placed next to that of Vincent, inscribed with the years 1857–1891 (fig. 71 [11]). Jo then returned to Auvers for another emotional occasion, this time accompanied by her son, Vincent Willem. She remained eternally grateful for the support she received: 'Dr. Gachet and his children continued to honour Vincent's memory with rare piety, which became a form of worship, touching in its simplicity and sincerity.'[12]

The Gachets not only cared for the grave, but had also served as a repository of memories about Van Gogh. Sending his condolences two weeks after the funeral, the doctor told Theo that he had been 'thinking about your brother the whole time… the more I think about it, the more I regard Vincent as a *giant*'.[13] Dr Gachet also revealed that he had 'started writing down the things I told you', referring to his reminiscences on the day of the funeral.

fig. 72 Louis van Ryssel (Paul Gachet Jr),
Medallion of Van Gogh, cast in 1905, bronze,
40 cm diameter, Musée d'Orsay, Paris

Theo, pleased with Dr Gachet's interest, had advised him: 'If you have continued your study of him, you really mustn't leave it in a drawer, where only a privileged few would know of it.'[14] Dr Gachet never went ahead with an immediate tribute, but instead developed ambitious plans to produce a comprehensive account of Vincent's life and work. It was not intended to be a published book, but a single manuscript, copied

fig. 73 Paul Gachet Jr at the graves
of Vincent and Theo, 1954,
photograph by Maurice Jarnoux

out in calligraphy by his son and profusely illustrated with watercolour
reproductions of the paintings in his collection.[15]

Despite this grandiose plan, all that now seems to survive of
Dr Gachet's writings on Van Gogh are a few lines recorded on 17
September 1890, mainly devoted to the relatively trivial matter of
his eating habits. Vincent was 'sober and even frugal, looking for
simplicity in his diet', preferring fruit and vegetables and enjoying
bread, particularly with olives. He drank wine, some beer and a lot
of coffee. At times he ate quickly, as if to get rid of something slightly
unpleasant. 'Sometimes, he spoke a lot', but at other times 'not at all'.
When not talking, his eye might 'indicate an inner anger'. Van Gogh
was pained when he heard nonsensical chatter, withdrawing into
silence.[16]

Although Dr Gachet would live for a further 19 years, he never
completed his manuscript. As Theo had feared, the doctor's work was
indeed abandoned 'in a drawer', with virtually all his notes eventually
disappearing.[17] Considering that he was erudite and a friend of
numerous writers[18], it is surprising that he failed to compile a record
of his encounter with Van Gogh. As a doctor (fig. 74), he presumably

fig. 74 Louis van Ryssel (Paul Gachet Jr), *Portrait of Dr Paul Gachet*, 1903,
watercolour and pencil on paper, 64 x 48 cm, Musée d'Orsay, Paris

kept contemporaneous medical notes, so it is a great loss that these too have been lost.[19]

Today Dr Gachet is best known as an art collector. It is often assumed that he owned just the eight Van Gogh paintings that now hang at the Musée d'Orsay in Paris – but in fact he possessed well over three times that number. He originally had 26 Van Gogh paintings, 14 drawings, 3 prints and a letter with a drawing.[20]

So how did Dr Gachet amass this treasure trove? The sheer number has understandably led to suspicions of underhand

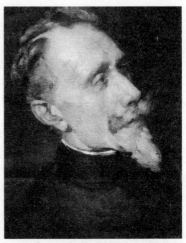

fig. 75 Emile Bernard, *Portrait of Paul Gachet Jr*, 1926, oil on canvas, 40 x 32 cm, Musée d'Orsay, Paris

acquisitions, sparked off by an interview with Adeline Ravoux, the innkeeper's daughter. In 1955 she claimed that immediately after the funeral the doctor had ordered his son to gather up the paintings that had been displayed around the coffin in the auberge. 'Roll them, Coco', he is said to have instructed Gachet Jr, calling him by a childhood nickname.[21] But this story seems unlikely, or at least the fact that they were furled. Most of the paintings were nailed to wooden stretchers and some would not have properly dried, so it would have been impossible to roll them up.

Vincent is known to have given at least three paintings to the doctor: *Dr Gachet's Garden* (plate 4), *Marguerite Gachet in the Garden* (fig. 28) and the second version of his portrait (plate 19).[22] Theo, who was very grateful for Dr Gachet's medical assistance and support, almost certainly gave him several more, either on the day of the funeral or during the doctor's visit to his Paris apartment on 20 August.[23]

These gifts would most likely have included works with a close personal link to the doctor, such as *Marguerite Gachet at the Piano*

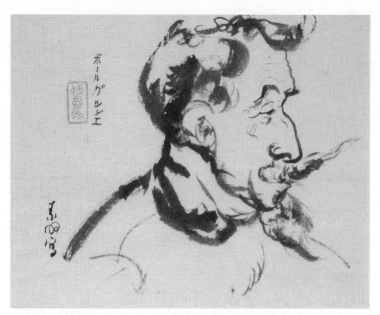

fig. 76 Yûki Somei, *Portrait of Paul Gachet Jr*, 1924, ink on paper,
24 x 35 cm, Musée Guimet, Paris

(plate 30) and *Cows* (after an etching made by Dr Gachet).[24] Theo also
gave the doctor's son *Japanese Vase with Roses* (fig. 38) to thank him
for staying with Vincent on the night of the shooting.[25] However, it
seems unlikely that Theo gave Dr Gachet all the works, so some were
probably bought, perhaps from Père Tanguy, whom the doctor had
known for well over a decade.[26] In the early 1890s prices remained
very low, so purchases would hardly have dented the doctor's budget.
Acquisitions from Tanguy would also help explain why nearly half of
Dr Gachet's Van Gogh paintings date from his periods in Paris and
Provence, predating his arrival in Auvers.[27]

Dr Gachet lived until the age of 80, dying of a heart attack in his
Auvers house in 1909. His body was taken to Paris for burial in Père
Lachaise cemetery. There is no evidence of any autopsy, perhaps
because by this time the Société d'Autopsie Mutuelle had passed its

heyday and faced a declining membership. Jo wrote an emotional condolence letter: 'Never, never will we forget, my son and myself, what he did for the memory of Vincent.'[28]

Gachet Jr (fig. 75) and his sister Marguerite continued to live in the Auvers house. In 1911 Gachet Jr married Emilienne Bazire, the former housekeeper of the doctor's collector friend Murer. They had no children and marriage does not appear to have greatly changed his way of life, while his sister never married. Gachet Jr and the two women led a simple existence in the family home, which remained very much as it had been in Van Gogh's time (fig. 77). Electricity and running water were not introduced until the 1950s and they never had a telephone.[29] Gachet Jr is said to have used his father's clothes until the end of his own life, including the coat that the doctor had worn during the Franco-Prussian war in 1870.[30]

Although Gachet Jr had briefly studied agricultural engineering in 1895–98, he never worked and neither did his sister. Their lifestyle was modest, they inherited the house and what money they needed came from the occasional sale of an artwork. Along with the Van Goghs, they owned nearly 50 paintings by Cézanne and Pissarro, as well as numerous other works. At today's prices the doctor's collection

fig. 77 Paul Gachet Jr in his salon, c.1935–40, Bignou album, Musée d'Orsay, Paris

plate 25 *Plain near Auvers*, July 1890, oil on canvas, 74 x 92 cm,
Neue Pinakothek, Bayerische Staatsgemäldesammlungen, Munich (F782)

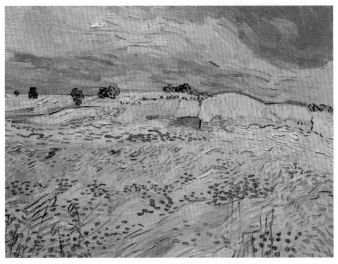

plate 26 *The Fields*, July 1890, oil on canvas, 50 x 65 cm,
private collection (F761)

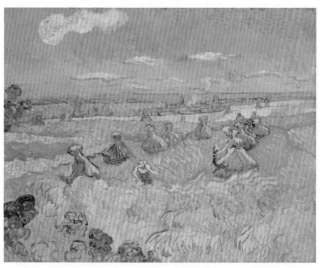

plate 27 *Wheatfields with Reaper*, July 1890, oil on canvas, 74 x 93 cm,
Toledo Museum of Art, Ohio (F559)

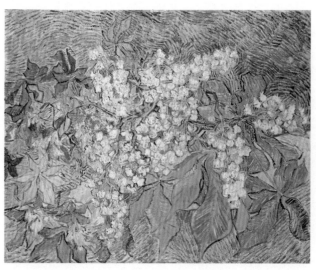

plate 28 *Blossoming Chestnut Branches*, May 1890, oil on canvas, 73 x 92 cm,
Bührle Collection, Zurich, on a long-term loan to Kunsthaus Zurich (F820)

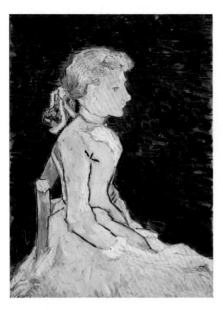

plate 29 *Portrait of Adeline Ravoux*
(second version for Theo), June 1890,
oil on canvas, 67 x 55 cm,
private collection (F769)

plate 30 *Marguerite Gachet at the Piano*,
June 1890, oil on canvas, 102 x 50 cm,
Kunstmuseum Basel (F772)

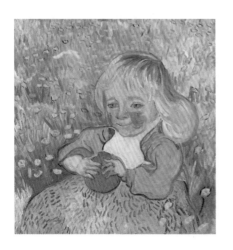

plate 31 *Child with Orange*, June-
July 1890, oil on canvas, 50 x 51 cm,
private collection (F785)

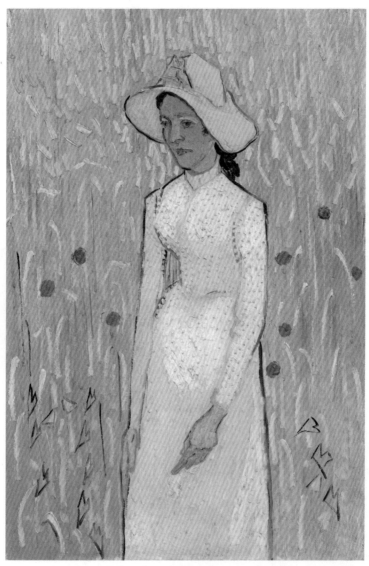

plate 32 *Girl in White*, July 1890, oil on canvas, 67 x 46 cm,
National Gallery of Art, Washington, DC (F788)

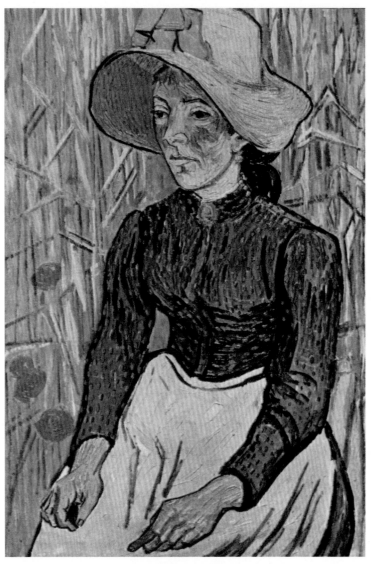

plate 33 *Girl against a Background of Wheat*, June 1890, oil on canvas, 92 x 73 cm,
Steven Cohen, Greenwich, Connecticut (F774)

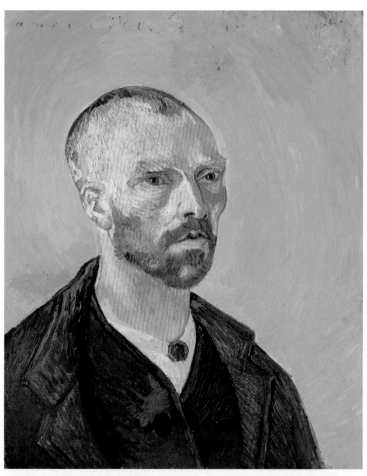

plate 34 *Self-portrait for Gauguin*, September 1888, oil on canvas, 62 x 45 cm, Harvard Art Museums/Fogg Art Museum, Cambridge, Massachusetts (F476)

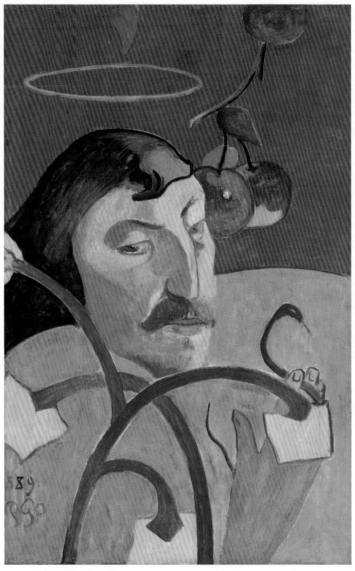

plate 35 Paul Gauguin, *Self-portrait with Halo*, December 1889, oil on panel,
79 x 51 cm, National Gallery of Art, Washington, DC

plate 36 *Self-portrait with bandaged Ear and Pipe*, January 1889, oil on canvas,
51 x 45 cm, private collection (F529)

plate 37 *Wheatfield under Thunderclouds*, July 1890, oil on canvas, 50 x 101 cm,
Van Gogh Museum, Amsterdam (Vincent van Gogh Foundation) (F778)

plate 38 *Landscape at Twilight*, June 1890, oil on canvas, 50 x 101 cm,
Van Gogh Museum, Amsterdam (Vincent van Gogh Foundation) (F770)

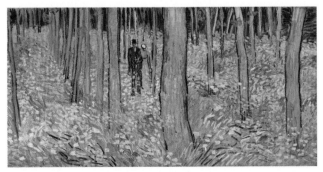

plate 39 *Undergrowth with two Figures*, June 1890, oil on canvas, 50 x 100 cm,
Cincinnati Art Museum (F773)

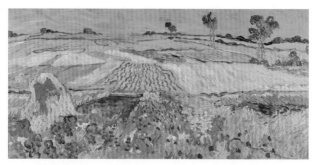

plate 40 *The Plain of Auvers*, June 1890, oil on canvas, 50 x 101 cm,
Osterreichische Galerie Belvedere, Vienna (F775)

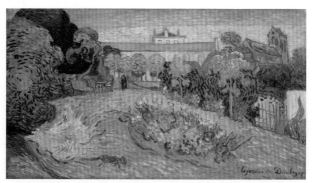

plate 41 *Daubigny's Garden* (first version), July 1890, oil on canvas, 50 x 101 cm,
Staechelin collection, on long-term loan to Fondation Beyeler, Riehen/Basel (F777)

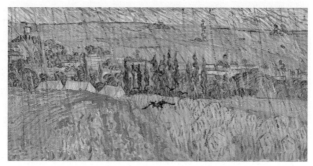

plate 42 *Landscape at Auvers in the Rain*, July 1890, oil on canvas, 50 x 100cm,
National Museum Wales, Cardiff (F811)

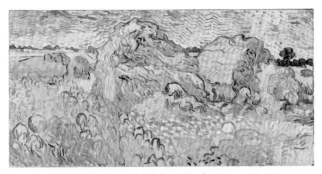

plate 43 *Field with Wheatstacks*, July 1890, oil on canvas, 50 x 100 cm,
Fondation Beyeler, Riehen/Basel (F809)

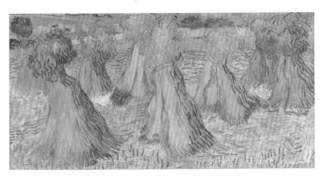

plate 44 *Sheaves of Wheat*, July 1890, oil on canvas, 51 x 102 cm,
Dallas Museum of Art (F771)

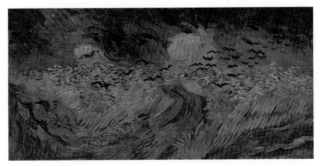

plate 45 *Wheatfield with Crows*, July 1890, oil on canvas, 51 x 103 cm,
Van Gogh Museum, Amsterdam (Vincent van Gogh Foundation) (F779)

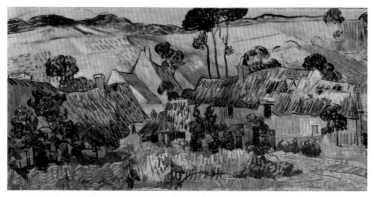

plate 46 *Farms near Auvers*, July 1890, oil on canvas, 50 x 100 cm,
Tate, London, on a long-term loan to National Gallery (F793)

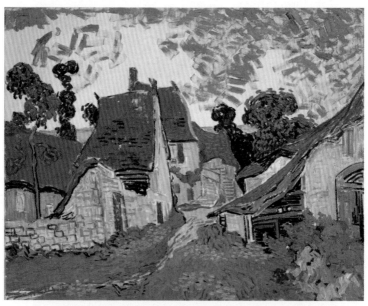

plate 47 *Road in Auvers*, May–June 1890, oil on canvas, 74 x 93 cm,
Ateneum Art Museum/Finnish National Gallery, Helsinki (F802)

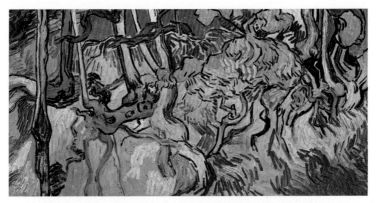

plate 48 *Tree Roots*, July 1890, oil on canvas, 50 x 100 cm, Van Gogh Museum, Amsterdam (Vincent van Gogh Foundation) (F816)

plate 49 *Postcard of Rue Daubigny*, showing site of Tree Roots and with part of the painting superimposed, c. 1905–10, Arthénon, Strasbourg

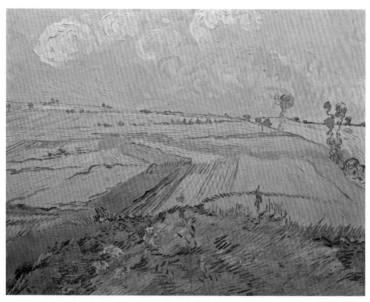

plate 50 *Wheatfields after the Rain*, July 1890, oil on canvas, 73 x 92 cm,
Carnegie Museum of Art, Pittsburgh (F781)

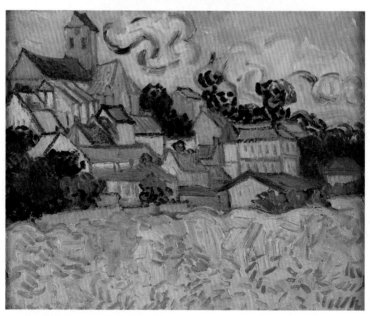

plate 51 Vincent van Gogh, *View of Auvers*, May-June 1890, oil on canvas, 34 x 42 cm,
Rhode Island School of Design Museum, Providence (F800)

plate 52 Book covers with fake Van Gogh selfportraits: Louis Piérard, *La Vie tragique de Vincent van Gogh*, Correa, Paris, 1946 ; Irving Stone, *Lust for Life: The Novel of Vincent van Gogh*, Grosset & Dunlap, New York, 1934; Heinz Lieser, *Vincent van Gogh, As seen by Himself*, Bayer, Leverkusen Germany, 1963; Bogomila Welsh-Ovcharov, *Vincent van Gogh: The Lost Arles Sketchbook*, Abrams, New York, 2016.

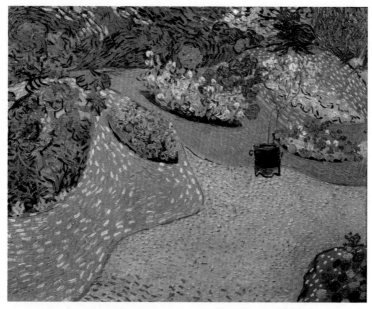

plate 53 *Garden at Auvers*, June 1890, oil on canvas,
64 x 80 cm, private collection, France (F814)

would be worth at least a billion pounds. Villagers periodically spotted Gachet Jr setting off for Paris with a package, on his way to see one of the dealers. 'When he travelled across Paris, a priceless painting under his arm, he took the metro', recalled his neighbour Christine Garnier.[31] He sold off the Van Gogh paintings gradually, from around 1912 up until 1950.[32]

While in his early 20s Gachet Jr had set out to become an artist. Working in a wide variety of media – drawing, etching, painting and sculpture – he was inspired by his father's two favourite masters, Cézanne and Van Gogh. From 1903–10 he achieved limited success, exhibiting several times at the Société des Artistes Indépendants in Paris. But he remained an amateur, never forging his own particular style, and he lost enthusiasm after the death of his father and the disruption of the First World War.

Gachet Jr then turned to art history, compiling a detailed catalogue of the major artists in his father's collection. By 1928 the task was almost complete, with separate volumes on Pissarro and other Impressionists, Cézanne, Amand Gautier and two on Van Gogh. Produced as typescripts for his own personal use, they remained unpublished.[33]

Until the late 1940s the family collection was shrouded in mystery. Gachet Jr refused to allow his Van Goghs to be photographed and very few art historians were admitted to his house. Among villagers he was regarded as highly secretive and known as 'the hermit of Auvers'.[34] His gate was kept locked (fig. 78) and on the

fig. 78 Paul Gachet Jr looking out from his gate, 1954, photograph by Maurice Jarnoux

steps leading up to the house was the blunt notice '*ne reçoit pas*' (no callers).

Gachet Jr's privacy was partly for security, because of the priceless collection (which he protected at night by keeping a revolver on his bedside table).[35] But more importantly, secrecy was deeply ingrained in his character – he was an extremely private person. There was one notable exception: he became fascinated with distant Japan and eventually welcomed hundreds of Japanese artists and art-lovers who flocked to see his Van Goghs

fig. 79 Marguerite Gachet at the piano, aged 77, 1947

(fig. 76).[36, 37] Perhaps the fact that they came from so far away and were transients meant that he never perceived them as a threat to his undisturbed life.

The Van Goghs hanging in the house must have been an amazing sight. The *Self-portrait with Swirling Background* (plate 1) was in the salon and *Portrait of Dr Gachet* (plate 19) hung just outside the kitchen, but most of the paintings were tucked away upstairs in the very private rooms.[38] One privileged relative who visited in 1891 described it as 'the little Louvre'.[39] With the exception of the paintings owned by the Schuffenecker brothers (mostly dispersed in the very early 1900s) and those later acquired by Kröller-Müller, the Gachets held the world's largest private collection of Van Gogh paintings outside the artist's family.[40]

Marguerite Gachet at the Piano (plate 30) hung, appropriately, in the sitter's bedroom, displayed in a white frame between two large Japanese prints of female figures.[41] In 1934 the Gachets (fig. 79 [42]) made the astonishing decision to sell this exceptionally personal painting to the Kunstmuseum Basel.[43] For more than 40 years it had never left the house and there were dozens of other works they could have sold.

Although it may come as a surprise, it has been suggested that Van Gogh and Marguerite had romantic feelings, but were prevented from having an affair by Dr Gachet. This idea was proposed by the Van Gogh specialist Marc Tralbaut in 1969, who described it as 'an old rumour'. He quoted Madame Liberge, a local woman who claimed to have been a childhood friend of Marguerite. The then elderly woman said that the doctor's daughter 'never admitted that she had fallen in love with the painter', but 'her whole attitude and everything she told me betrayed her true feelings'.[44] This seems to represent flimsy evidence of a thwarted affair.[45]

Would Marguerite, who had just celebrated her 21st birthday, really have been attracted to a socially awkward 37-year-old man who had mutilated his ear and had just emerged from a year in a mental asylum? Even if Vincent had been attracted by her youthful beauty, surely he would have realized that any signs of his intentions would be spotted and rebuffed by Dr Gachet, with whom he wished to maintain good relations? And if the doctor had suspected anything, would he ever have allowed his daughter to pose? Marguerite went on to live a reclusive life, never marrying, and there is little indication that she was ever searching for a partner. Finally, if Van Gogh had been so important in her life, why at the age of 65 did she agree to the unnecessary sale of a portrait that had graced her bedroom

fig. 80 Souvenirs of Van Gogh
(including palette, paint tubes, Goncourt book,
Japanese print, Japanese vase, etc), c.1953

wall for her entire adult years? Madame Liberge's tale, although intriguing, sounds extremely unlikely.

With the outbreak of the Second World War the collection came under threat. Gachet Jr was understandably concerned about German bombs (some later hit the nearby town of Pontoise) and the subsequent occupation of France in 1940. He took the Van Goghs off his walls and hid them in a secret void which had been carved into the cliff at the back of the house.

By the end of the war old age was creeping up on the Gachet household. Gachet Jr's wife Emilienne died in 1948 and his sister Marguerite the following year. Although Gachet Jr remained in good health, these tragic losses led him to reconsider the future of the collection. Consulting with his fragile sister, just months before her death, they took the generous decision to donate works to the French state. This was arranged with the Louvre's curator René Huyghe and his successor Germain Bazin.

In 1949 Gachet Jr and his sister gave their two greatest Van Goghs to the Louvre, which then displayed modern paintings in the nearby Jeu de Paume gallery. These were the *Self-portrait with Swirling Background* (plate 1) and *Portrait of Dr Gachet* (plate 19), along with a self-portrait by Guillaumin. Two years later Gachet Jr offered *Church at Auvers* (plate 20), although on this occasion he received part of its value as a payment.[46] He also gave three paintings by Cézanne, two by Pissarro and others by Monet, Renoir and Sisley. In 1954 he made his final donation to the Louvre, which included five Van Goghs: *Dr Gachet's Garden* (plate 4), *Marguerite Gachet in the Garden* (fig. 28), *Japanese Vase with Roses* (fig. 38), *Cottages at Cordeville* (plate 6) and *Two Children*.[47] At the same time he also gave four paintings by Cézanne and one by Pissarro. In 1950 he had donated *Cows*, Van Gogh's painted version of a print after a picture in Lille, to the museum in that city. These donations doubled the number of Van Goghs in French museums.

A varied assortment of lesser items were also given to various museums. These included: the cap Dr Gachet wore in the Van Gogh

portrait, a collection of letters from female patients at the Salpêtrière asylum, the family piano, vases selected by Cézanne and Van Gogh for flower still lifes, electromagnetic medical equipment, the palette used by Van Gogh (fig. 80 [48]), several dresses from Dr Gachet's wife, Japanese prints that came from Van Gogh's room at the auberge and the plaster death heads of guillotined criminals.[49]

For Gachet Jr the donations seemed a sensible solution, since he had no close heirs, his financial needs remained relatively modest and gifts to museums honoured his father. He could have left the works as a bequest, but chose instead to offer them during his lifetime. Gachet Jr had suffered scorn for hiding the collection and there were even suggestions that some of his paintings might be fakes, so he may have hoped that his generosity would clear his name and win some well-deserved praise.

Gachet Jr's benevolence provided the impetus for a highly successful exhibition on *Van Gogh et les Peintres d'Auvers-sur-Oise*, held in the winter of 1954–55 in the Orangerie gallery in the Tuileries gardens in Paris. All his donations were exhibited, making the Gachet collection internationally famous. The Louvre paintings later passed to the Musée d'Orsay in 1986, when the museum of the 19th-century was opened.

With the donations Gachet Jr also broke his lifetime's silence about the family's links with Van Gogh and the story of the collection.[50] Between 1952 and 1954 he wrote a series of booklets, most importantly *Souvenirs de Cézanne et de Van Gogh à Auvers*.[51] In 1956 he he went on to publish a book, *Deux Amis des Impressionnistes: Le Docteur Gachet et Murer*, focussing on his father's artistic links, and this was followed by a collection of correspondence, *Lettres Impressionnistes au Dr Gachet et à Murer*.[52]

When Gachet Jr died in 1962 he had still not succeeded in publishing the magnum opus on Van Gogh's period in Auvers, a task which he had taken over from his father in 1909. It was assumed that he had failed to complete the book. Decades after his death, in 1990, Roger Golbéry, a distant relative of the doctor, wrote his personal account of the Gachets, *Mon Oncle, Paul Gachet*.[53] He heard rumours

that Gachet Jr's manuscript had indeed been finished, although it was then lost.

Golbéry assiduously pursued various leads, discovering that a few months before Gachet Jr died the manuscript had been offered to a French publisher. His death presumably complicated matters and the publisher eventually dropped out of the venture. In the 1970s the text was then circulated to other potential publishers, who all rejected it for unknown reasons, and it was eventually returned to Gachet Jr's notary.

When approached by Golbéry the retired notary initially could not recall the manuscript, but eventually he found it buried in his archive. In 1994 the text was finally published as *Les 70 Jours de Van Gogh à Auvers* [54], with added commentary notes by Alain Mothe, the author of his own study on Vincent's Auvers period.[55] Although Gachet Jr unfortunately did not record sources for most of the key details and the book is now dated, it nevertheless provides important testimony about Van Gogh's final weeks.

Gachet Jr had died in the house where he had been born. After his extremely generous gifts to French museums, he bequeathed what remained of his estate to the descendants of the doctor's brother Louis, who had long before settled in Algeria. The heirs of Louis put the Auvers house on the market to realize the proceeds.

There was pressure for the house to be bought by a local government body and opened up for visitors, but these efforts failed. In 1963 it was sold to a private buyer, but fortunately one with genuine passion and commitment. It became the home of Ursula Vandenbroucke, an American art historian who had written her thesis on Gauguin, and her husband Gilles. They lived there until both of their deaths in 1992. Having treated the house sensitively with minimal intervention, its basic structure was well preserved.

Following the deaths of the Vandenbroucke couple there was yet another period of uncertainty, but in 1999 the house was bought by the Val d'Oise département (county) for a relatively modest 2m francs (€300,000). After renovations, it was opened to the public in 2003 as a

small museum. The ground and first floors offer a display of works on paper and memorabilia relating to the Gachets, including a version of Van Gogh's etched portrait of the doctor (which is shown occasionally). Although most of the original furnishings have long gone, efforts have been made to preserve something of its original atmosphere. Visitors are also able to explore the garden where Van Gogh painted the portrait of Dr Gachet, his two garden scenes and flower still lifes.

The remnants of the Gachet family collection have fared less well, having been dispersed in a series of auctions.[56] Over a thousand prints, ranging from 16th-century works to those etched by Dr Gachet and his son, were sold off. The furniture and antiques that Van Gogh found so overbearing have long since disappeared. Considering that the contents of the house had been cherished by Dr Gachet and his son for nearly a century, it is unfortunate that more was not done at an earlier stage to preserve them in their original setting. Perhaps this was partly because of Gachet Jr's sense of privacy: he might not have welcomed the idea of 21st-century visitors peering into his home.

Despite Gachet Jr's generosity to French museums, the long-term secrecy about the family collection and his awkward character help explain why he faced vilification in the art world, with accusations about fakes. Those who accused the Gachets pointed out that both the doctor and his son were artists, so could have produced works in Van Gogh's style. The doctor's student Derousse had made watercolour copies of Van Gogh's paintings for the magnus opus and it was thought that she could also have turned her hand to oil paints.

Gachet Jr's reputational problems began soon after the end of the Second World War. In 1947 the poet Antonin Artaud's essay *Van Gogh le Suicidé de la Société* suggested that the doctor should be held partly responsible for the artist's death, since he apparently did little to treat him.[57] A few years later Louis Anfray, a retired naval officer and Van Gogh enthusiast, published a series of articles alleging that the etching (fig. 31) and second version of the painted portrait (plate 19) of Dr Gachet were not by Van Gogh, but by the doctor himself.[58]

Although Jo's son Vincent Willem continued to be friends with Gachet Jr up until the early 1950s, relations then soured badly. Vincent Willem had taken over responsibility for the artist's heritage after Jo's death in 1925. At this time he was setting out to carve out an independent career, and had little inclination to live off the reputation of

fig. 81 Vincent Willem van Gogh (the artist's nephew) at the Tate Gallery, London, with some of the paintings that he was lending, 1947

his uncle. He became a management consultant in the engineering sector and was often called 'The Engineer', to distinguish him from the artist, whose name he shared. But after the war he felt more confident in his life and played a greater role in promoting the Van Gogh legacy (fig. 81).

In 1954 Gachet Jr gave the painting *Garden of the Asylum* to a foundation that The Engineer was intending to set up in the Netherlands. However, by this time Vincent Willem was beginning to feel increasingly suspicious about Gachet Jr's collection, which he suspected included fakes. He even believed that the donated *Garden of the Asylum* was a fake, which left a cloud hanging over the picture for decades.[59] In 1971 The Engineer privately made the astonishing (and quite incorrect) claim that only two of the Gachet Van Goghs in the Louvre were authentic.[60]

The two authors of the major Van Gogh catalogues also turned against Gachet Jr. The Dutch specialist Jacob-Baart de la Faille had always found Gachet Jr difficult, ever since he first visited him in 1923. On that initial encounter he was shown the paintings, but prohibited from photographing them for what was intended to be a comprehensively illustrated publication. De la Faille had been working

for years on what would be the first *catalogue raisonné* (or complete compilation) of a modern artist, an indication of Van Gogh's dizzying rise to fame. His massive four-volume catalogue, published in 1928, represented a magnificent achievement, since he was starting from scratch and assembling images was then a complicated exercise.[61]

As the years went by de la Faille became increasingly suspicious of the doctor's son and in the 1950s he revised his judgement on the second version of *Portrait of Dr Gachet*, dismissing it as a fake. Following de la Faille's death in 1959, the editors of his revised catalogue in 1970 reversed this position, deeming the portrait to be authentic.[62]

Jan Hulsker, the author of the later key catalogue of Van Gogh's work, also turned against the Gachets. In his first edition, in 1977 he had described Gachet Jr as 'seemingly a reliable source'. But in his revised 1996 publication, he made a U-turn, castigating the doctor's son as 'totally unreliable'.[63] Hulsker died in 2002, aged 95, and his criticism of the Gachet paintings is now being pursued by the French writer Benoit Landais, who has long studied the artist's work. Widely regarded as a maverick, Landais takes a very different approach from the established Van Gogh specialists by rejecting a number of widely accepted paintings as fakes and championing the cause of others that have been roundly dismissed. A prolific author, his books include *L'Affaire Gachet: 'L'Audace des Bandits'*, a polemic against the doctor.[64]

It was partly to rebut accusations of fakery that in 1999 a major exhibition was organised to present a rather different story. *Cézanne to Van Gogh: The Collection of Doctor Gachet*, curated by the French and American scholars Anne Distel and Susan Stein, opened at the Grand Palais in Paris and went on to the Metropolitan Museum of Art and the Van Gogh Museum. Normally the Gachet-donated paintings at the Musée d'Orsay do not travel, but exceptionally they were allowed out on loan to New York and Amsterdam.

For the 1999 exhibition, seven of the Gachet Van Goghs were subjected to a detailed examination at the research laboratory of the Musées de France. Paintings analyst Elisabeth Ravaud found that x-rays showed that

they had 'all the sureness and rapidity of the artist's gesture'.[65] Works by Dr Gachet, Gachet Jr and Derousse were also examined, but it was concluded that none of these three amateur artists were sufficiently talented to have made credible copies of Van Goghs. When they did make copies, they first drew the outlines and then filled in the colours, rather like a child painting by numbers. Critics might well argue that the French museum specialists had a vested interest in confirming authenticity, but the exhibition and accompanying catalogue add greatly to our knowledge.[66]

It would be nearly a quarter of a century before the next major Auvers exhibition, organised by the Van Gogh Museum and the Museé d'Orsay in Paris in 2023–24.[67] Of the 74 paintings done in Auvers, 48 were included, along with 28 drawings. This represented a magnificent achievement and it is unlikely that such a comprehensive exhibition on Van Gogh's Auvers period will ever be mounted again. It was a marvellous sight to see so many of the Auvers paintings reassembled together – and seeing the authentic works helps a little in weeding out the fakes.

CHAPTER TWENTY ONE

FAKE?

'The difference from a genuine one is less noticeable'[1]

Having begun his career as an art dealer, Van Gogh was only too aware that the more successful an artist becomes, the more their pictures will be faked. Referring to Camille Corot, then the most imitated 19th-century painter, he readily admitted that forgeries can often be difficult to detect – sometimes, as he said, there are few 'noticeable' differences from the real thing. Since Van Gogh failed dismally to sell his own paintings, it of course never occurred to him that anyone should bother faking his own work.[2]

The situation would change dramatically – and within only a few decades. In 1971 Rewald believed that Van Gogh may have been forged 'more frequently than any other modern master'. As he noted, there have certainly been 'more heated discussions and differences of opinion, more experts attacking other experts... than for any other artist of that period.'[3] These attributional debates are testimony to the passions that Van Gogh arouses – as well as the huge sums of money at stake.

A few Van Gogh fakes are simply innocent misattributions of works by his contemporaries; others are imitations that were produced as tributes to the artist and later passed off as originals; and many are forgeries deliberately created to deceive. Right from the early 1900s weeding out Van Gogh fakes has proved a major challenge for art

fig. 82 Anonymous,
Stairway at Auvers, 1910s,
oil on canvas, 21 x 26 cm,
private collection (F796)

historians and dealers. A glance at books on Van Gogh that unwittingly featured fake self-portraits on their covers is a salutary reminder of the problem (plate 52).

There are three main ways of confirming the authenticity of artworks. The first is provenance – tracing a painting back to the artist's time. The second is technical investigation – this should determine that all the pigments and materials were available during their lifetime and that a picture's execution is consistent with their studio practice. And the third is connoisseurship, an informed eye deeply attuned to the painter's style.

In the case of Van Gogh, pictures that can be securely traced back to Jo Bonger are highly likely to be authentic, although very occasionally works coming from the family collection have turned out to be by colleagues who painted in a somewhat similar style. The difficulty comes with paintings without a firm provenance, especially those that first emerged after the 1910s, when Van Gogh was beginning to become highly collectable.

There are particular challenges in authenticating Van Gogh works. Occasionally he made several versions of the same composition, either as gifts or to capture different effects. This practice has been eagerly

exploited by forgers, since they can create variants of authentic works, passing them off as what Van Gogh termed his 'repetitions'.

Another difficulty follows from the fact that Van Gogh's style was constantly evolving. The differences between his early Dutch paintings and later French paintings are enormous, ranging from the earthy tones of *The Potato Eaters* to his more colourful Auvers works.[4] With such a rapid development it can be tempting to accept paintings that are slightly out of character – offering more leeway for deceit.

Van Gogh's remarkable letters offer both obstacles and opportunities for forgers. So much is known about his artistic output and techniques from the correspondence, making it more difficult to introduce fakes. But some paintings mentioned in the letters have been lost, offering enticing gaps to be filled. Just because a picture is referred to in a letter, it is not necessarily authentic – conversely, if it is not mentioned in the correspondence, it is not necessarily fake. Of the Auvers paintings, just over one-third are mentioned in the letters, the remainder not.

What is of little value in Van Gogh's case is a signature, since he only signed a small proportion of his output and signatures can be forged. When it comes to questions of attribution, one should be slightly more suspicious of a picture signed 'Vincent' than an unsigned one. A signed

fig. 83 Anonymous,
Village Road with Trees,
before 1910, oil on canvas,
64 x 78 cm, Kröller-Müller
Museum, Otterlo (F815)

picture is superficially more attractive to buyers (and advertises it as a Van Gogh), a fact well appreciated by the fakers.

Although Van Gogh forgeries began to emerge as early as the 1910s it was not until 1928 that the market was suddenly flooded with dubious works. Otto Wacker, a minor German art dealer, claimed to have acquired more than 33 Van Goghs from an unnamed Russian aristocrat who had smuggled them out of the communist Soviet Union and sent them to Switzerland. Wacker arranged for them to be exhibited for sale with the respected Berlin dealer in modern art Paul Cassirer.

Just as the exhibition was being hung Cassirer suddenly had doubts about the authenticity of some of the pictures. On examining them more carefully, he concluded that all were forgeries and cancelled the show. They included two previously unknown versions of an authentic landscape, *Wheatfields after the Rain* (plate 50).[5]

The Wacker paintings had been authenticated by leading specialists, including de la Faille. Seeing the Wacker paintings shortly before his 1928 catalogue went to press, de la Faille made the disastrous mistake of including them. Then faced with an acutely embarrassing situation, he quickly retracted his authentication. Two years later de la Faille published an addendum volume to his catalogue entitled *Les Faux Van Gogh*, recording 174 Van Gogh fakes, including the Wacker works.[6] Legal proceedings were instituted against Wacker, with his trial taking place in 1932. By this time it had emerged that most of the paintings had been produced by his brother Leonhard. Otto Wacker was imprisoned for fraud.[7]

The question of Van Gogh fakes was then attracting international media coverage, which led to the director of Berlin's Nationalgalerie becoming embroiled in a controversy. Ludwig Justi, whose ambition was to build up the gallery's modern art collection, wanted to buy the version of *Daubigny's Garden* with the painted-over cat. This is the only double-square composition of which two versions existed and some art historians argued that only the one with the cat was authentic (plate 41) and the one with the painted-over pet – which was being bought by the Nationalgalerie – was a fake.[8]

In 1929 the purchase went ahead, although the picture soon suffered a fate that Justi could never have imagined at the time: the painting would be branded as 'degenerate' by the Nazis and was sold off in 1937. Decades later it was bought for the Hiroshima Museum of Art, which opened in 1978. Although there has in the past been much debate over which of the two versions of *Daubigny's Garden* is authentic, it is now very widely accepted that both are the real thing.[9]

Fakes continued to surface in the mid-20th century, but by the 1990s there was a surge of interest in and research on the authenticity of Van Gogh paintings, partly due to the soaring financial value of his work. Among the questioned pictures was another version (fig. 82) of the authentic *Stairway at Auvers* (plate 12). This smaller and cruder painting had been sold at Sotheby's in 1984 to a Japanese collector for £473,000, a substantial sum at the time. It then reappeared at the same auction house in 1990, estimated at up to £3m, a huge increase in just six years.[10] But shortly before the sale questions were raised about its loose, expressionist style and eminent specialists expressed doubts about its authenticity. Sotheby's withdrew the picture just before the sale and since then it has disappeared.[11]

The fakes controversy intensified when Hulsker published the revised edition of his catalogue in 1996. In it he argued that 'in the Auvers period, the number of paintings attributed to Van Gogh far exceeds the amount of work he could have done in the seventy days'.[12] Rather than prune his 1978 listing, Hulsker put question marks against forty-five paintings and drawings from all periods in his revised catalogue, suggesting that they were not authentic. This was reported by *The Art Newspaper* (for which I write), giving the problem international coverage.[13] The debate was soon extended, with numerous Van Gogh experts weighing in. It quickly became apparent that the authenticity of around 100 paintings and drawings was questionable. These included high-profile works such as the version of the *Sunflowers* that had been sold in 1987 to the Yasuda insurance company for £25m – although this painting was eventually confirmed as authentic.[14]

Museum curators around the world began examining their questioned Van Gogh works. A 2005 survey revealed that 38 paintings and drawings owned by museums had either been downgraded or were being seriously doubted by their own curators.[15] Since over one-third of Van Gogh's oeuvre is still in private collections (whose owners would hardly publicly question their own works), the 38 represented a very substantial number.

Among the Auvers works that were downgraded by museums was *Village Road with Trees* (fig. 83), part of the distinguished Kröller-Müller collection. Kröller-Müller had bought the painting in 1913 from a Hungarian collection, which was quite early for a fake, but this later gave a false sense of security. In 2003 the Kröller-Müller Museum's catalogue of its Van Goghs pointed out that the trees are 'sloppily rendered and botanically indeterminate', with part of the foreground 'little more than a sludgy mass'.[16] A technical examination revealed an unusual paint-layer structure. The landscape was banished to the storeroom, where it remains, recorded as 'formerly attributed to Vincent van Gogh'.[17]

Another doubtful work was the drawing of *Path between Garden Wall*, bequeathed to the Fine Arts Museums of San Francisco in 1975.[18] The composition is weak, lacking a sense of depth. It was downgraded soon after it was acquired, but it is now again deemed authentic – another indication that Van Gogh scholarship never stands still.

In 1914 Sweden's Nationalmuseum acquired *Wheatfields with Reaper* (fig. 84), which appeared to be another version of the painting in Toledo, Ohio (plate 27). First questioned in the 1940s, in 1999 it was properly examined by specialists in Paris. The brushstrokes were found to be unlike those of Van Gogh and the painting was therefore downgraded by the Stockholm museum. It is now kept in storage as an anonymous work.

One of the paintings that has provoked the most intense debate is *Garden at Auvers* (plate 53). Doubts about the picture were hardly

surprising, since stylistically it is unique in the artist's Auvers output. The landscape is less realistic and more decorative and abstract, composed partly of blocks of patterned colours, and the curious perspective suggests a bird's eye view.

In 1992 *Garden at Auvers* was bought by the banker Jean-Marc Vernes for 55m francs ($10m).[19] After his death, four years later, it was offered at the Tajan auction house in Paris.[20] A few weeks before the 1996 auction there were claims in the media that the picture was a fake, partly based on the uncertainty over its early provenance.[21] Although it is probably the painting entitled 'Jardin' in an 1890 inventory and sold by Jo in 1908, sceptics argued that this was another garden landscape. To add to suspicions, *Garden at Auvers* had been owned by the Schuffenecker brothers – who have been accused of faking Van Goghs.[22]

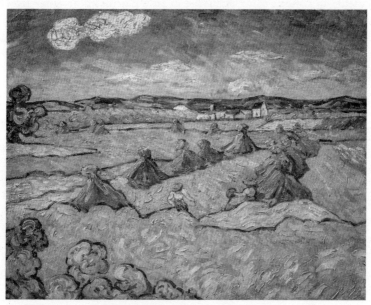

fig. 84 Anonymous, *Wheatfield with Reaper,* c.1905–10, oil on carton on canvas, 53 x 67 cm, Nationalmuseum, Stockholm (F560)

Hardly surprisingly, potential buyers were wary of buying a picture whose authenticity had been so publicly questioned. At the 1996 auction it remained unsold. The owners, Pierre Vernes and Edith Vernes-Karaoglan, then tried to get the 1992 sale to their late father cancelled, on the grounds that key information about its provenance had been withheld. Following a lengthy legal case in 2004 the French supreme court rejected their claim. By this time the authenticity of the painting had been confirmed by the Van Gogh Museum and other specialists.[23] It has also been exhibited as authentic in a string of major exhibitions.[24] Although unreported in the media, *Garden at Auvers* was sold in 2017 by the Vernes heirs, privately through the Parisian auctioneer Marc-Arthur Kohn.[25]

What has had little coverage was Van Gogh cataloguer Hulsker's apparent eventual drastic pruning of the Auvers oeuvre. In 2000, in a letter to Landais (only published in 2019), he listed no fewer than 20 paintings included in his published catalogues which he privately dismissed as fakes.[26] These included all but four of the Gachet-owned works. The 20 paintings represent just over a quarter of the 76 Auvers works that he had fully accepted in 1978, but it seems highly unlikely that so many generally accepted Auvers paintings could be fakes.

In numerical terms, the largest single group of questionable Van Goghs emerged in 2016, in the book *Vincent van Gogh: The Lost Arles Sketchbook* (this is, however, not the only Van Gogh book with a fake self-portrait on the cover, see plate 52).[27] Written by the established Canadian specialist Bogomila Welsh-Ovcharov, and introduced by the British expert Ronald Pickvance, it argued that 64 drawings in a newly discovered sketchbook were done by the artist in Arles.[28] The emergence of these unknown sketches naturally generated great excitement – and controversy.

The Van Gogh Museum has a general policy of not making unsolicited comments on the authenticity of works in other collections, but on this occasion it issued a strong statement, concluding that the sketches are 'much later imitations of Van Gogh's drawings by someone inspired by

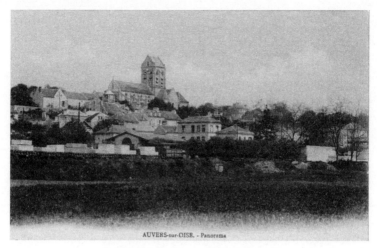

reproductions'.[29] It pointed to problems over the type of ink, the apparent discolouration of the ink, the type of pen or brush used, topographical errors in the sketches, style, the sequence in which the disbound sketchbook had been reconstructed and the lack of a secure provenance. Since 2017 little more has been heard about these controversial drawings – they have neither been exhibited nor openly sold and presumably mainly remain in the hands of their anonymous owner.

With new research, the pendulum is now swinging away from the 1990s cull. A few works that were downgraded have recently been rehabilitated. In 1974, *View of Auvers* (plate 51) had been taken off display at the Rhode Island School of Design Museum and sent to the storeroom, dismissed as 'a pastiche by an unknown hand'.[30] Their curators felt that the colouring and paint handling seemed wrong. However, in 2016 detailed research at the Van Gogh Museum confirmed its authenticity – and photographs suggest the topography is right (fig. 85).[31]

Seven other paintings that were downgraded by museums in the late 1990s and early 2000s have also recently been deemed to be

authentic.[32] The Van Gogh Museum has now come to play a key role in attributional issues, since it has the curatorial expertise, conservation specialists with the best experience and equipment, and documentary resources. An undiscovered Van Gogh emerges from all his career perhaps once in a decade. However, no previously unknown and authenticated Auvers paintings have been found since the 1920s.

But with endless debates on attribution, does it really matter that there are so many Van Gogh fakes around? It certainly does financially, as the owners of the unauthenticated *Stairway at Auvers* discovered. But for art historians, too, it is vital to weed them out. To take an example: if the 'lost' Arles sketchbook had been accepted, it would have transformed the way that we regard Van Gogh's artistic development in Provence. The 64 unknown sketches would have roughly doubled the number of stand-alone drawings from his Arles period.[33] But they are drawn in a different and crude manner compared with his long-accepted works. If the sketchbook had been accepted, then Van Gogh would be deemed a worse draughtsman than we had thought – and it would be impossible to determine how his style evolved. In short, fakes distort our view of the true artist.

And for the public, authenticity is important. When visitors go to a museum or exhibition they want to be confident that they are being shown the real thing, not an imitation. It fails to respect Van Gogh's legacy if we allow his oeuvre to be weakened with works that do not come from his own hand.

CHAPTER TWENTY-TWO

HIDDEN PORTRAIT

'I would like to do portraits which would look like
apparitions to people a century later'[1]

When the original version of *Portrait of Dr Gachet* left the Auvers
auberge it was to embark on an extraordinary adventure (plate 18).[2]
The painting, among the first to be acquired by a German museum, was
seized by the Nazis as 'degenerate', sold off and evacuated to America,
auctioned for an unprecedented sum in 1990 and then threatened
with a proposed 'cremation' in Japan. Today, the masterpiece has
disappeared and its ownership remains a mystery, leading to endless
speculation about its fate.

On Vincent's death the first version of *Portrait of Dr Gachet* had passed
to Theo and then to his wife Jo. One might have expected it to be among
the paintings that Jo would have held onto, due to its very personal link.
After all, it depicts the doctor who had cared for Vincent in his final weeks
and had become his friend. But it turned out to be among the first works
that Jo sold off, possibly to erase memories of that traumatic period.

In 1897 the portrait was bought by Alice Ruben-Faber, a wealthy
Copenhagen art student and one of the pioneer female collectors of
Van Gogh. A most unusual photograph (fig. 86) shows her in bed a few
weeks after its acquisition. She is pregnant, with the unframed portrait
casually propped up next to her pillow, along with a Maurice Denis
painting of a mother and child. This photograph is probably the first to

fig. 86 Alice Ruben-Faber, pregnant in bed next to *Portrait of Dr Gachet* and Maurice Denis's *Maternité à la Pomme*, spring 1897, photograph

depict a Van Gogh painting in a collector's home.[3]

Ruben-Faber later transferred the portrait to her friend Mogens Ballin, a Danish artist, who probably offered to help her sell it. In 1904 the painting was acquired by Count Harry Kessler, an avant-garde German critic, collector and director of the modern art museum in Weimar. He owned no fewer than three other Van Goghs of the Auvers period: *Thatched Cottages and Houses* (plate 5), *Wheatfields after the Rain* (plate 50) and *View of Auvers* (plate 51). Kessler held onto *Portrait of Dr Gachet* until 1910, when he consigned it to the Parisian dealer Eugène Druet.

Later that year Druet lent the portrait to the now famed Post-Impressionist exhibition at the Grafton Galleries in London. A battered label on the reverse of the painting's frame still has a faded handwritten text reading 'la Grafton Gallery/Londres'.[4] This confirms that the painting was already in an ornate gilded frame. In 1912, a year after the London exhibition, it was purchased for the Städel Museum in Frankfurt. The portrait immediately became a great inspiration for early 20th-century German artists, particularly the Expressionists.

Fry, who had organised the Post-Impressionist show, commented soon after the sale that despite the 'outcry' which the portrait had caused in London, it had now been deemed worthy of the Städel. He then added: 'We in England shall probably have to wait twenty years and then complain that there are no more Van Goghs to be had except at the price of a Rembrandt.'[5]

After the Nazis came to power in 1933 they denounced Van Gogh as a 'degenerate' artist and at this point *Portrait of Dr Gachet* was taken off display for its own protection and put into secure storage, along with other avant-garde paintings. Of the 21 Van Goghs in all German museums, five were later confiscated by the Reich Ministry for Public Enlightenment and Propaganda and sold off – arguably more to make money for Hitler's regime than for ideological reasons. These included Frankfurt's *Portrait of Dr Gachet* and Berlin's *Daubigny's Garden* at the Nationalgalerie. The Städel received 150,000 reichsmarks in compensation for its portrait, just under half its market value at the time.[6]

In December 1937 *Portrait of Dr Gachet* was sent to Berlin and the following year it was formally confiscated by the Nazi deputy leader Hermann Göring, who sold it to Franz Koenigs, a German banker and collector resident in Amsterdam. Shortly afterwards it was acquired in somewhat unclear circumstances by Siegfried Kramarsky, who was another German banker in Amsterdam.[7] Being Jewish, Kramarsky fled from Holland in November 1939, ending up in New York.

It has only recently emerged that *Portrait of Dr Gachet* had first gone to London, on loan from Kramarsky for a Van Gogh exhibition due to be held at the Cassirer gallery. The painting arrived on 12 August 1939, but with war imminent, the unpublicized London show was cancelled at the last minute.[8] War broke out on 3 September and *Portrait of Dr Gachet* was quickly shipped on to Kramarsky in New York.

Kramarsky died in 1961, with the Van Gogh passing to a family trust. His widow Lola eventually sent it to be auctioned at Christie's in 1990 (fig. 87). Estimated to sell for $40m–50m, the price soared to $82.5 million, more than double the £25 million paid for the *Sunflowers* only three years earlier. This remained the highest price for any artwork at auction until 2004, when it was overtaken by a Picasso. Even today, more than three decades after the 1990 auction, it is the second most expensive Van Gogh to come under the hammer, after the 2022 sale of the Arles landscape *Orchard with Cypresses*,

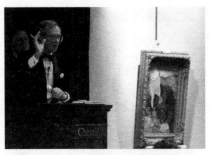

fig. 87 Auction of *Portrait of Dr Gachet*, Christie's,
London, 15 May 1990

fig. 88 Japanese businessman
Ryoei Saito

which sold at Christie's for $117m. With inflation, the $82.5m is now equivalent to just over twice this sum today.

So how had the price of *Portrait of Dr Gachet* fared since Van Gogh's time? In 1897 Ruben-Faber bought the painting for 300 francs ($58). It was sold by Ballin in 1904 for 1,238 marks ($293). The acquisition for the Frankfurt museum cost 20,000 francs ($3,861). When Koenigs bought the painting under the Nazi regime in 1938 he paid the equivalent of $53,300. Of course inflation has changed the value of these figures. At the 1897 sale the portrait cost the equivalent of around $2,000 at today's prices, with the 1938 price now amounting to nearly $1m.[9]

In 1990 the buyer at $82.5m was the Japanese businessman Ryoei Saito (fig. 88), chairman of a major paper company. Two days later he splashed out again and snapped up Renoir's *Bal du Moulin de la Galette* for almost as much, paying $78.1 million at Sotheby's. This was at the time when Japanese purchases of the Impressionists and Post-Impressionists were at their height.

Portrait of Dr Gachet was flown to Tokyo, where Saito had it stored in a secure warehouse, which he apparently visited just once a year. In 1991 he informed journalists that on his death he wanted the Van Gogh to be cremated: 'I've been telling my children to burn the paintings with my coffin when I die, as my inheritance tax will be tens of billion yen.'[10] Saito's

last years proved to be disastrous: in 1993 he was accused of bribery and his paper company faced a financial crisis. He died three years later, but fortunately his funeral wish was never implemented – the threat had just been his morbid sense of humour.

In 1998 *Portrait of Dr Gachet* was quietly sold by Saito's heirs, in a private deal, to the Austrian investment manager Wolfgang Flöttl. He too soon faced financial problems and in 2008 was accused of fraud, although he was later fully cleared on appeal. In 2012 the painting was sold to its present anonymous owner.

fig. 89 Empty frame for *Portrait of Dr Gachet*, in the exhibition 'Making Van Gogh', Städel Museum, Frankfurt, 2019

Who now is the mystery owner of *Portrait of Dr Gachet*? The curators of the *Making Van Gogh: A German Love Story* exhibition at the Städel Museum in 2019 made strenuous efforts to track down the owner to request a loan so that it could temporarily return to its old home, but were unable to make direct contact with them. The museum ended up displaying the painting's empty frame (fig. 89), a poignant reminder of its loss during the Nazi era. The Städel also commissioned the journalist Johannes Nichelmann to investigate who had bought the portrait.

One of Nichelmann's key informants was the New York dealer David Nash, who had handled the private sale to Flöttl in 1998. Although not involved when Flöttl sold it on in 2012, Nash revealed that Sotheby's had brokered a deal with 'an Italian collector who already owns four or five other major Van Gogh paintings and who is living in Switzerland'. Nash added that 'this Italian collector is dead' and 'the family is working out what to do with it'.[11] Stefan Koldehoff, a Cologne-based journalist and Van Gogh specialist,

reported that Sotheby's privately referred to the deceased owner as 'the Lugano Man', a resident of the Swiss lakeside city close to the Italian border.[12]

So why was the painting withheld from the Städel exhibition? The family is apparently 'very discreet', according to the museum's curator, Alexander Eiling.[13] There could also be issues involving the late collector's estate, a problem that frequently affects the extremely wealthy. But there is also a possible Nazi-era claim.

When *Portrait of Dr Gachet* was sold at Christie's in 1990 the name of Koenigs, who bought the painting from the Nazi regime, did not appear in the published provenance in the catalogue, although it is now fairly certain that it passed through his hands.[14] Christine Koenigs, an Amsterdam-based granddaughter of the banker, believes that the picture came into Kramarsky's hands in questionable circumstances. She argues that Kramarsky was 'only the custodian of the Van Gogh portrait, and did not acquire legal ownership' from her grandfather.[15] Christine Koenigs also reports that she made a claim for the portrait in 1999, soon after Flöttel bought it, although the strength of her claim remains unknown.

The two versions of *Portrait of Dr Gachet* have never been brought together since the day that Van Gogh worked on them in June 1890. The first version passed through various private owners and was only on public view at the Städel from 1912 until 1933. After the war Kramarsky was extremely generous in lending it to exhibitions, mainly in America, but it never came to Paris, where the other version resided.

The second version, owned by the Gachets, was hidden away in their house until it was donated to the Louvre in 1949. Strenuous efforts were twice made to borrow the first version from Kramarsky for Gachet exhibition in 1954, 1999 and 2023.

Hopefully at some point it will be possible to bring together the two versions of *Portrait of Dr Gachet*.[16] This would offer conservators the opportunity to examine the two pictures, to compare the techniques and discover more about the changes in the second version, completed a few days later for the doctor. Visually, it would be a treat to see the two magnificent portraits reunited for the first time since they were painted.

CHAPTER TWENTY-THREE

PILGRIMS TO THE INN

'[Gachet] directed me to an inn where they were asking
6 francs a day ... I've found one where I'll pay 3.5'[1]

Late in the evening of 21 July 1985 Dominique-Charles Janssens, a Belgian export director with the Danone food company, was driving back to Paris after a family excursion. While passing through the centre of Auvers his car was hit from behind by another vehicle. Janssens had to be rushed to hospital. During his recuperation he was reading the police report and was surprised to discover that the accident had taken place very close to the house where Van Gogh had lodged. Nearly a century after the artist's stay, this car crash was about to transform his life – and the fortunes of the auberge.[2]

Following Van Gogh's death the Ravouxs had continued to run the auberge until 1893, when they left to manage a brasserie in Meulan, 20 kilometres away. Their period in Auvers had been just three years and the suicide of one of their lodgers in an upstairs room must have cast a shadow over their lives, both personally and in terms of business. On leaving they took with them two paintings that they had been given – the first version of *Portrait of Adeline Ravoux* and *La Mairie* (plate 3). They probably felt ambivalent about them, particularly the portrait of their young daughter painted just a few weeks before the artist had shot himself.

In 1905, while still in Meulan, Arthur Ravoux was approached in his brasserie by four foreigners who were searching for paintings by

fig. 90 Book cover of *Lust for Life*, John
Lane, London, 1956

Van Gogh, presumably tipped off by
someone who had told them that he
had once run the auberge in Auvers.
Ravoux, astonished by the request,
readily agree to sell the two pictures
for 100 francs (then £4).[3] In 1953
Arthur's daughter gave an interview
in which she said that one of the
men was an American named Harry
Harronson – if so, these would be the
first Van Goghs to be acquired by a US
buyer.[4] Adeline recalled that the party
comprised two Americans, a German
and Dutchman.[5] In 1906, a year after
the Ravoux sale, the 50-franc *La
Mairie* was apparently sold for 28,000
francs by a Parisian dealer.[6]

Meanwhile back in Auvers the Café de la Mairie passed through a
succession of hands. From the 1920s, with the artist's growing fame,
visitors from Paris began to arrive and ask to see 'Van Gogh's Room'.
Among them was Irving Stone, who was researching his novel *Lust
for Life* (fig. 90). He came in 1930, on the fortieth anniversary of the
artist's death, later writing emotionally of the experience of lying on
'the bed in which he had died'.[7]

In 1946 a plaque was installed on the façade of the building,
recording the stay and death of the painter: 'Le peintre Vincent van
Gogh vécut dans cette Maison et y mourut le 29 Juillet 1890' (fig. 93).
By this time the auberge had been re-baptised the Café-Restaurant
à Van Gogh – an indication that it was no longer just a congenial
rendezvous venue for the villagers (fig. 91).

A major change came in 1952, when Roger and Micheline Tagliana
took over the auberge.[8] By then the building was badly in need of
renovation, which they did with sensitivity, although the original zinc bar

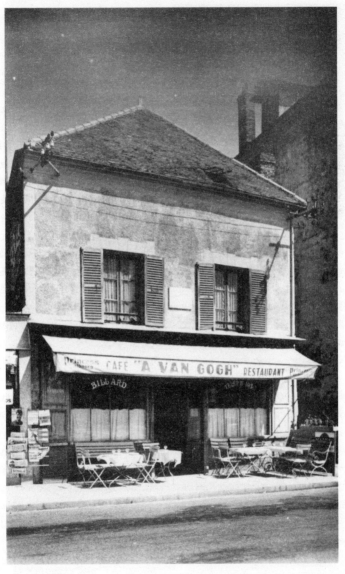

fig. 91 Exterior of the Auberge Ravoux, 1950s, postcard, Archive Tagliana, Auvers

fig. 92 Adeline Ravoux, aged 77, looking at a reproduction of her portrait aged 12, 1954

was removed and the dilapidated 'painter's room' demolished. In 1955 Van Gogh's second-floor room was opened up to visitors. None of the original furniture survived, so the Taglianas acquired pieces of the period: an iron bed, chest of drawers, wicker chair, oil lamp, small table and an 1890 calendar. Gachet Jr also lent his father's easel, which had probably been used by Van Gogh during his visits.

In 1953 Adeline Ravoux-Carrié[9], then 75 and living in Normandy, was tracked down and gave a series of interviews about Van Gogh (fig. 92).[10, 11] The following year she returned to the auberge, sharing her reminiscences with the Taglianas. Along with Gachet Jr, Adeline was among the very few people still alive who had known the artist in France.

Since the interviews were given more than sixty years after Van Gogh's death it is difficult to determine how much they were really Adeline's own memories of 1890. The suicide of a lodger would have been highly traumatic and difficult to forget. But being only 12 at the time, presumably many of the details would have been relayed later by her father, who lived until 1914. Van Gogh's letters had been widely published and no doubt she read and reread those from Auvers, colouring her recollections. Her interviews appear to include an element of genuine recall, but considerably overlaid with other material. Adeline's basic message, not surprisingly, was that her parents had done their best for Vincent. Dr Gachet, on the other hand, was portrayed as having offered little support to his patient.

Another major event at the auberge was the filming of the 1955 movie *Lust for Life*, directed by Vincente Minnelli. For realism, much of

it was filmed in the actual places where Van Gogh had lived. Kirk Douglas, playing Van Gogh, descended on Auvers, a cause of great excitement still vividly remembered today by its more elderly residents. Some of the action took place in the auberge itself and Douglas later recalled the final scene in the wheatfield: 'It was horrible to be standing

fig. 93 Plaque on the Auberge Ravoux, unveiled in 1946

in the field where he was painting his last painting … It was the most painful film I ever made.'[12]

Fortunately, the Taglianas developed a deep commitment to the arts and were keen to link the heritage of the auberge with contemporary painting and sculpture (fig. 94). To this end they held changing displays, either in the café-restaurant or in a small gallery they later set up on the first floor. The most important show, in 1960, was devoted to Emile Bernard. Supported by the artist's son Michel-Ange, the pictures on display included *Funeral* (fig. 57). To ensure security, Roger Tagliana brought down a camp bed and slept surrounded by the works of Van Gogh's loyal friend.[13]

The Taglianas also played a key role in bringing an important sculpture by Ossip Zadkine to Auvers. Zadkine, born in Belarus and resident in France, was a great admirer of Van Gogh. His bronze figure of the artist encumbered by his painting equipment was unveiled in 1961 in a small garden area between the auberge and the station. Zadkine also designed sculptures dedicated to the painter for other places in Vincent's life – his birthplace Zundert, Wasmes in the coal-mining area of the Belgian Borinage and the asylum outside Saint-Rémy-de-Provence.

Roger Tagliana died in 1981 and four years later Micheline decided to retire. It was at this point that the authorities had listed the auberge as

fig. 94 Exhibition organised by the Tagliana family in the café of the auberge, with works by Charles Matton and Michel Charpentier, 1958, Archive Tagliana, Auvers

an historical site. When the building went on sale there was pressure for it to be bought by the municipality, but to no avail. Among private buyers who expressed interest in acquiring the property was the fashion couturier Pierre Cardin.

It was to be Janssens who in 1987 emerged as the eventual buyer. At the time of the road crash he had no particular interest in Van Gogh, but while recuperating he began to read the artist's letters – and immediately developed a passionate interest in Vincent's life and work. As Janssens likes to tell friends: 'I discovered Van Gogh by accident!' On learning that the building was for sale, he boldly decided to abandon his business career and submit an offer. With great energy, he took on the challenge of presenting the auberge to a contemporary audience.

Janssens paid 3m French francs (then about £270,000), but the real financial investment was to come as the complex restoration of an historic property and the provision of visitor facilities began. Restoration, overseen by the Parisian architect Bernard Schoebel, began in 1988. But obtaining the necessary planning permissions and the meticulous work by dedicated craftsmen took time and it was not until 1993 that the first visitors were welcomed into the Auberge Ravoux/Maison de Van Gogh.

The ground floor, which had always been the café and brasserie, was presented as a dining room, preserving much of the atmosphere of the 1890s. Part of the first floor was converted into a bookshop. On the second floor a room was set aside for audio-visual presentations and Hirschig's former bedroom was preserved.

But the greatest care was obviously lavished on Van Gogh's small attic bedroom. After much consideration, Janssens removed the late 19th-century furnishings that the Taglianas had acquired from elsewhere, leaving the room starkly empty, except for a rustic chair. He wanted it to be a calm, intimate space for contemplation. 'Visitors can furnish it with their own feelings or experiences', he says. Mass tourism would trample through the tranquility and so only small groups of up to a dozen or so are admitted at any one time: 'The room should be preserved as a refuge of silence away from the frenzy of the external world.'[14]

Janssens still has one last dream for the auberge: he wants to display an original Van Gogh painting from the Auvers period. This would fulfil the artist's wishes, since in June 1890 Vincent had written to Theo that 'one day or another I believe I'll find a way to do an exhibition of my work in a café'.[15] He immediately added that he wouldn't mind 'exhibiting with [Jules] Chéret', the prolific artist best known for his dramatic posters of Parisian music-hall life.[16]

Writing from the auberge, probably while enjoying a meal, Vincent must have got the idea of using the café walls to display his own work. It is even possible that Ravoux allowed him to hang a few pictures. In the 1950s the Taglianas had already taken up the concept with their usually modest exhibitions, but Janssens had a much more audacious plan for the Institut Van Gogh, his non-profit foundation which supports the preservation of the auberge.

Janssens wants to hang an original Van Gogh painting in the room where the artist lived, conceived his pictures, slept and finally breathed his last. To this end he has installed a high-security glass display case designed by Jean-Michel Wilmotte, who created the case for Leonardo da Vinci's *Mona Lisa* at the Louvre. It takes up an entire side wall of the bedroom. That was the relatively easy part: the challenge has been to borrow or even buy a Van Gogh. On several occasions Janssens got close to attaining his goal, but it has kept eluding him.

The first chance came in 1999 when he nearly secured the loan of *Landscape with Train* (plate 16) from the Pushkin Museum in Moscow.

In return Janssens would have arranged for the loan of a substantial group of paintings by Balthus to Russia.[17] The arrangement needed to be overseen by the French authorities, but they blocked the Van Gogh loan on the grounds that the auberge was not a recognized museum.

In 2003 Janssens was optimistic about buying *The Fields* (plate 26).[18] Despite having ambitious fundraising ideas, with corporate support, the price proved impossible to raise. Four years later the unnamed private owner put the painting up for auction at Sotheby's, with an estimate of $28–35 million. Even though a striking Auvers landscape, it failed to sell and remains in a private collection.[19]

More recently, Janssens tried to acquire *Garden at Auvers* (plate 53). Once again fundraising proved too much of a challenge and the painting was sold to a private owner in 2017. But he has not given up. There are still around 20 Auvers paintings in private collections and he keeps his eye on them, waiting for the right opportunity.

Meanwhile, the empty room attracts art-lovers from all over the world. It has become particularly popular with East Asians, who account for around 40 per cent of the usual 50,000 visitors a year. Whatever their origins, Janssens says that they are 'not really tourists, but pilgrims'.[20]

CHAPTER TWENTY-FOUR

TODAY

'Success is the worst thing that can happen in a painter's life'[1]

Vincent van Gogh, who failed to sell his work in his lifetime, is now among the half dozen most popular painters of all time – alongside giants such as Leonardo, Michelangelo, Rembrandt, Vermeer, Monet and Picasso. *Sunflowers, Starry Night* and his self-portraits are instantly recognizable to billions of people from all over the world. Van Gogh's works have a powerful immediacy and daring colours that appeal, but they also possess a dynamism and depth that deserve deeper appreciation.

It is not only the art, but also the artist's personal story that fascinates and resonates with so many people today. Vincent led an extraordinary and eventful life, facing enormous challenges. At the age of 16 he started working for an art dealer, but later switched to serve as a missionary among the Belgian coalminers. It was not until he was 27 that he finally set out to become an artist, completing his vast output in just ten years. Among the companions he temporarily lived with were Sien Hoornik, a former prostitute in The Hague, and Gauguin, in the Yellow House in Arles. It comes as no surprise that his story should have inspired novelists and filmmakers.

It is thanks to his eloquent letters that we know so much about Vincent's life. These were published in various editions in the 20th

century, with the definitive version coming out in 2009, in six large volumes and online.[2] Vincent's 902 letters amount to nearly a million words, giving us what is essentially a diary of the development of his career. This correspondence is the most revealing of any artist in history.

Needless to say, as Van Gogh's fame has soared, so too have his prices. Back in 1987, one of the versions of *Sunflowers* sold for £25 million, three times more than any artwork had ever fetched at auction – until then previous records had all been for old masters. Later that year *Irises* soared higher, going at auction for an astonishing $54 million. Then in 1990 the first version of *Portrait of Dr Gachet* was hammered down at nearly $83 million. Other Auvers paintings that have changed hands since then include *Girl Against a Background of Wheat* (plate 33), which in 1997 was bought by the Las Vegas casino owner Steve Wynn (fig. 95) for around $50 million. For a couple of years it hung in the Bellagio Gallery of Fine Art, in one of his casinos. This gallery offered something for non-gamblers to enjoy while their companions were spending money. Eight years later, after Wynn's company faced financial problems, the Van Gogh was acquired by the American hedge-fund owner Steven Cohen, reputedly for $80 million.[3]

The story of the Auvers still life *Poppies and Daisies* (fig. 40) is dramatic evidence of how Van Gogh's prices have rocketed. The picture may have originally been owned by Dr Gachet, in whose garden it was painted.[4] After passing through several private collections it was sold in 1926 for £1,200. Only two years later the price had risen to $12,000, when it was bought by the American businessman Conger Goodyear.[5] In 1962 his son George lent the still life to the Albright-Knox Art Gallery in Buffalo, New York. George decided to sell it in 1990, with part of the proceeds going to the museum. Christie's put the Van Gogh up for auction with an estimate of $12–16 million, but it failed to reach its reserve price. It was sold privately the following year, probably for around $10m – nearly a thousand times what Conger Goodyear had paid.

In 2014 the anonymous European owner of *Poppies and Daisies* sent it back to auction, where it soared to $62 million. The buyer turned out to be Wang Zhongjun, a Chinese billionaire entertainment company owner and an amateur artist who enjoys painting flower still lifes (fig. 96). Wang was casual about the purchase, thinking it would 'make my home more colourful'. While bidding, he 'felt really relaxed', even after the price went way above the high estimate. He said that the final sum turned out to be 'slightly lower than I expected'.[6]

Wang's purchase is an indication of how the Van Gogh market has shifted, from the early days when works were only of interest to avant-garde collectors to the billionaires of today. In the first few decades after the Second World War the main buyers were American, along with some Europeans. By the 1980s they were overtaken by the Japanese, who quickly developed a taste for the big names of Impressionism and Post-Impressionism. Since 2000 there has been a major shift as new emerging markets have opened up, particularly in Russia, South Korea and, above all, in China.

Another sign of Van Gogh's expanding global popularity is the burgeoning crowds who flock to see his work. In 1962 Theo's son, Vincent Willem (The Engineer), donated the family collection to the Dutch state, for the creation of the Van Gogh Museum. The Amsterdam municipality provided the land, the national government funded the building and running costs of the museum, and the Van Gogh family received the tax-free equivalent of £6 million – a small fraction of the market value of the artworks. The collection comprises around 200 Van Gogh paintings, 400 drawings, several sketchbooks, 700 letters by the artist and a comprehensive archive.

When the museum opened in 1973 it was anticipated that it would attract about 60,000 visitors a year.[7] The 2019 figure, before Covid-19, was 2.1 million – thirty-five times the number originally expected. It is by far the world's most popular museum devoted to a single artist and is only behind the Rijksmuseum, with its Rembrandts and Vermeers, as the most-visited Dutch museum.

fig. 95 American casino owner Steve Wynn with *Girl against a Background of Wheat* (plate 33) and Gauguin's *Bathers* (1902), *c.*1999

Van Gogh could never have imagined that one day he would become an artistic superstar, although a select few recognised his talent before his death. Camille Pissarro, who had met Van Gogh in Paris in 1887, said at the time that 'he would either go mad or leave us far behind'. A few years later he added that 'little did I know that he would do both'.[8]

Had Van Gogh realized that his work would eventually be appreciated, he might never have pulled the trigger, abruptly ending his career at the age of 37. If he had continued, and enjoyed reasonable health, he could well have lived and worked for another 20 or 30 years.

And where might that have taken his art? Van Gogh would have seen the rise of the Nabis (Prophet) artists in the mid-1890s, including Pierre Bonnard and Maurice Denis. These were followed in the early 1900s by the Fauve (Wild Beast) painters, such as Henri Matisse and André Derain, and the Die Brücke (The Bridge) group, with Erich Heckel and Emil Nolde. In the 1910s came the German Expressionists, led by artists such as Ernst Kirchner and Alexej von Jawlensky. By the

eve of the First World War Picasso had already become a key figure. For all these later artists, Van Gogh provided an inspiration and model of what a contemporary artist should be.

Writing from Arles, Vincent had predicted that 'the painter of the future is a *colourist*'.[9] This was just what the Nabis, Fauves, Brücke artists and Expressionists were aiming to achieve, using colour in ways that would transform traditional 19th-century art into Modernism. As the German artist Max Pechstein once declared: 'Van Gogh was the father of us all!'[10]

And how would Vincent have responded to the rapidly evolving scene? As an artist he was constantly moving forward, at ferocious speed. This suggests that he would have continued to remain in the vanguard, at a key period in the development of modern art. Many artists in their later years become stuck in their ways, repeating what has proved successful, although a few masters continue to progress and in some cases produce some of their finest work in their mature years.

fig. 96 Chinese entertainment company owner Wang Zhongjun with
Poppies and Daisies (fig. 40), Sotheby's, 4 November 2014

When in their early 80s Monet completed his enormous waterlily cycle and Matisse did his striking cut-outs. Picasso made some of his boldest pictures at an even later age. With Van Gogh's astonishing artistic imagination and determination, what might he have achieved?

A NOTE TO THE READER

This paperback edition (2024) is an updated version of the original 2021 publication (with different pagination). I would like to pay tribute to the comprehensive exhibition 'Van Gogh in Auvers-sur-Oise: His final Months', held at the Van Gogh Museum in Amsterdam (12 May–3 September 2023) and the Musée d'Orsay in Paris (3 October 2023–4 February 2024). Its catalogue was edited by curators Nienke Bakker, Emmanuel Coquery, Teio Meedendorp and Louis van Tilborgh. Among their chievements were dating the Auvers paintings and establishing most of the landscapes depicted. This data has been incorporated in the present book.

Endnotes give the sources of quotations, along with further details. Frequently cited sources in the notes have abbreviated references, with the full references in the Bibliography. Van Gogh's letters are numbered from the definitive 2009 edition, *Vincent van Gogh – The Letters: The Complete Illustrated and Annotated Edition*, edited by Leo Jansen, Hans Luijten and Nienke Bakker (www.vangoghletters.org). Van Gogh's paintings are identified by the 'F' numbers from the 1970 *catalogue raisonné* by Jacob-Baart de la Faille, *The Works of Vincent van Gogh: His Paintings and Drawings*. Unless otherwise specified, illustrated works are by Van Gogh (in the captions, height is given before width). Artworks and the archive at the Van Gogh Museum in Amsterdam are mainly owned by the Vincent van Gogh Foundation, run by the family. The Dr Paul Ferdinand Gachet and Paul Louis Gachet Papers are held at the Wildenstein Plattner Institute, Inc, New York.

ON THE TRAIL
OF VAN GOGH

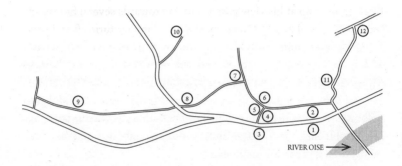

RIVER OISE →

Auvers-sur-Oise, about one hour from Paris (30 kilometres), is a delightful place to explore. In a full day out, one can see the main Van Gogh sites, learn more about the other artists who worked in the village, take in some countryside air and enjoy a lunch.

Almost opposite the station (1) is the former garden of Daubigny's widow, painted by Van Gogh (plate 41), which one can peek into through the gate of 22 Rue du Général de Gaulle (2). Go left out of the station along the main road one soon reaches a small green area on the right side, with a Zadkine statue dedicated to Van Gogh and the tourist office. Just after this is the *mairie* (town hall) (plate 3), which looks very much as it did in the artist's time (3).

Immediately afterwards, almost opposite the town hall, stands the Auberge Ravoux (4), where Vincent stayed. It is normally open

to visitors, except for a winter closure period. An audio-visual presentation on the second floor gives an overview of Van Gogh's seventy days in Auvers. Visitors can see the small room that was occupied in 1890 by a fellow Dutch artist, Anton Hirschig. Then comes the poignant space that was Van Gogh's bedroom, empty except for a solitary chair (fig. 2). The large room on the ground floor was originally the café and bar.

On leaving the auberge turn right, walking up Rue de la Sansonne. Just off the lane is the Musée Daubigny (5), a small museum showing a changing selection of 19th-century art. Van Gogh set up his easel in the street, so look up at his view past a stairway towards several houses in Rue Daubigny (plate 12). On reaching Rue Daubigny, turn left and near the entrance to number 48, you reach the recently discovered spot (6) where Van Gogh painted *Tree Roots* (plates 48 and 49). Five minutes further on one comes to the Maison/Atelier de Daubigny (7), the house and studio (open to visitors) where Charles-François Daubigny lived and worked, with wall paintings and his landscape pictures.

Retrace your steps in Rue Daubigny for one minute and then turn into Rue Léry towards the Château d'Auvers (8), where there is an audio-visual presentation on Van Gogh and Impressionism, along with some original pictures by artists who worked in the village. The next stop is the Maison Gachet (9), in what is now Rue Gachet, another ten minutes beyond the château. There one can visit the house of this extraordinary and eclectic doctor, as well as relaxing in the garden where Van Gogh painted most of his flower still lifes.

Now may be the time to return to the centre of Auvers. But for those wanting to see the place where Van Gogh probably fired the shot, go back to the château and at the entrance keep walking up the main road. Take the first lane on the right, the Chemin des Berthelees, and then stop just before a junction with Allée Zadkine. The spot (10) is near a gate through the stone wall into the château and a plaque with a Van Gogh self-portrait, but the former wheatfield is now a modern estate and car park, so little remains of the artist's time.

After returning to the centre there are two more sights, which are both important: the church and cemetery. The church (plate 20) (11) is a short climb above the station. A few minutes' walk further on is the cemetery, with the graves of the Van Gogh brothers, adjacent to the fields. After paying homage in the cemetery (12), take in the vista of the rolling fields, which proved such an inspiration for Van Gogh. On walking back down towards the station, those with more time can stroll along the nearby River Oise.

Back in Paris, don't miss a visit to the Musée d'Orsay, to see the seven Van Gogh paintings donated by Dr Gachet, along with the museum's fabulous collection of the Impressionists and Post-Impressionists.

CHRONOLOGY

1890

Late March 1890 Theo van Gogh meets Dr Paul Gachet in Paris to discuss Vincent's move to Auvers-sur-Oise

16 May Vincent van Gogh leaves the asylum of Saint-Paul-de-Mausole, just outside Saint-Rémy-de-Provence, to take the overnight express for Paris

17 May Theo meets Vincent at the Gare de Lyon in Paris, returning to the apartment at 8 Cité Pigalle, where he introduces him to his new wife Johanna (Jo) Bonger and their four-month old baby, Vincent Willem

18 May Vincent and Theo visit art exhibitions

19 May Vincent visits Père Julien Tanguy's art supplies shop

20 May Vincent leaves for Auvers, meets Dr Gachet and lodges at the Café de la Mairie (Auberge Ravoux) in Rue de la Gare

27 May First lunch with Dr Gachet

3 June Starts first version of *Portrait of Dr Gachet* (plate 18)

4 June Dr Gachet visits Theo in Paris, while Vincent works on *Church at Auvers* (plate 20)

8 June Theo, Jo and baby Vincent Willem visit Auvers for the day, lunching at Dr Gachet's

15 June Etched *Portrait of Dr Gachet* (fig. 31)

6 July Vincent visits Theo, Jo and the baby in Paris for the day

7 July Theo warns his bosses at the Boussod & Valadon gallery that he will leave and set up as an independent art dealer if they do not increase his salary

15 July Theo, Jo and the infant depart for Holland to see their families

18 July Theo returns to Paris, leaving Jo and the infant to stay on in the Netherlands for a little longer

21 July Theo backs down in his dispute with Boussod & Valadon

27 July Vincent paints *Tree Roots* (plate 48) and in the evening, at around 7.30pm, he walks to the wheatfields, shoots himself in the chest and, badly injured, returns to the auberge

28 July Theo hears the news and rushes to Auvers

29 July Vincent dies at 1.30am, aged 37

30 July Funeral

3 August Theo leaves Paris to mourn with family members in the Netherlands

16 August Theo, Jo and the baby return to Paris from the
Netherlands

18 August Theo meets the dealer Paul Durand-Ruel to discuss a
possible exhibition and Dr Gachet comes for supper

Late September Theo, with help from Emile Bernard, sets up an
exhibition of Vincent's work in the empty apartment in the same
building that he intends to move into

4 October Theo manifests serious signs of a mental problem, then
deteriorates very quickly in the coming days

12 October Theo, in a very poor state, is sent to a Paris clinic

7 November Theo is moved to Utrecht, to the Willem Arntsz Klinik

1891

25 January Theo dies in Utrecht of syphilis, aged 33

ENDNOTES

PREFACE

(pp. 7–16)

1. *Van Gogh's Chair* (January 1889, F498).
2. Interview, 6 November 2020.
3. Interview, 10 April 2019.
4. Bakker, Van Tilborgh and Prins, 2016, p. 80 (the gun was included in the museum's exhibition *On the Verge of Insanity* in 2016). However, Dominique-Charles Janssens, who runs the auberge, is more sceptical, believing that 'the chances that this revolver is not that of Van Gogh seem much greater than the opposite' (statement, 19 June 2019). I first heard the story about the gun from a well-informed source in 2001.
5. I was given the name by several local sources.
6. Rémy Le Fur, Paris, 19 June 2019, lot 1.
7. Naifeh and Smith, 2011, appendix on Vincent's fatal wounding, pp. 869–85.
8. Jacqueline Sonolet in André Pecker, *La Médicine à Paris du XIIIe au XXe Siècle*, Hervas, Paris, 1984, p. 441.
9. *L'Art Vivant*, 15 July 1923, p. 554.
10. Trublot (Paul Alexis), *Le Cri du Peuple*, 15 August 1887.
11. Letter 873 (20 May 1890).
12. Four casts were sold by Gachet Jr to the Wellcome Collection in 1927 and went on long-term loan to London's Science Museum in 1976 (inventory A158243-6). These were the heads of Lacenaire, Lescure and Norbert (the museum has one other head, which could be of Avril or Dumollard). See Gachet Jr, 1956, pp. 19 and 89; Johnston-Saint purchases 1925–30 (Wellcome Collection archive); and Gertrude Prescott, 'Gachet and Johnston-Saint', *Medical History*, July 1987, pp. 217–24.
13. Gachet Jr, 1953a, unpaginated; Gachet Jr, 1994, p 258; and Gachet Jr to Gustave Coquiot, c.1922 (Van Gogh Museum archive, b3305).
14. The Société d'Autopsie Mutuelle had been established in 1876 by the Société d'Anthropologie de Paris, of which Dr Gachet was a member. In 1887 Dr Gachet was a founding member of the associated Société du Dîner Lamarck, which honoured the evolutionist Jean-Baptiste Lamarck.
15. *Blessure et Maladie de M. Gambetta: Relation de l'Autopsie*, Masson, Paris, 1883.
16. Georges Rivière, *Renoir et ses Amis*, Floury, Paris, 1921, p. 215.
17. Georges Rivière, *Cézanne: Le Peintre Solitaire*, Floury, Paris, 1933, p. 108. See also Rivière, 'Les Impressionnistes chez eux', *L'Art Vivant*, 1 January 1926, p. 925.
18. Dr Gachet's membership is mentioned in Jean Cherpin, *L'Oeuvre gravé de Cézanne*, Arts et Livres de Provence, Marseille, 1972, p. 29. Gachet Jr was shown the text before publication, writing an enthusiastic introduction and responding over two minor factual inaccuracies on other matters, but did not comment on the Société d'Autopsie Mutuelle (Gachet Jr to Cherpin, 15 April 1957, p. 19) .
19. Gachet Jr, 1956, p. 17.
20. It has only been published in Koldehoff, 2003, p. 21.
21. Inevitably this means writing in considerable detail about Van Gogh's suicide. In Van Gogh's time little assistance was available to those thinking of ending their lives. Today help is provided by the Samaritans in the UK (telephone 116 123) and similar organisations elsewhere.
22. The number of surviving Auvers paintings is 74 and the artist gave away a few that subsequently disappeared. Van Gogh was in Auvers for 71 days, but on the last day he died at 1.30am.

PROLOGUE:
INTERLUDE IN PARIS
(pp. 17–23)

1. Unsent letter RM19 (c.21 May 1890).
2. Bonger, 1958, p. L.
3. For further background on the ear incident see Gayford, 2006; Bailey, 2016; and Murphy, 2016.
4. For further background on the asylum, see Bailey, 2018.
5. Letter 801 (10 September 1889).
6. Letter 807 (4 October 1889).
7. Medical register, Saint-Paul-de-Mausole (Bakker, Van Tilborgh and Prins, 2016, pp. 156–9).
8. Letter from ministry of the interior to the Bouches-du-Rhône prefet, 6 June 1874 (Archives Départementales, Bouches-du-Rhône, Marseille, inventory 5X138). See also Evelyne Duret, *Un Asile en Provence,* Universitaires de Provence, Aix-en-Provence, 2020, p. 135.
9. Letter 868 (4 May 1890).
10. Bonger, 1958, p. L.
11. Bonger, 1958, p. L.
12. Letter 879 (5 June 1890).
13. Theo to Wil, 2 June 1890 (Van Gogh Museum archive, b931).
14. For details: F671 and F543 (Letter 879, 5 June 1890); F412 (Letter 887, 14 June 1890); F403, F404 and F555 (Jo to Theo, 16 March 1889, Jansen and Robert, 1999, p. 221, note 10); and F82 (Bonger, 1958, p. L). The pictures in the apartment were moved around periodically.
15. Bonger, 1958, p. LI.
16. Bonger, 1958, p. LI.
17. 1890, Musée des Beaux-Arts, Rouen. See Letters 879 (5 June 1890, with sketch) and 893 (28 June 1890).
18. Letter 870 (11 May 1890), also 869 (10 May 1890). Although actually attending the exhibition is not mentioned in the correspondence, it seems very likely that Vincent would have gone, since it was due to close on 22 May. For Van Gogh's earlier relations with Bing see also Letter 642 (15 July 1888).
19. Andries to Hendrik and Hermine Bonger, 21 May 1890 (Van Gogh Museum archive, b1852).
20. Vincent may have visited Boussod & Valadon since he later mentioned seeing the work of Jan Voerman, which had been exhibited there, although it is also possible he saw the work in Theo's apartment (Letter 902, 23 July 1890).
21. Unsent letter RM20 (24 May 1890).
22. Bonger, 1958, p. L.
23. Bonger, 1958, p. LI.
24. Letter 873 (20 May 1890).
25. Unsent letter RM20 (24 May 1890).
26. Theo to Dr Gachet, 19 May 1890 (Gachet Jr, 1957a, pp. 149-50). As Dr Gachet would have been in Paris later in the week for his work, Vincent may well have wanted to arrive in Auvers while he was there and could provide direct assistance.

PART I:

74 PAINTINGS IN 70 DAYS

CHAPTER ONE:
FIRST IMPRESSIONS
(pp. 25–34)

1. Letter 873 (20 May 1890).
2. Adolphe Joanne, *Les Environs de Paris,* Hachette, Paris, 1872, p. 271.
3. Coquiot, 1923, p. 244. The Auberge Saint-Aubin was at 53–55 Rue François Villon, where the building still stands.
4. Arthur Ravoux had run a wine shop in Menucourt, 15 kilometres away, which he had given up the at the end of 1889. They took over the Auvers auberge on 30 January 1890 (*Le Progrès de Seine-et-Oise,* 30 November 1889 and 1 February 1890).
5. The photographs, from the Ravoux descendants, were acquired in 1987 by Janssens for the Institut Van Gogh, Auvers. The man is Arthur and the woman is presumably his wife Louise.
6. Victor Jean Ravoux was born on 26 April 1879 in Rueil and Léonie Adolphine Ravoux on 24 November 1881 in Aubervilliers. Both died a few weeks after their birth.

7. The photograph was first published in *Les Nouvelles Littéraires*, 16 April 1953 and reprinted by Tralbaut (1969, p. 304). This print, acquired from the Ravoux descendants in 1987, has been visually strengthened by the Institut Van Gogh. The photograph dates from the period when the Ravoux family were in Auvers, in 1890–93. Arthur Ravoux is on the left. Adeline Ravoux said in the 1950s that she was the young woman in the doorway. She would have been 12 in 1890, and as the woman in the photograph looks older, this points to a date nearer 1893 (see Ravoux, *Les Nouvelles Littéraires*, 16 April 1953 and Ravoux, 1955, p. 15). Adeline stated that her younger sister Germaine was standing on a chair near the table on the left. Germaine would have been aged 2 in 1890, and as the child appears older, this too suggests a slightly later date for the photograph. Adeline also said that the infant in the doorway was Raoul the child of their neighbour, the carpenter Levert. The identity of the three men together at a table remains unknown.

8. There has been some confusion over whether the room was on the first or second floors (European terminology). Gustave Coquiot wrote that it was 'under the roof' on the second floor (*Les Indépendants 1884–1920*, Ollendorff, Paris, 1921, p. 245), although after this Gachet Jr told him that it was on the first floor (Gachet Jr to Gustave Coquiot, 5 August 1922, Van Gogh Museum archive, b3312), which was then accepted by Coquiot (1923, p. 245). Gachet Jr informed Doiteau and Leroy that it was on the first floor (1928, p. 92). A late 1930s photograph by Willy Maywald (*Verve*, March 1938) also appears to show a first-floor room. However, Anton Hirschig, who slept in the adjacent room and should be an authoritative source, said that it was on the second floor (Hirschig to Albert Plasschaert, 8 September 1911, Van Gogh Museum archive, b3023), as did Adeline Ravoux

(1955, p. 7). The fact that the rent was relatively modest also suggests that it was more likely a small attic room.

9. Letter 626 (16–20 June 1888).

10. Alexis Martin, *Promenades et Excursions dans les Environs de Paris (Région du Nord)*, Hennuyer, Paris, 1894, opposite p. 82.

11. The print gives a reasonable general impression of Auvers, although it is not completely topographically correct.

12. *Le Monde Illustré*, 30 May 1868.

13. Letter 875 (25 May 1890).

14. This sketch has suffered from light exposure, darkening the paper and fading the image. Although it is not certain that it represents the Auberge Ravoux, this was claimed by Gachet Jr (1994, pp. LV and 245–6) and seems very likely.

15. Letter 875 (25 May 1890).

16. Camille Corot had visited Auvers occasionally from the 1850s up to the early 1870s. Honoré Daumier lived in nearby Valmondois from the 1860s until his death in 1879. Armand Guillaumin was a frequent visitor to Auvers.

17. Now Rue Gachet.

18. These two prints were recovered by Dr Gachet after Van Gogh's death and the figures were later cut out and mounted on a single piece of gold paper with a Japanese inscription. This is now at the Musée d'Orsay, Paris (donated by Gachet Jr in 1958). See Chris Uhlenbeck, Louis van Tilborgh and Shigeru Oikawa, *Japanese Prints: The Collection of Vincent van Gogh*, Van Gogh Museum, Amsterdam, 2018, pp. 36–37.

19. Letter 873 (20 May 1890).

CHAPTER TWO:
THE ECLECTIC DOCTOR
(pp. 35–43)

1. Letter 879 (5 June 1890).

2. Letter 873 (20 May 1890).

3. The best source on Dr Gachet is Distel and Stein, 1999, along with publications by his son (Gachet Jr, 1956 and Gachet Jr, 1994), and Golbéry, 1990. See also

two theses: Remo Fabbri, 'An Inquiry into the Life and Thought of Dr Paul-Ferdinand Gachet', Yale University, New Haven,1964 and Nathalie Renault, 'Le Docteur Paul Ferdinand Gachet: Un Médecin-artiste au Temps des Impressionnistes', Université Paul Sabatier, Toulouse, 2005. For a highly critical view of Dr Gachet and his son, see the writings of Benoit Landais.

4. Unsent letter RM20 (24 May 1890).
5. Letter 875 (25 May 1890).
6. Letter 875 (25 May 1890).
7. Letter 875 (25 May 1890), see also 901 (22 July 1890).
8. Letter 875 (25 May 1890).
9. Letter 873 (20 May 1890).
10. Marguerite Poradowska, 'Le Vase d'Urbino: Ultimes Souvenirs d'Auvers 1891', recorded on 10 August 1918 (Wildenstein Plattner Institute archive, ref. ziy5p8h8).
11. Letter 873 (20 May 1890).
12. Photograph in Wildenstein Plattner Institute archive, ref. 6160611b (reproduced in Gachet, 1956, fig. 28).
13. Bonger, 1958, p. LI.
14. Photograph in Wildenstein Plattner Institute archive, ref. 3n27ep64 (reproduced in Gachet, 1956, plate 10).
15. La Société des Eclectiques, *Almanach fantaisiste pour 1882*, Lemerre, Paris, 1881, pp. i-ii.
16. Gachet Jr, 1956, p. 68. See also the exhibition booklet *Les Dîners des Eclectiques et le Docteur Gachet* (Maison du Docteur Gachet, Auvers, 2017).
17. Gachet, 1858, p. 45.
18. Dr Gachet's Auvers house was in Rue Rémy/Rue des Vessenots (now 78 Rue Gachet). His Paris apartment was at 78 Rue du Faubourg Saint-Denis, where he also held his consultations.
19. Millon, 1998, pp. 204-8. Millon argued that there is circumstantial evidence that Louise and Dr Gachet had been lovers in the mid 1860s, and that he fathered her daughter (also named Louise) before his marriage, although this remains speculation.

20. *Le Vélocipède Illustré*, 12 May–9 June 1870.
21. Science Museum, London, inventory A58245.
22. Société des Eclectiques, December 1899 (an example of the print is in the Bibliothèque Nationale de France, Paris).
23. Gachet Jr, 1956, p. 19.
24. Wildenstein Plattner Institute archive, ref. 6160611b (reproduced in Gachet, 1956, fig. 24).
25. The original Zurbarán painting, now at the National Gallery, London (*St Francis in Meditation*, 1635–39), was the subject of several prints in the 19th century.
26. Van Gogh in Letter 879 (5 June 1890) called them aloe and cypress, but Gachet Jr, who knew the individual trees, corrected Van Gogh's mistake (Gachet Jr, 1994, p. 64 and Distel and Stein, 1999, pp. 78, 80 and 217–8).
27. Gachet Jr, 1994, p. 63.
28. Letter 877 (3 June 1890).
29. Letter 877 (3 June 1890).

CHAPTER THREE:
NESTS

(**pp. 44–6**)
1. Letter 873 (20 May 1890).
2. Letter 874 (c.21 May 1890) and unsent letter RM19 (c.21 May 1890).
3. Letter 809 (c.8 October 1889).
4. Letter 507 (c.9 June 1885), see also 515 (c.14 July 1885) and 533 (4 October 1885).
5. Albert Aurier, 'Les Isolés: Vincent van Gogh', *Mercure de France*, January 1890, p. 25.
6. Letter 874 (c.21 May 1890) and unsent letter RM20 (24 May 1890).
7. Cottages in Rue du Gré (Bakker and others, 2023, p. 206)
8. Letter 874 (c.21 May 1890).
9. Cottages at 24 Rue Rajon (Bakker and others, 2023, p. 208).
10. Probably the house at 18 Rue Rajon (Mothe, 2003, p. 72 and Veen, 2010, p. 123). The lower part still survives, remodelled and with a tiled roof – it is now a restaurant, Le Cordeville.
11. Cottages in Rue du Four (Bakker and others, 2023, p. 210).

CHAPTER FOUR:
INTO THE LANDSCAPE
(pp. 47–51)

1. Letter 891 (24 June 1890).
2. The farmhouse, which still survives, is at 20 Rue Carnot, at the corner with Rue Roger (Carol Wilson and Catherine Young, 'Deux Tableaux de Vincent van Gogh identifiés à Auvers-sur-Oise', *Vivre en Val-d'Oise*, November 1995, pp. 62–5, see also Mothe, 2003, p. 38; Veen and Knapp, 2010, pp. 74 and 79; and Bakker and others, 2023, p. 211).
3. Houses in Rue des Meulières (Bakker and others, 2023, 206).
4. The white house at the top of the painting still survives at 30 Rue Daubigny.
5. *Poppy Field* had a chequered history during the Second World War (Ten Berge, Meedendorp, Vergeest and Verhoogt, 2003, pp. 392–3). It was recovered in Germany in 1948 by the Dutch authorities and is now on permanent loan to the Kunstmuseum, The Hague. See Letter 887 (14 June 1890).
6. The location could be at the end of Rue Guérin, the section now known as Rue des Cressonnières (Mothe, 2003, p.160) or the Lilot jetty in Chaponval (fig. 27).
7. The view is from the hamlet of Montcel, from Rue Rajon (Mothe, 2003, p. 151) or the adjacent railway embankment, looking down on the road that is now Rue Marcel Martin.
8. The bridge was destroyed by French troops in 1914, to stop the invading Germans, and rebuilt after both the First and Second World Wars.
9. Letter 886 (13 June 1890).
10. Letter 886 (13 June 1890). The view is from the hillside of the hamlet of Saint-Martin. The road below is Rue François Villon and the buildings (which still survive) then served as an inn, at 53–55 Rue François Villon (Mothe, 2003, p. 74).
11. It is possible that the scene is from Les Vessenots (Bakker and others, 2023, p. 208).

CHAPTER FIVE:
PORTRAIT OF DR GACHET
(pp. 52–9)

1. Letter 886 (13 June 1890).
2. Letter 879 (5 June 1890).
3. These include painted portraits by Ambroise Detrez (1850–52), Amand Gautier (1854 and 1859-61) and Norbert Goeneutte (1891, fig. 19), drawings by Cézanne (two works, both1872–73) and three sculptures by Henry Fugère (1898). See Distel and Stein, 1999, pp. 32–3.
4. Van Gogh made four surviving versions of *The Arlésienne* (February 1890), but the one he took to Auvers was either F540 (Galleria Nazionale d'Arte Moderna Contemporanea, Rome) or F541 (Kröller-Müller Museum, Otterlo).
5. *Still Life with plaster Statuette*, 1887 (F360, Kröller-Müller Museum, Otterlo). The loan of *Germinie Lacerteux* is recorded in Gachet Jr, 1994, p. 99 and *La Fille Elisa* appears in a photograph of 'Souvenirs' (fig. 80). It is unclear whether the two books were loans or gifts.
6. Wildenstein Plattner Institute archive, ref. 75qds8t1.
7. The hands can be seen in photographs (Wildenstein Plattner Institute archive, ref. owgml50q and 8hrfty7r).
8. Goeneutte used and may have invented the nickname (Coquiot, 1923, p. 54).
9. Doiteau, September 1923, p. 216.
10. He also wears the rosette in a photograph (fig. 29).
11. Letter 877 (3 June 1890).
12. Letters 879 (5 June 1890) and unsent letter RM23 (c.17 June 1890).
13. Letter 877 (3 June 1890).
14. Gachet Jr, 1994, pp. 102–5 and 114.
15. It is possible that the colours may have faded differently in the two versions, because of the pigments used, which might account for some of the differences in colouration.
16. Gachet Jr, 1994, p. 103.
17. Gachet Jr, 1953a, unpaginated.
18. Sjraar van Heugten and Fieke Pabst, *The Graphic Work of Vincent van Gogh*,

Waanders, Zwolle, 1995, pp. 79–86 and 99–106. A few more examples of the print have emerged since the publication of this study.

19. The 25 May date is argued in Doiteau, November 1923, p. 253 and Gachet Jr, 1994, pp. 56–7. The 15 June date is given, probably as the correct date, by Sjraar van Heugten and Fieke Pabst (*The Graphic Work of Vincent van Gogh,* Van Gogh Museum, Amsterdam, 1995, p. 79, see also Distel and Stein, 1999, pp. 101). Theo referred to the etching in Letter 890 (23 June 1890), further evidence that the 15 June date is most likely.

20. Gachet Jr, 1953a, unpaginated.

21. Letter 889 (17 June 1890).

22. Unsent letter RM23 (c.17 June 1890). *Road with a Cypress and a Star* (early May 1890, F683, Kröller-Müller Museum, Otterlo). The drawings of the *Sunflowers* are in his Auvers sketchbook (Van der Wolk, 1987, pp. 240–1, also pp. 302-9). See also Letter 889 (17 June 1890).

23. Letter 886 (13 June 1890).

CHAPTER SIX:
FAMILY VISIT
(pp. 60–7)

1. Letter 879 (5 June 1890).

2. Letter 880 (5 June 1890).

3. The adjacent restaurant, A la Halte de Chaponval, was run by Félix Penel, an artist and friend of Dr Gachet. It is very likely that Van Gogh met Penel at some point during his Auvers stay.

4. Bonger, 1958, p. LI.

5. Bonger, 1958, p. LI-LII. Vincent used the French expression: *cocorico.*

6. *Qui était le Docteur Gachet?,* Office de Tourisme, Auvers, 2003, p. 29. It is difficult to establish exactly when he owned all these animals, but he would certainly have had a good selection of them on the day of Theo's visit. It has also been claimed that Dr Gachet always had 16 to 18 cats (Gustave Coquiot, *Paul Cézanne,* Ollendorff, Paris, c.1919, p. 53).

7. The painting is lost (Distel and Stein, 1999, p. 132). He also contributed a print

of a pair of pigs in Arsène Houssaye, *Le Cochon,* Librairie de l'Eau-forte, Paris, 1876, p. 40.

8. Letter 879 (5 June 1890).

9. For a history of the church, see J. Ramond and E. Mesplé, *Notre-Dame d'Auvers,* Sanctuaires et Pélerinages, Paris, c.1962.

10. The painting was not reproduced until the 1950s, in black and white (André Malraux, 'Une Leçon de Fidélité', *Arts,* 21 December 1951) and then in colour (Germain Bazin, 'Van Gogh et les Peintres d'Auvers chez le Docteur Gachet', *L'Amour de l'Art,* 1952, plate 1).

11. Van Gogh did a number of paintings of the Nuenen church, but the one that is closest in composition is *The Old Tower,* May 1884 (F88, Bührle Collection, on long-term loan to Kunsthaus Zurich).

12. Letter 879 (5 June 1890).

13. Gachet Jr to Jo, c.19 February 1912 (Van Gogh Museum archive, b3398).

14. Bonger, 1958, p. LII.

15. Letter 881 (10 June 1890).

16. Letter 877 (3 June 1890).

17. Stolwijk and Veenenbos, 2002, p. 76.

18. Letter 883 (11 June 1890).

19. Reproduced in Gachet Jr, 1956, plate 21.

20. Because of Van Gogh's interest in Japanese art, he hoped to meet the artist Louis Dumoulin, who visited Japan in 1888 and was working partly in Auvers in May-June 1890. It is unclear if they actually met. See Letters 874 (c.21 May 1890) and 877 (3 June 1890).

21. Gachet, 1858, p. 102.

CHAPTER SEVEN:
VAST WHEATFIELDS
(pp. 68–71)

1. Letter 899 (10–14 July 1890).

2. Letter 811 (c.21 October 1889).

3. Possibly Les Vessenots, west of the centre of Auvers (Bakker and others, p.212). The painting may depict the Four farm, viewed from the fields off Rue de Four (Mothe, 2003, p. 164), which also appears in plate 8.

4. Letter 886 (13 June 1890). The house may possibly be that of Numa Crohin (Gachet Jr, 1994, pp. 130 and 177, n. 83).
5. Unsent letter RM23 (c.17 June 1890). A second painting of wheat sketched in the unsent letter is lost or was never completed.
6. Unsent letter RM23 (c.17 June 1890).
7. Letter 902 (23 July 1890).
8. The track probably leads to the neighbouring village of Hérouville, to the north of Auvers.
9. Letter 898 (c.10 July 1890). Van Gogh was probably referring to two double-square wheatfield paintings (plates 37 and 45).
10. Letter 898 (c.10 July 1890).
11. The sky is often seen as stormy, but Veen (2010, p. 222) writes that 'lovely masses of clouds roll through a blue sky'.
12. Letter 899 (10–14 July 1890).
13. Until the 1990s this picture was thought to have been possibly painted in Arles, but the consensus now is that it dates from Auvers.

CHAPTER EIGHT:
BOUQUETS
(pp. 72–6)

1. Letter 877 (3 June 1890).
2. Letter 899 (10–14 July 1890).
3. Letters 877 (3 June 1890) and 873 (20 May 1890). Dr Gachet's Cézannes included *Geraniums and Coreopsis in a small Delft Vase* (private collection), *Bouquet with Yellow Dahlias, Bouquet in a small Delft Vase* and probably *Dahlias in a large Delft Vase* (all 1873, with the latter three now at the Musée d'Orsay, Paris). Dr Gachet also owned Monet's *Chrysanthemums* (1878, Musée d'Orsay).
4. Around 43 flower still lifes from Paris survive, but others must have been lost.
5. F453, F454, F455, F456, F457, F458 and F459.
6. F678 (Van Gogh Museum, Amsterdam), F680 and F682 (both Metropolitan Museum of Art, New York) and F681 (National Gallery of Art, Washington, DC).

7. *Blossoming Chestnut Branches* was stolen from the Bührle Collection in Zurich, along with three other paintings, on 10 February 2008, but was recovered eight days later.
8. Letter 22 (30 April 1874).
9. These included the pair which were later mounted on gold paper, 14 prints which were later assembled in a portfolio by Gachet Jr (Musée Guimet, Paris), two sheets by Keisai Eisen (lost) and two larger prints (one at the Courtauld Gallery, London, the other stolen from there). See Chris Uhlenbeck, Louis van Tilborgh and Shigeru Oikawa, *Japanese Prints: The Collection of Vincent van Gogh*, Van Gogh Museum, Amsterdam, 2018, pp. 37, 54–5, 213 (note 17) and 214 (note 23) and Gachet Jr, 1994, p. 254.
10. In French this fabric is called *torchon*. Along with figs 59, and 66, it was also used for *Daubigny's Garden* (F765, Musée d'Orsay, Paris) and *Ears of Wheat* (F767, Van Gogh Museum). See *The Art Newspaper*, September 2007.
11. Letter 889 (17 June 1890).

CHAPTER NINE:
PORTRAITS
(pp. 77–81)

1. Letter 879 (5 June 1890).
2. Letter 879 (5 June 1890).
3. Letters 877 (3 June 1890) and 879 (5 June 1890).
4. Letter 877 (3 June 1890).
5. The object has sometimes been seen as a ball, but it is more likely to be an orange. It was recorded as an orange in an 1890 inventory (Andries Bonger list, no. 273, Van Gogh Museum archive, b3055).
6. Germaine's older sister Adeline said in the 1950s that the painting depicted a child of their neighbour, the carpenter Levert (Ravoux, 1955, p. 15, which was repeated by Gachet Jr, 1994, p. 201). But Levert does not appear to have had a child aged two (as specified by Adeline).
7. The second version, kept by Vincent and Theo, is now in a private collection (plate 29). There is also a third portrait,

possibly also of Adeline, now at the Cleveland Museum of Art (F786), in which the woman has the same clothing and hair, although she looks considerably older than 12.

8. Letter 891 (24 June 1890).
9. Adeline was born on 20 November 1877 in Rueil, making her 12 when Van Gogh was in Auvers, although her age is often stated as 13. Adeline herself said on several occasions in the 1950s (including Ravoux, 1955, pp. 9–10) that she was the sitter in the portrait. One version of the portrait (F769) was simply known as 'the woman in blue' from the 1890s until the 1920s. The sitter is described as 'la Demoiselle de chez Ravoux' (the young woman from the Ravouxs) and 'Mlle [Mademoiselle] Ravoux' in Coquiot, 1923, pp. 253 and 320.
10. Ravoux, 1955, p. 9–10. Some of her comments were presumably based on what she had later read about the artist or gleaned from his letters. For instance, Van Gogh described his Arles *Sunflower* paintings in a published letter as 'a symphony in blue and yellow' (Letter 666, 21–22 August 1888).
11. Ravoux, 1955, p. 9.
12. Van Gogh Museum archive, T-797.
13. The 1860s Alphonse Juvenois piano was donated by Gachet Jr in 1952 to what is now the Musée des Instruments de Musique, Brussels.
14. Gachet Jr, 1956, p. 128.
15. Gachet Jr, 1953b, unpaginated.
16. F1623r (June 1890, Van Gogh Museum, Amsterdam).
17. Wildenstein Plattner Institute archive, ref. ousepya2.
18. Letter 893 (28 June 1890).
19. Note dated 14 October 1960. Yves Vasseur, *Vincent van Gogh: Matters of Identity* (Yale University Press, 2021, pp. 102–36). Vasseur reproduces a now-lost 1908 painting by Gachet Jr of Marguerite playing the harmonium, suggesting that it represents Van Gogh's composition (p. 122, also Wildenstein Plattner Insitute archive, ref. m0m91hat).

However, it is more likely to be an imaginary image, painted in homage to Van Gogh. Vasseur successfully tracked down the Gachet harmonium instrument (now at Artothèque, Mons).
20. Letter 902 (23 July 1890). See also Gachet Jr, 1994, p. 141 and the pamphlet by Paul Guedon (*M. Félix Vernier*, Frémont, Beaumont-sur-Oise, 1892). The Hirschig portrait, which was given to Vernier, is lost.
21. Letters 891 (24 June 1890) and 896 (2 July 1890).
22. Unsent letter RM23 (c. 17 June 1890).
23. The same model may possibly appear in a third portrait, *Young Woman against a Pink Background* (June 1890, F518, Kröller-Müller Museum, Otterlo).

CHAPTER TEN:
GAUGUIN'S TROPICAL DREAM
(pp. 82–5)
1. Letter 889 (17 June 1890).
2. Letter 884 (c.13 June 1890).
3. Letter 889 (17 June 1890).
4. Bailey, 2016, p. 154.
5. Letter 801 (10 September 1889).
6. Implied by Letter 884 (c.13 June 1890).
7. Daniel Wildenstein, *Gauguin: Catalogue Raisonné of the Paintings (1873–1888)*, Wildenstein Institute, Paris, 2002, W82–W91 (vol. i, pp. 93–103).
8. Letter 892 (c.28 June 1890). By a curious coincidence, Gauguin's estranged wife Mette had once nearly ended up staying with the doctor. In 1883 Eugène Murer, a close friend of Dr Gachet, had asked the doctor whether he might be able to rent some rooms for a month. Murer explained: 'It is for Madame Gauguin; I think you know her husband. The woman is charming, very agreeable, not a poseur and with fairly simple tastes' (Murer to Dr Gachet, 12 June 1883, Gachet Jr, 1957a, pp. 168–9, where the letter is incorrectly dated to 1890). The rental arrangement never went ahead.
9. Letter 884 (c.13 June 1890).
10. Unsent letter RM23 (c.17 June 1890).

11. Unsent letter RM23 (c.17 June 1890).
12. Letter 897 (5 July 1890). The paintings sold were *Oranges and Lemons with a View of Pont-Aven* (1889, Museum Langmatt, Baden) and *Dogs Running in the Grass* (1888, location unknown).
13. Letter 892 (c.28 June 1890). Van Gogh seems to have replied to Gauguin on 1 or 2 July 1890, but the letter has been lost (Pickvance, 1992, p. 83).

CHAPTER ELEVEN:
DAY TRIP TO PARIS
(pp. 86–91)
1. Letter 896 (2 July 1890).
2. Vincent nearly saw Theo a week later, since Camille Pissarro had invited the two brothers to visit Eragny on 14 July (Camille Pissarro to Theo, 6 July 1890, sold at Drouot, Paris, 2 July 2002). Theo was about to leave for the Netherlands, and declined the invitation.
3. Letter 894 (30 June–1 July 1890).
4. *Cypresses* (June 1889, F620, Kröller-Müller Museum, Otterlo). Bonger wrote (1958, p. LII) that Aurier had come on 6 July, although they might also have met at Aurier's during Van Gogh's 17–20 May Paris stay (as reported by Julien Leclercq (*Exposition d'Oeuvres de Vincent van Gogh*, Bernheim-Jeune, Paris, 1901).
5. Bonger, 1958, p. LII.
6. Henri Perruchot, *Toulouse-Lautrec: A definitive Biography*, Perpetua, London, 1960, opposite p. 96.
7. Musée Toulouse-Lautrec, Albi. Letter 898 (c.10 July 1890). Van Gogh could have briefly visited Toulouse-Lautrec's studio, which was five minutes' walk away in Rue Tourlaque, or the painting may have been brought to Theo's apartment.
8. Letter 898 (c.10 July 1890). For background on de Swart, see Jaap Versteegh, *Fatale Kunst: Leven en Werk van Sara de Swart*, Nijmegen, 2016. There had been talk of Vincent meeting his artist friend Ernest Quost in Paris, but this did not happen (Letter 890, 23 June 1890). The idea had also been mooted of meeting Edmund Walpole Brooke, an

Australian artist who had been brought up in Japan and was studying in Paris and partly working in Auvers (where he stayed at the Hotel du Cadran, Rue Victor Hugo). See Letters 896 (2 July 1890) and 897 (5 July 1890) and his visitor's card (Van Gogh Museum archive, b9063). For information on Brooke, see Tsukasa Kōdera, Cornelia Homburg and Yukihiro Sato, *Van Gogh & Japan*, Seigensha, Kyoto, 2017, pp. 173-4, 180 and 205-9.
9. Bonger, 1958, p. LII.
10. Letter 894 (30 June–1 July 1890).
11. Letter 894 (30 June–1 July 1890).
12. Jo to Mien Bonger, 21 April 1890 (Van Gogh Museum archive, b4303).
13. Maurice Joyant, *Henri de Toulouse-Lautrec 1864–1901: Peintre*, Floury, Paris, 1926, p. 118.
14. Letter 894 (30 June–1 July 1890).
15. On 7 July Theo and Jo decided to go ahead with the move, then changed their mind later in the month, and finally went ahead in September– so the uncertainty was very unsettling.
16. Bonger, 1958, p. LII.
17. Unsent letter RM24 (7 July 1890). Vincent appears to have sent a letter to Theo based on the RM24 draft, probably on 7 or 8 July, but this has not been preserved. This letter was referred to in Theo's letter to Mother and Wil (24 August 1890, Van Gogh Museum archive, b936), but the page of the 24 August letter summarizing the letter from Vincent appears to have been destroyed or lost by the family, since this page is missing.
18. Letter 898 (c.10 July 1890). Jo's conciliatory letter is lost.
19. Letter 898 (c.10 July 1890).
20. In addition to plate 37, he painted *Wheatfield with Crows* (plate 45) and *Daubigny's Garden* (plate 41).
21. Letter 898 (c.10 July 1890).

CHAPTER TWELVE:
DOUBLE SQUARES
(pp. 92–6)

1. Letter 891 (24 June 1890).
2. Letter 891 (24 June 1890). The published letter translates *soir* as 'night', but 'evening' is more accurate. Van Gogh viewed the château from just west of the centre of the village looking north west, a few hundred metres from the building, at a spot near what is now Rue Van Gogh or Rue Alphonse Calle (see Bakker and others, p. 213).
3. Letter 896 (2 July 1890).
4. Letter 896 (2 July 1890).
5. Letter 893 (28 June 1890).
6. Letter 450 (mid-June 1884).
7. The garden is at 24 Rue du Général de Gaulle (with the house located in Rue Daubigny).
8. *Daubigny's Garden* (F765, Van Gogh Museum, Amsterdam).
9. Letter 898 (c.10 July 1890).
10. Villa Ida (earlier known as the Villa Richard) still stands at 10 Rue Daubigny.
11. It has often been assumed to have been painted in the wheatfields just to the west of the cemetery (Gachet Jr, 1994, p. 221), although it is quite possible that the view is from the other side of the river, near Méry-sur-Oise (Veen and Knapp, 2010, p. 205 and Bakker and others, 2023, p. 217).
12. Van Gogh's painting is *Bridge in the Rain*, October–November 1887 (F372, Van Gogh Museum, Amsterdam).

CHAPTER THIRTEEN:
LAST PICTURE
(pp. 97–101)

1. Letter 898 (c.10 July 1890).
2. Carel Blotkamp, *The End: Artists' Late and Last Works*, Reaktion, London, 2019.
3. For a brief study on this picture, see John Leighton, *Vincent van Gogh: Wheatfield with Crows*, Waanders, Zwolle, 1999.
4. Bonger, 1958, p. LII.
5. *De Nieuwe Gids*, December 1890, p. 268.
6. *Nederland* (journal), March 1891, p. 318.
7. *Vincent van Gogh*, Stedelijk Museum, Amsterdam, 1905, no. 234; *Vincent*

van Gogh, Moderne gallery, Munich, 1908, no. 71; and *Vincent van Gogh-Paul Cézanne*, Emil Richter gallery, Dresden, 1908, no 69.
8. Letter 898 (c.10 July 1890).
9. Letter 902 (23 July 1890).
10. F780, Kunsthaus Zurich.
11. Albert Chatelet, 'Le dernier tableau de Van Gogh', *Archives de l'Art Français*, 1978, pp. 339–42.
12. For a detailed study of this painting, see Marja Supinen and Tuulikki Kilpinen, *Ateneum* (Finnish National Gallery Bulletin), 1994, pp. 32–81.
13. The location is 67 Rue Daubigny (Gachet Jr, 1994, pp. 72 and 87 note 43, and Bakker and others, 2023, p. 208).
14. Depicting 24 Rue Rajon (Bakker and others, 2023, p. 218).
15. Société des Artistes Indépendants, 1891, no. 1204. Van Gogh sometimes used the term *esquisse* (sketch) for an oil painting. See Maes and Van Tilborgh, 2012, pp. 67-8.
16. Depicting 24 Rue Rajon, Cordeville (Bakker and others, 2023, p. 218)
17. Two other Auvers paintings that could be regarded as unfinished are *Cottages* (F758, private collection) and *Farmhouse* (plate 7), but both date from late May–mid-June 1890.
18. Maes and Van Tilborgh, 2012, p. 71, note 37. The article is in the *Nieuwe Rotterdamse Courant*, 5 September 1893. The author has been identified as Andries Bonger because his sister Jo wrote the words 'A. Bonger' on the cutting in her scrapbook (Van Gogh Museum archive).
19. Van Gogh painted two other 'undergrowth' pictures in Auvers: *Undergrowth with two Figures* (plate 39) and *Trees* (F817, private collection), but only the former is 'full of sun and life' and is possibly unfinished. Van Gogh's letters show that *Undergrowth with two Figures* was painted in late June (Letters 891, 24 June 1890 and 896, 2 July 1890).
20. *Nederland* (journal), March 1891, p. 319. De Meester also wrote that the painting was 'full of sun and life', the precise expression that would be used two

years later by Andries Bonger (*Nieuwe Rotterdamse Courant*, 5 September 1893). Presumably Bonger either read de Meester's article, agreed with the words and repeated them, or he had earlier used the words when speaking with de Meester. But whichever was the case, Bonger, who knew Van Gogh's later paintings and life so well, believed that *Tree Roots* was the very last picture.

21. Veen, 2020.
22. Letter 902 (23 July 1890).

PART II: THE END

CHAPTER FOURTEEN:
SHOT
(pp. 103–6)

1. Letter 506 (c.2 June 1885). Van Gogh was citing a quotation from Emile Zola, *Au Bonheur des Dames*, Charpentier, Paris, 1883, p. 389.
2. There are a number of reports from witnesses about what happened on 27 July, many with conflicting details. I have set out to record what seems the most likely scenario, based wherever possible on 1890s accounts. Two of the most reliable recent summaries are Rohan, 2012 and Van Tilborgh and Meedendorp, 2013.
3. The earliest source to report that Van Gogh set off to paint was Bernard, who may have wished to emphasise his friend's commitment to his work (Bernard to Aurier, 31 July 1890, McWilliam, 2012, p. 117). But in the same letter, Bernard wrote that Van Gogh's easel and folding stool were placed next to his coffin. No painting equipment was apparently recovered after the shooting and it is rather unlikely that Van Gogh had two sets.
4. Bernard to Aurier, 31 July 1890 (McWilliam, 2012, p. 117).
5. Hirschig wrote in 1911 that the gun belonged to Ravoux (Hirschig to Albert Plasschaert, 8 September 1911, Van Gogh Museum archive, b3023), although this remains unconfirmed.

6. As an adult, Gachet Jr kept a revolver by his bedside (Golbéry, 1990, p. 76), which might suggest that his father had also owned a gun for self-protection.
7. It has been suggested that Ravoux lent the gun to scare away crows (Gustave Coquiot, *Des Peintres maudits*, Delpeuch, Paris, 1924, p. 329 and Tralbaut, 1969, p. 329), but this is unlikely since the crows would have posed little problem to Van Gogh.
8. Statement by Pierre Leboeuf, 28 January 2004, recording that his great-grandfather Augustin had sold the weapon (reproduced in Rohan, 2012, p. 67).
9. The shop was established in 1854 by Augustin Leboeuf and remained in business at the same address, 8 Rue de l'Hôtel de Ville, Pontoise, right up until 2018. See Christiane Leroy, *Vivre en Val d'Oise*, November 2002, pp. 28–31.
10. The Lefaucheux revolver found in the field in c.1960 had a 7mm calibre. In Gachet Jr's book he wrote that it was a 7mm gun which had been used (Gachet Jr, 1994, p. 248), although in an earlier letter he had given the calibre as 9mm (Gachet Jr to Jo, 19 February 1912, Van Gogh Museum archive, b3398). René Secrétan gave the calibre of his gun as 0.38 inches (9.6mm) (Doiteau, 1957, p. 46), but this was probably not the gun used in the shooting.
11. There is an alternative route to the location, to the east (rather than the west) of the château, but it was steep and is probably slightly longer.
12. It has also been suggested that the shooting took place down in the village itself, in a farmyard in Rue Boucher, towards Chaponval. But this theory was only put forward in the 1950s by Marc Tralbaut, following an interview with a Madame Liberge, who heard the story from her unnamed father (Tralbaut, *Van Gogh: A pictorial Biography*, Thames & Hudson, London, 1958, p. 123 and with more detail, Tralbaut, 1969, pp. 326–7). This account was accepted in Naifeh and Smith (2011, p. 872), but there is little evidence to support the Rue Boucher

theory. Although Tralbaut does not identify the people involved, Madame Liberge was presumably Laure Crohin (1884–1958), who married Dr Fernand Liberge in 1907. Laure was therefore not 'about the same age as Marguerite Gachet' (born 1869) and unlikely to have been a childhood friend of hers, as Tralbaut claims (1969, p. 326) – since they were 15 years apart in age. Laure's father, who is supposed to have known about the shooting, was Numa Prosper Crohin (born 1859).

13. Bernard to Aurier, 31 July 1890 (McWilliam, 2012, p. 117).

14. *Le Régional* (7 August 1890) and *L'Echo Pontoisien* (7 August 1890). Both Bernard and the newspapers probably got their information from Arthur Ravoux and/or Dr Gachet.

15. Rohan, 2012, p. 57. Although not named in Rohan's study, the nun was Hélène Lignereux, who wrote her memories in 1998 ('La Mémoire d'Auvers', a manuscript compiled at the suggestion of Claude Millon). Her grandfather was Léon Adrien Jacquin (1872–1944).

16. Coquiot, 1923, p. 258; Doiteau and Leroy, 1928, p. 91; and Ravoux, 1955, p. 12.

17. Sometimes spelt Bartelets (1813 plan cadastral, Archives Départementales, Val d'Oise, Pontoise, ref. 3P1953).

18. *La Plume*, 15 June 1905, p. 606.

19. Gachet Jr, 1994, p. 247. A photograph of the location was published in 1954 (Maximilien Gauthier, "Van Gogh à Auvers", *Les Nouvelles Littéraires*, 25 November 1954). The photograph in the newspaper was mistakenly reversed. It has recently been suggested by Wouter van der Veen that the "chateau" was probably a building now generally known as the Manoir de Colombieres (housing since 1986 the Musée de Daubigny) which is very close to the auberge (*L'Oeil*, September 2023).

20. Gachet Jr, 1994, pp. 247–8. This account is detailed, suggesting it may come from now-lost medical notes by Dr Gachet.

21. It is possible that there were no bullets left, something went wrong with the gun or he dropped the weapon and could not find it or pick it up – but it seems more likely that he never attempted to fire a second shot.

22. Bernard to Aurier, 31 July 1890 (McWilliam, 2012, p. 117).

CHAPTER FIFTEEN:
FINAL HOURS
(pp. 107–112)

1. Van Gogh, on 27 July 1890 in Bernard to Aurier, 31 July 1890 (McWilliam, 2012, p. 117).

2. Theo to Jo, 1 August 1890 (Jansen and Robert, 1999, p. 279).

3. Gachet Jr to Jo, c.19 February 1912 (Van Gogh Museum archive, b3398).

4. Gachet Jr, 1956, p. 35.

5. Gachet Jr, 1994, p. 248.

6. Gachet Jr to Jo, c.19 February 1912 (Van Gogh Museum archive, b3398). Murer also gave a similar account, presumably based on what he had been told by Dr Gachet (Marianna Burt, 'Le Pâtissier Murer', *L'Oeil*, December 1975, p. 61).

7. Theo's letter to Dr Gachet of 9 May 1890 included both his home and office addresses (Van Gogh Museum archive, b2014).

8. Van Gogh Museum archive, b3265.

9. Dr Gachet to Theo, 27 July 1890 (Van Gogh Museum archive, b3265).

10. Ravoux, 1955, p. 13. Adeline named one of the gendarmes as [Emile] Rigaumont. Bernard also reported the arrival of the gendarmes (Bernard to Aurier, 31 July 1890, McWilliam, 2012, p. 117).

11. Theo to Jo, 28 July 1890 (Jansen and Robert, 1999, p. 269).

12. Theo to Jo, 28 July 1890 (Jansen and Robert, 1999, pp. 269–70).

13. Hirschig to Albert Plasschaert, 8 September 1911 (Van Gogh Museum archive, b3023). See also a later account by Hirschig in Abraham Bredius, 'Herinneringen aan Vincent van Gogh', *Oud Holland*, 1934, p. 44.

14. *Le Régional*, 7 August 1890 (fig. 60).

15. The death record gives the time as 1.30 am, although Gachet Jr recorded it as 'about 1am' (Gachet Jr, 1994, p. 252), as does Doiteau and Leroy (1928, p. 94), presumably based on information from Gachet Jr.

16. Theo to Jo, 1 August 1890 (Jansen and Robert, 1999, p. 279).

17. Theo to Lies, 5 August 1890 (Pickvance, 1992, pp. 72–3).

18. Gachet Jr, 1994, p. 255.

19. Gachet Jr, 1956, p. 118.

20. Mother and Wil to Jo, 31 July 1890 (Van Gogh Museum archive, b1003).

21. Jo to Theo, 1 August 1890 (Jansen and Robert, 1999, p. 277).

CHAPTER SIXTEEN:
FUNERAL
(pp. 113–121)

1. Letter 638 (9–10 July 1888).

2. Hirschig to Albert Plasschaert, 8 September 1911 (Van Gogh Museum archive, b3023).

3. Distel and Stein, 1999, p. 141, n. 6.

4. Of the 36 painted self-portraits, only one from September 1889 depicts him without facial hair (F525, private collection). Coquiot recorded that on Van Gogh's arrival in Auvers in May he was shaven, but after that he was irregular in shaving (notebook, 1922, Van Gogh Museum archive, b3348, p. 127).

5. Distel and Stein, 1999, p. 140.

6. The drawing for Theo is now at the Van Gogh Museum, Amsterdam. Dr Gachet also made two other deathbed works: a drawing (private collection) and an etching (various collections, including the Musée d'Orsay, Paris). Although the oil painting (fig. 54) is normally dated to 1890, it could have been painted for Jo in 1905 from an 1890 work. See Distel and Stein, 1999, pp. 140–1 and Eugène Tardieu, 'Le Salon des Indépendants', Le Magazine Français Illustré, 25 April 1891, p. 535.

7. The main evidence for it being virtually all the ear is a drawing by Van Gogh's Arles doctor, Félix Rey, made in 1930 (Bancroft Library, University of California, Berkeley). This discovery was published in Murphy, 2016. My view is that Van Gogh removed most of the ear, but not all of it (Bailey, 2016, p. 206, note 16).

8. Adeline Ravoux later reported that the coffin had been made by Vincent Levert, a carpenter who lived near the auberge (Ravoux, 1955, p. 15), but the Godard receipt confirms their involvement (Van Gogh Museum archive).

9. Gachet Jr, 1994, p. 252.

10. Van Gogh Museum archive, b1993.

11. Andreas Obst's privately published study (Obst, 2010) provides an excellent account of the funeral and the moving of Vincent's remains in 1905. I am very grateful for Obst's assistance.

12. Hirschig to Albert Plasschaert, 8 September 1911 (Van Gogh Museum archive, b3023). A possible incision to remove the bullet might have exacerbated the leakage.

13. Bonger, 1958, p. LIII.

14. Bernard to Aurier, 31 July 1890 (McWilliam, 2012, p. 118).

15. Bernard to Aurier, 31 July 1890 (McWilliam, 2012, p. 118).

16. Ravoux, 1955, p. 15.

17. Theo to Jo, 1 August 1890 (Jansen and Robert, 1999, p. 279).

18. The 1893 painting, possibly uncompleted, was first reproduced in Art Documents, February 1953, p. 1. It may depict the funeral of Van Gogh (accepted by Gachet Jr, 1994, p. 256), as opposed to another funeral, although this is not certain. It is, however, accepted as Van Gogh's funeral in Jean-Jacques Luthi and Armand Israël, Emile Bernard: Sa Vie, son Oeuvre, Catalogue raisonné, Editions Catalogues Raisonnés, Paris, 2014, no. 335, p. 194.

19. There is no evidence that Dr Mazery attended.

20. There are two main sources on those who attended. The earliest is Bernard to Aurier, 31 July 1890 (McWilliam, 2012, p. 117–8) which lists Laval, Tanguy, Lucien Pissarro

and Lauzet. Gachet Jr (1994, pp. 255 and 278–9) added Andries Bonger, Hirschig, Martínez, Hoschedé, Bourges, Pearce, Wickenden, Los Ríos, Mesdag and Van der Valk and Camille Pissarro (it was in fact his son Lucien). See also Theo to his mother Anna, 31 July 1890 (Van Gogh Museum archive, b1003) and Andries Bonger to Coquiot, 23 July 1922 (Van Gogh Museum archive, b899).

21. *L'Echo de Paris*, 13 February 1894.

22. Bernard to Aurier, 31 July 1890 (McWilliam, 2012, p. 117). Bernard returned to Auvers in August or early September 1890 to see the gravestone (Theo to Dr Gachet, 12 September 1890, Van Gogh Museum archive, b2015).

23. Both Bernard and Laval had exchanged self-portraits with Vincent: Van Gogh's *Self-portrait for Laval*, December 1888 (F501, private collection); Laval's *Self-portrait for Vincent*, October 1888 (Van Gogh Museum, Amsterdam); and Bernard's *Self-portrait for Vincent*, September 1888 (Van Gogh Museum, Amsterdam).

24. Andries Bonger to Gustave Coquiot, 23 July 1922 (Van Gogh Museum archive, b899). The presence of Denis is very uncertain, since it is only noted in this source, 32 years later.

25. Theo to Jo, 1 August 1890 (Jansen and Robert, 1999, p. 279).

26. Although known as Murer, his real name was Meunier. Marianna Burt, 'Le Pâtissier Murer', *L'Oeil*, December 1975, pp. 61 and 92, notes 3 and 24, with quotations from a manuscript then in Burt's possession. (Van der Veen tracked her down in 2023, and was told that the manuscript had been burnt in a fire many years ago). This source states that Murer claimed to have met Van Gogh in Auvers and, if so, he would almost certainly have attended the funeral if he had been in the village on the day. This claim is also made in Murer to Théodore Duret, 18 July 1905 (Montaigne, 2010, p. 31). Murer at some point acquired Van Gogh's *Fritillaries* (spring 1887, F213, Musée d'Orsay, Paris).

27. Gachet Jr, 1994, p. 255. Hoschedé sometimes stayed in Auvers, but lived mainly in Paris. He probably would only have attended if he had been in Auvers on the day.

28. Van Gogh had apparently met Ten Cate briefly in 1881 (Letter 188, 21 November 1881) and probably saw him again in Auvers. Gachet Jr recounts Ten Cate's claimed encounter with Van Gogh (Gachet Jr, 1994, p. 288–9 and *Le Courrier Français*, 5 January 1913).

29. Letter 881 (10 June 1890), see also 885 (13 June 1890). The identity of these Americans remains unclear.

30. See Mary Lublin, *A Rare Elegance: The Paintings of Charles Sprague Pearce*, Jordan-Volpe, New York, 1993. Pearce's French wife Louise (Antonia) Bonjean, also an artist, may have attended the funeral. Pearce remained at Auvers until his death in 1914 and was then buried close to Van Gogh.

31. Alfred Wickenden (Robert's son) in 'Castle in Bohemia' (typescript in family collection, mid 20th century, p. 60). Robert's daughter Yvonne Wickenden wrote a paper on 'The Funeral Rites of Vincent van Gogh' (typescript in family collection, c.1930), although this wrongly claims that Van Gogh shot himself in his room (p. 4), and see Edgar Collard, *The Gazette* (Montreal), 29 October 1960. See also the thesis of Susan Gustavison, 'Robert J. Wickenden and the Late Nineteenth-Century Print Revival' (Concordia University, Montreal, 1989). Robert Wickenden published articles on Daubigny in *The Century Magazine*, July 1892, pp. 323–37 and *The Print Collector's Quarterly*, April 1913, pp. 76–206.

32. Adeline Ravoux later claimed that Martínez was a lodger at the auberge, which is probably incorrect, although he may well have patronized the café (1955, p. 7).

33. Bernard to Aurier, 31 July 1890 (McWilliam, 2012, p. 118).

34. Bernard to Aurier, 31 July 1890, (McWilliam, 2012, p. 118).

35. Theo to Jo, 1 August 1890 (Jansen and Robert, 1999, p. 279).

36. Bernard to Aurier, 31 July 1890 (McWilliam, 2012, p. 119).
37. Theo to Jo, 1 August 1890 (Jansen and Robert, 1999, p. 279).

CHAPTER SEVENTEEN:
SUICIDE OR MURDER
(pp. 122–145)

1. Letter 765 (30 April 1889).
2. In 1947 the French writer Antonin Artaud published an essay entitled *Van Gogh: Le Suicidé de la Société* (K, Paris, 1947), which argued that it was 'society' that had killed the artist, although not in a literal sense. An English translation has been published by Catherine Petit and Paul Bick, *Van Gogh: The Man Suicided by Society*, Vauxhall, London, 2019. This records that 'society, in order to punish him for having torn himself from its grip, suicided him' (p. 7) and 'he was dispatched by Dr Gachet who, instead of recommending rest and solitude, sent him off to paint from nature' (p. 50).
3. Naifeh and Smith, 2011, pp. 869–85.
4. Naifeh and Smith, 2011, p. 869.
5. Doiteau, 1957. See also Bernard Secrétan, *Secrétan: Histoire d'une Famille Lausannoise de 1400 à nos Jours*, Val de Faye, Lausanne, 2003, pp. 183–4.
6. Rewald never published this himself, but another Van Gogh expert wrote: 'There is a rumor in Auvers that young boys shot Vincent accidentally. The story goes that they were reluctant to speak up for fear of being accused of murder and that Van Gogh decided to protect them and to be a martyr' (Wilfred Arnold, *Vincent van Gogh: Chemicals, Crises and Creativity*, Birkhaüser, Boston, 1992, p. 259). Arnold added in a footnote: 'This was first recounted to me in 1988 by Professor John Rewald, who professed no particular belief in its accuracy'.
7. Although in a subsequent interview, Naifeh responded that Van Gogh was 'covering up his own murder' (CBS, 16 October 2011).
8. Interviews with Naifeh, CBS, 16 October 2011 and BBC, 17 October 2011.
9. Naifeh and Smith, 'The Van Gogh Mystery', *Vanity Fair*, December 2014, p. 144.
10. René claimed that Van Gogh had taken the gun from his fishing bag, which he had left for a short while near the bank of the Oise (Doiteau, 1957, p. 46). This would have had to be before René's departure from the Auvers area in mid-July. If so, surely René would have noticed the disappearance of the gun, and have been worried about its loss.
11. Doiteau, 1957, p. 48–9.
12. Dr Mazery moved from Auvers in the mid-1890s and died in 1921 in Royat.
13. Doiteau and Leroy, p. 92.
14. Naifeh and Smith, 2011, p. 877.
15. Van Tilborgh and Meedendorp, 2013, p. 459.
16. Doiteau and Leroy, 1928, p. 92.
17. Gachet Jr, 1994, p. 247.
18. Rohan, 2012.
19. Report of July 2006 in Rohan, 2012, pp. 113–5.
20. Di Maio to Naifeh, 24 June 2013. See also *Vanity Fair*, December 2014, pp. 171–2.
21. Di Maio to Naifeh, 24 June 2013. See also *Vanity Fair*, December 2014, pp. 171–2.
22. Doiteau and Leroy, p. 92 and Gachet, 1994, p. 247.
23. Theo to Jo, 24 December 1888 (Jansen and Robert, 1999, p. 68).
24. Roulin to Theo, 26 December 1888 (Van Gogh Museum archive, b1065).
25. Letter 750 (19 March 1889).
26. Coquiot, 1923, p. 194. A month earlier Van Gogh had suffered severe delusions about being 'poisoned' (Frédéric Salles to Theo, 7 February 1889, Van Gogh Museum archive, b1046).
27. Letter 765 (30 April 1889).
28. Jo to Mien Bonger, 9 August 1889 (Van Gogh Museum archive, b4292).
29. Letter 801 (10 September 1889). He repeated this expression twice in this letter, a probable indication of its importance in his own mind.
30. Peyron to Theo, c.2 September 1889 (Van Gogh Museum archive, b650), which is a postscript to Letter 798 (c.2 September 1889).

31. This is strongly implied in Letter 835 (3 January 1890).

32. Letter 842 (20 January 1890).

33. Peyron's note in the medical register, 16 May 1890 (Bakker, Van Tilborgh and Prins, 2016, p. 157).

34. Sister Epiphane (Rosine Deschanel) (Louis Piérard, *La Vie Tragique de Vincent van Gogh*, Correa, Paris,1946, p. 186) and Poulet (Jean de Beucken, *Un Portrait de Vincent van Gogh*, Balancier, Liège, 1938, pp. 133–4 and Tralbaut, 1969, p. 290). See also Bailey, 2018, pp. 123–9.

35. Van Gogh Museum archive, b4794a.

36. Martin Bailey, 'Vincent's other Brother: Cor van Gogh', *Apollo*, October 1993, pp. 218–9 and note 18 and Chris Schoeman, *The Unknown Van Gogh: The Life of Cornelis van Gogh*, Zebra Press, Cape Town, 2015, pp. 156–7 and 196, note 28.

37. Van Gogh Museum archive, b5324.

38. See Hans Luijten, *Alles voor Vincent: Het Leven van Jo van Gogh–Bonger*, Prometheus, Amsterdam, 2019, pp. 279 and 533. For further details of Wil's life see Willem-Jan Verlinden, *The Van Gogh Sisters*, Thames & Hudson, London, 2021 (on suicidal thoughts, see p. 102).

39. Erik van Faassen, 'Willemina van Gogh', *De Combinatie, maandblad van Veldwijk*, January 1986, pp. 7–13. A memo by Wil's brother-in-law, Joan Marius van Houton, dated 17 May 1941, states that she 'tried to commit suicide' (Van Gogh Museum archive, b4418).

40. Family background, of course, also needs to be considered. The children had been brought up in a loving, middle-class family with no particularly traumatic events apparent in their childhood and adolescence, although Vincent's difficult life and suicide (or their father's sudden death in 1885) could well have affected Cor and Wil. On balance, however, it would seem that their psychological problems were more likely to have been caused by an inherited medical condition rather than their family environment.

41. Letter 900 (14 July 1890).

42. Theo to Mother and Wil, 22 July 1889 (Van Gogh Museum archive, b933).

43. Letter 902 (23 July 1890).

44. Bernard to Aurier, 31 July 1890 (McWilliam, 2012, p. 117).

45. Theo to Jo, 1 August 1890 (Jansen and Robert, 1999, p. 279).

46. Theo to Lies, 5 August 1890 (Pickvance, 1992, p. 72).

47. Although a much less important consideration, suicide was regarded as sinful in Catholic France. Even if Theo did not perceive it in those terms, the fact that Vincent had been thought of as having taken his own life would be regarded as negatively impacting on the family's reputation.

48. On this date it was actually a suicide attempt, rather than a suicide, so it is possible that Dr Gachet may have written these words at some point after the death.

49. Dr Gachet to Theo, c.15 August 1890 (Pickvance, 1992, p. 145).

50. Bernard to Aurier, 31 July 1890 (McWilliam, 2012, p. 117).

51. Despite extensive efforts over the years, no records of the gendarmes' visit have been found in local archives.

52. Bernard to Aurier, 31 July 1890 (McWilliam, 2012, p. 117).

53. Georges Seurat wrote: 'Signac told me about his death as follows: "he slapped a bullet in his side"' (Seurat to Maurice Beaubourg, 28 August 1890; letter sold by Aguttes, Neuilly-sur-Seine, 1 April 2019, lot 154). Gauguin, in his 1903 memoir *Avant et Après*, wrote that 'Van Gogh shot himself in the stomach' (Crès, Paris, 1923, p. 24).

54. Ravoux, 1955, p. 12.

55. Hirschig to Plasschaert, 8 September 1911 (Van Gogh Museum archive, b3023).

56. I later tracked down a death notice in *Moniteur des Arts* (22 August 1890). Although the report includes several mistakes, it does go into considerable detail.

57. Letter from Lies to Theo and Jo, 2 August 1890 (Pickvance, 1992, p. 68).

58. Van Tilborgh and Meedendorp, 2013, p. 462.

59. Letter 804 (19 September 1889).

60. Letter 898 (c.10 July 1890).
61. Theo to Jo, 28 July 1890 (Jansen and Robert, 1999, p. 269).

CHAPTER EIGHTEEN:
THEO'S TRAGEDY
(pp. 147–151)

1. Unsent letter RM25 (23 July 1890).
2. Unsent letter RM25 (23 July 1890). An image of this important letter has very rarely been reproduced in print (see Bakker, Van Tilborgh and Prins, 2016, p. 82)..
3. Unsent letter RM25 (23 July 1890). Theo probably found or was handed this letter on 28 or 29 July. On the reverse of the page is the pencilled text 'M [Monsieur] Levasseur/chez [at] Boussod'. Its significance is unclear, but it is likely to refer to a member of the Levasseur family who worked as an engraver for Boussod & Valadon. The most notable was Jules-Gabriel Levasseur, but Theo's address book lists an H. Levasseur and an Alf. Levasseur (*Van Gogh à Paris*, Musée d'Orsay, Paris, 1988, pp. 361 and 363).
4. Letter 902 (23 July 1890).
5. Unsent letter RM25 (23 July 1890). In the final phrase is *'mais que veux tu'*, *tu* (you) strictly speaking refers to Theo, but Vincent may well have meant 'one', in more general terms
6. Theo to Jo, 25 July 1890 (Jansen and Robert, 1899, p. 261).
7. Theo to Jo, 1 August 1890 (Jansen and Robert, 1999, p. 279).
8. Jo to Theo, 31 July and 1 August 1890 (Jansen and Robert, 1999, pp. 276–7).
9. The quotation is cited by Tralbaut, although confusingly he attributes it to having been said to two different Dutch artists: Isaac Israëls (Tralbaut, 1959, p. 126) and Joseph Isaäcson (Tralbaut, 1969, p. 336).
10. Dr Gachet to Theo, c.15 August 1890 (Pickvance, 1992, p. 144).
11. Jo to Hendrik and Hermine Bonger, 22 August 1890 (Van Gogh Museum archive, b4307).

12. Andries to Hendrik and Hermine Bonger, 22 September 1890 (Henk Bonger, 'Un Amstellodamois à Paris' in Dieuwke de Hoop Scheffer and others, *Liber Amicorum Karel G. Boon*, Swets en Zeitlinger, Amsterdam, 1974, p. 69).
13. Johan de Meester, *Algemeen Handelsblad*, 31 December 1890.
14. Bernard, *Lettres de Vincent Van Gogh*, Vollard, Paris, 1911, p. 3.
15. Andries Bonger to Dr Gachet, 10 October 1890 (Gachet Jr, 1994, p. 291).
16. Camille to Lucien, 18 October 1890 (Doiteau, 1940, p. 84).
17. Piet Voskuil, 'Het Medische Dossier van Theo van Gogh', *Nederlands Tijdschrift voor Geneeskunde*, 1992, pp. 1777–9 and 'De Doodsoorzaak van Theo van Gogh', *Nederlands Tijdschrift voor Geneeskunde*, 7 May 2009. For a much earlier study of Theo's medical condition, see Doiteau, 1940, pp. 76–87.
18. Jansen and Robert, 1999, p. 49.
19. Van Gogh Museum archive, b4913.
20. Jo's diary, 25 January 1896 (Van Gogh Museum archive, vol. 4, diary published online).
21. The surviving correspondence between Vincent and Theo includes numerous references to Theo's health, although none specifically refer to syphilis. However, it is possible that any letters which had mentioned this would have been destroyed by Jo, who would have found the subject extremely distressing. Surviving correspondence refers to Theo being prescribed potassium iodide, which was used to treat syphilis, although it was also taken for other conditions (Letters 611, 20 May 1888 and 743, 28 January 1889).
22. Jo's diary, 29 (incorrectly inscribed 28) January 1892 (Van Gogh Museum archive, vol. 3, diary published online).
23. Jo's diary, 29 (incorrectly inscribed 28) January 1892 (Van Gogh Museum archive, vol. 3, diary published online).

PART III: FAME & FORTUNES

CHAPTER NINETEEN:
BIRTH OF A LEGEND
(pp. 143–151)

1. Letter 638 (9–10 July 1888).
2. John Rewald, 1986, p. 244. On Van Gogh's rise to fame, see Carol Zemel, *The Formation of a Legend: Van Gogh Criticism 1890–1920*, UMI, Ann Arbor, 1980; Kōdera, 1993; and Nathalie Heinrich, *The Glory of Van Gogh: An Anthology of Admiration*, Princeton, 1996.
3. Around 900 oil paintings survive. Some others were abandoned by the artist or are now lost, so Van Gogh's total output must have been close to 1,000.
4. November 1888 (F495, Pushkin Museum, Moscow). Although Van Gogh is traditionally said to have sold only a single painting, he probably sold one or two more (Martin Bailey, 'Van Gogh's first sale: A self-portrait in London', *Apollo*, March 1996, pp. 20–1).
5. References from January to July 1890 (published in Paris unless otherwise stated) include: *La Jeune Belgique* (Brussels), January 1890, p. 95 and February 1890, p. 124; *Mercure de France*, January, pp. 24–9, March, p. 90 and May 1890, p. 175; *L'Art Moderne* (Brussels), 19 January; *Het Vaderland* (The Hague), 28 January; *Le Figaro*, 29 January; *Art et Critique*, 1 February, p. 77 and 22 February, p. 126; *Le XIXe Siècle*, 21 March 1890; *La Lanterne*, 21 March; *La République Française*, 21 March; *La Petite Presse*, 21 March; *L'Echo de Paris*, 25 March; *L'Evénement*, 26 March; *L'Art et Critique*, 29 March; *Gil Blas*, 30 March; *Le Siècle*, 31 March; *La France Moderne*, 3 April; *Journal des Artistes*, 6 April; *La Justice*, 22 April; and *De Portefeuille* (Amsterdam), 10 and 17 May.
6. 'Les isolés: Vincent van Gogh', *Mercure de France*, January 1890, pp. 24–29 (quotation from p. 29), with a shortened version published in the Brussels journal *L'Art Moderne*, 19 January 1890, pp. 20–22.
7. Obituaries and death notices published in 1890 (published in Paris unless otherwise indicated) include: *L'Art Moderne* (Brussels), 3 August; *De Amsterdammer* (Amsterdam), 10 August; *Het Vaderland* (The Hague), 12 August; *Journal des Artistes*, 24 August; *La Jeune Belgique* (Brussels), August 1890, p. 323; *Mercure de France*, August, p. 330; *La Revue Indépendante*, September 1890, pp. 391–402; *De Nieuwe Gids* (Amsterdam), December 1890 and *Algemeen Handelsblad* (Amsterdam), 31 December; and *Moniteur des Arts* (22 August 1890)
8. Pickvance, 1992, pp. 109, 114 and 149.
9. *Les Hommes d'Aujourd'hui*, July 1891, pp. 1–4 (with Bernard's illustration based on Van Gogh' s *Self-Portrait* (summer 1887, F526, Detroit Institute of Arts) and 'Vincent van Gogh', *La Plume*, 1 September 1891, pp. 300–1.
10. *Mercure de France*, April 1893–February 1895 and August 1897 and *Lettres de Vincent van Gogh*, Vollard, Paris, 1911. For an English transslation of bernard's introduction, see *My Friend Emile Bernard* (Zwirner, New York, 2023, introduced by Bailey)
11. Gauguin to Theo, c.2 August 1890 (Pickvance, 1992, p. 133).
12. Gauguin to Bernard, August 1890 (Maurice Malingue, *Lettres de Gauguin à sa Femme et à ses Amis*, Grasset, Paris, 1946, pp. 200–1). See also, Gauguin to Bernard, August 1890 (Christie's, 19 May 2000, lot 169). Gauguin later revealed that Van Gogh had written, in his last letter to him, that it was better 'to die in a good condition than a degraded one'. Gauguin recalled the lost letter in his 1903 memoir (Paul Gauguin, *Avant et Après*, Crès, Paris, 1923, p. 24).
13. Gauguin to Bernard, October 1890 (Maurice Malingue, *Lettres de Gauguin à sa Femme et à ses Amis*, Grasset, Paris, 1946, p. 204).
14. Jo's diary, 15 November 1891 (Van Gogh Museum archive, vol. 3, diary published online).

15. Jo's diary, 24 February 1892 and 15 November 1891 (Van Gogh Museum archive, vol. 3, diary published online). For the definitive biography of Jo, see Hans Luijten, *Alles voor Vincent: Het Leven van Jo van Gogh-Bonger* (Prometheus, Amsterdam, 2019). An English translation has been published, Luijten, 2023.

16. Valuations compiled by Jan Veth, 23 June 1891 (Van Gogh Museum archive, b2215). Technically Theo's art collection passed to his one-year-old son Vincent Willem, but it would be administered by Jo into her old age.

17. Stolwijk and Veenenbos, 2002, p. 27.

18. Karl Osthaus had bought *Wheatfield with Reaper* (September 1889, F619, Folkwang Museum, Essen) in 1902, but the collection was privately owned, although shown to the public.

19. See Berge, Meedendorp, Vergeest and Verhoogt, 2003 and Teio Meedendorp, *Drawings and Prints by Vincent van Gogh in the Collection of the Kröller-Müller Museum*, Kröller-Müller Museum, Otterlo, 2007.

20. Three paintings (F518, F563 and F752) and the etching (F1664). Kröller-Müller also owned a painting that is no longer attributed to Van Gogh (fig. 83) and another, which she gave to her son Robert (plate 13).

21. Jo's diary, 6 March 1892 (Van Gogh Museum archive, vol. 4, diary published online).

22. Jo van Gogh-Bonger, *Vincent van Gogh: Brieven aan zijn Broeder*, Amsterdam, De Wereldbibliotheek, 1914, later translated into English as *The Letters of Vincent van Gogh to his Brother*, Constable, London, 1927–9.

23. Bonger, 1958, p. XIII.

24. Duret to Dr Gachet, 4 April 1900 (Wildenstein Plattner Institute archive, ref 6160611b). Duret's *Vincent van Gogh* (Bernheim Jeune, Paris, 1916) covers Auvers on pp. 88–93.

25. Meier-Graefe to Dr Gachet, 9 and 21 July 1903 (Wildenstein Plattner Institute archive, ref. fri6iwgf). *Entwicklungsgeschichte der Modernen Kunst*, Hoffmann, Stuttgart, 1904, vol. i, pp. 114–30 (translated as *Modern Art: Being a Contribution to a new System of Aesthetics*, Heinemann, London, 1908, vol. i, pp. 202–12).

26. Julius Meier-Graefe, *Vincent van Gogh*, Piper, Munich, 1922 (translated into English as *Vincent van Gogh: A Biographical Study*, Medici, London, 1922).

27. Walter Feilchenfeldt, *Vincent van Gogh & Paul Cassirer, Berlin: The Reception of Van Gogh in Germany from 1901 to 1914*, Van Gogh Museum, Amsterdam, 1988, pp. 41–2.

28. Gachet Jr to Jo, April 1905 (cited by Louis van Tilborgh in Eva Mendgen, *In Perfect Harmony: Picture + Frame*, Van Gogh Museum, Amsterdam, 1995, pp. 178 and 261, n. 51).

CHAPTER TWENTY:
FATHER AND SON
(pp. 152–170)

1. Letter 878 (5 June 1890). Marguerite was actually 20.

2. Gachet Jr, 1994, pp. 256 and 303. The precise location of the first grave is unknown, but it was probably in the fifth row of section C, in the north west part of the cemetery (Obst, 2010, p. 33).

3. Published by Stefan Koldehoff in *Art: Das Kunstmagazin*, October 2020, p. 20. The watercolour is inscribed 'Tombe de Vincent avant l'exhumation', which means that the inscription (with the word *avant*, before) must have been added at the time of the exhumation in 1905 or later. The watercolour is likely to have been painted at the graveside, although it is possible that it was done later, based on Derousse's memory or a quick pencil sketch.

4. Dr Gachet to Jo, 26 September 1904 (Van Gogh Museum archive, b3411).

5. Jo to Gachet Jr, 5 October 1904 (Van Gogh Museum archive, b2127).

6. In gratitude, after her 1905 visit Jo sent Gachet Jr the original of Vincent's letter

with the sketch of the painting *Marguerite Gachet at the Piano* as a gift (Letter 893, 28 June 1890). The original letter is now lost.

7. Gachet Jr, 1953a, unpaginated and Gachet Jr, 1994, p. 258.

8. Gachet Jr, 1953a, unpaginated and Gachet Jr, 1994, p. 258. Jo later 'remembered clearly the shape of the skull' (Coquiot notebook on his visit to the Netherlands and Belgium, entry of 13 June 1922, p. 56, Van Gogh Museum archive, b7150).

9. Gachet Jr to Jo, 25 September 1904 (Van Gogh Museum archive, b3411).

10. Gachet Jr, 1953a, unpaginated. Gachet Jr kept to his commitment and in 1953 he gave 100,000 francs to the municipality to pay for the perpetual care of the double grave.

11. The unpublished watercolour was painted by Coquiot in his notes (Van Gogh Museum archive, b3348).

12. Bonger, 1958, p. LI.

13. Dr Gachet to Theo, c.15 August 1890 (Pickvance, 1992, p. 144).

14. Theo to Dr Gachet, 12 September 1890 (Van Gogh Museum archive, b2015).

15. Gachet Jr to Coquiot, 1 April 1922 (Van Gogh Museum archive, b3310). See also Julius Meier-Graefe (who suggests the images might have been etched), *Modern Art: Being a Contribution to a new System of Aesthetics*, Heinemann, London, 1908, vol. i, pp. 211.

16. Gachet Jr, 1994, p. 107.

17. Judging by the archive at the Wildenstein Plattner Institute, Gachet Jr seems to have been a meticulous keeper of his father's papers – which makes it all the more surprising that any notes on Van Gogh by his father were not preserved.

18. A list of Dr Gachet's friends includes 31 professional writers, including many art critics ('Quelques Amis et Connaissances du Dr. P. F. Gachet', Wildenstein Plattner Institute archive, ref. 6c0sd8la).

19. Gachet Jr passed on what was said to be his father's diagnosis of Van Gogh's medical problems, but this uninformative summary (if correctly relayed by Meier-Graefe) almost certainly came from his memory, not from records. According to Gachet Jr: '[Dr] Gachet thinks the smell of turpentine was injurious to Van Gogh, and also that painting in the open air had done him no good; he could not overcome the habit of tearing his hat off when he was at work, and the sun at last burnt all the hair off his scalp, till it was only separated from the brain by a thin case of bone' (Julius Meier-Graefe, *Modern Art: Being a Contribution to a new System of Aesthetics*, Heinemann, London, 1908, vol. i, p. 211).

20. Distel and Stein, 1999, pp. 212–30.

21. Ravoux, 1955, p. 15.

22. Letter 877 (3 June 1890).

23. Theo made other gifts to Bernard (F794), Ravoux (F768 and F790) and Chevalier (F673). Dr Mazery is also supposed to have owned two unidentified Van Goghs, which he later sold for 35,000 francs (Auvers Mairie to Coquiot, 26 March 1922; Coquiot notebook, 1922, Van Gogh Museum archive, b3348).

24. *Cows* (F822, Palais Beaux-Arts, Lille). Dr Gachet's print had been made after a Jacob Jordaens painting in the Lille museum (*Study of Five Cows*, c.1620).

25. Paul Gachet Jr, 1953a, unpaginated and Gachet Jr, 1994, p. 94.

26. 'Quelques Amis et Connaissances du Dr. P. F. Gachet', Wildenstein Plattner Institute archive, ref. 6c0sd8la. Tanguy died in 1894, so any purchases would have probably been made by then or immediately afterwards from his widow.

27. The pre-Auvers paintings are: F217, F324, F580, F644, F659, F673, F674, F726, F727, F728, F740 and plate 1.

28. Jo to Gachet Jr, 13 January 1909 (Gachet Jr, 1994, p. 297). She also wrote an obituary in the *Nieuwe Rotterdamsche Courant*, 14 January 1909 and *La Chronique des Arts et de la Curiosité*, 16 January 1909.

29. Golbéry, 1990, p. 112 and Garnier, 1965, p. 46.

30. Tromp, 2010, pp. 257–8.

31. Garnier, 1965, p. 46.
32. Distel and Stein, 1999, p. 163.
33. Now at the Wildenstein Plattner Institute archive (ref. n4jzm95t). In 1940 Gachet Jr completed a catalogue of Guillaumin's work. Much of the material was published in Distel and Stein, 1999, pp. 185–241.
34. *Paris Match,* 25 December 1954, p. 52.
35. Golbéry, 1990, p. 76.
36. Dated 1930 by the Musée Guimet, but Yûki Somei visited Auvers in 1924, so this may well be the correct year (Omoto, 2009, pp. 84-5).
37. Gachet Jr kept three visitors' books with inscriptions by Japanese guests from 1922–39, with a total of 245 signatures (Omoto, 2009).
38. Golbéry, 1990, pp. 74–5.
39. Marguerite Poradowska, 'Le Vase d'Urbino: Ultimes Souvenirs d'Auvers 1891', recorded on 10 August 1918 (Wildenstein Plattner Institute archive, ref. ziy5p8h8).
40. Emile Schuffenecker was a close friend of Gauguin. Emile and his brother Amédée amassed nearly 40 Van Gogh paintings during the 1890s.
41. The two prints were by Kesaï Eisen (Gachet J, 1953b, unpaginated and Gachet Jr, 1994, p. 254).
42. *Images du Monde,* 11 February 1947.
43. It was bought by the museum via the Eugène Blot gallery, Paris for 315,000 French francs. My thanks to Joanna Smalcerz, provenance researcher at the Kunstmuseum Basel.
44. Tralbaut, 1969, pp. 337–8.
45. It was Madame Liberge who also claimed that Van Gogh had shot himself in Rue Boucher, despite overwhelming evidence that it had been behind the château.
46. *Church at Auvers* was valued at 15m French (old) francs and Gachet Jr was paid 8m (Distel and Stein, 1999, p. 211). Although the Musée d'Orsay's website records that the financial contribution came from 'an anonymous Canadian donation', it was from New York-born Princess Winnaretta Singer-Polignac,

who lived in England, but whose estate passed to a Canadian entity.
47. F783, Musée d'Orsay, Paris.
48. Gachet Jr, 1953a, unpaginated.
49. Distel and Stein, 1999, p. 24, note 100 and p. 184.
50. In 1931 Gachet Jr had offered to write an illustrated article on his father for the Wellcome Institute, but his proposal was unfortunately declined (Gertrude Prescott, 'Gachet and Johnston-Saint', *Medical History,* July 1987, p. 223).
51. Gachet Jr, 1953a, see also Gachet Jr, 1953b, 1953c, 1954a and 1954b.
52. Gachet Jr, 1957a.
53. Golbéry, 1990. Golbéry is the grandson of the wife of Gachet Jr's sister-in-law Alphonsine Bazire.
54. Gachet Jr, 1994. The story of the discovery of the manuscript is dealt with by Golbéry in Gachet Jr, 1994, pp. 9–15.
55. Gachet Jr, 1994 and Mothe, 1987 and 2003.
56. Sales of Gachet material took place at: Drouot, Paris, 21 May 1958; Dhiver, Pontoise, 8 March 1963; Robiony, Nice, 21-22 April 1965; Drouot, Paris, 15 May 1993; Drouot, Paris, 19 February 1996; and Aponem, Auvers, 22 November 2009.
57. *Van Gogh le Suicidé de la Société,* K, Paris, p. 47.
58. 'L'Enigme du Cuivre gravé', *Art-Documents,* March 1954, pp. 8–11 and *Les Cahiers de Van Gogh,* no. 3 (1957), pp. 8-11.
59. *Garden of the Asylum* (November 1889, F569, Van Gogh Museum). For confirmation of its authenticity, see Ella Hendriks and Louis van Tilborgh, 'Van Gogh's "Garden of the Asylum": Genuine or Fake?', *The Burlington Magazine,* March 2001, pp. 145–56 and Tromp, 2010, pp. 259–60.
60. The only works at the Louvre he accepted as authentic were *Self-portrait with Swirling Background* (plate 1) and *Church at Auvers* (plate 20). He rejected the other six: *Portrait of Dr Gachet* (plate 19), *Dr Gachet's Garden* (plate 4), *Marguerite Gachet in the Garden* (fig. 28), *Japanese Vase with Roses* (fig. 38),

Cottages at Cordeville (plate 5) and Two Children (F783). See Tromp, 2010, pp. 264–5, citing note by V.W. van Gogh, 9 March 1971.

61. Jacob-Baart de la Faille, L'Oeuvre de Vincent van Gogh: Catalogue Raisonné, Van Oest, Brussels, 1928, 4 vols.

62. De la Faille, 1970, F754, pp. 292 and 703.

63. Hulsker, 1977 (English edition), p. 485 and Hulsker, 1996, p. 460.

64. Landais, 2019.

65. Distel and Stein, 1999, p. 70.

66. The seven examined paintings were: Self-portrait with Swirling Background (plate 1), Church at Auvers (plate 20), Portrait of Dr Gachet (plate 19), Dr Gachet's Garden (plate 4), Japanese Vase with Roses (fig. 38), Two Children (F783) and Cows (F822).

67. Bakker and others, 2023

CHAPTER TWENTY-ONE:
FAKE?

(pp. 171–180)

1. Letter 171 (26 August 1881).

2. For background on Van Gogh fakes see Roland Dorn and Walter Feilchenfeldt, 'Genuine or Fake? On the History and Problems of Van Gogh Connoisseurship' in Kōdera 1993, pp. 263–307, and Tromp, 2010.

3. John Rewald, 'Vincent van Gogh 1880–1971', ARTNews, February 1971, p. 63.

4. F82 (April–May 1885, Van Gogh Museum, Amsterdam).

5. The fakes are F812 and F813 (both now lost).

6. Jacob-Baart de la Faille, Les Faux Van Gogh, Van Oest, Brussels, 1930.

7. For details on the Wacker case, see Walter Feilchenfeldt, 'Van Gogh Fakes: The Wacker Affair', Simiolis, 1989, pp. 289–316; Tromp, 2010; Stefan Koldehoff, Van Gogh Museum Journal, 2002, pp. 8–25 and 138–49; and Nora and Stefan Koldehoff, Der van Gogh-Coup: Otto Wackers Aufstieg und Fall, Nimbus, Wädenswil (Switzerland), 2020.

8. Tromp, 2010, pp. 80–2.

9. The Hiroshima painting (F776) was examined in 2008 and accepted by the Van Gogh Museum (Daubigny's Garden, 1890 by Vincent van Gogh, Hiroshima Museum of Art, 2008). The Basel version is also accepted by the Van Gogh Museum and nearly all other specialists (although rejected in Benoit Landais and Hanspeter Born, Die verschwundene Katze, Echtzeit, Basel, 2009).

10. Sotheby's, London, 26 June 1984, lot 13 and 26 June 1990, lot 18.

11. Dismissed by Roland Dorn and Walter Feilchenfeldt, 'Genuine or Fake? On the History and Problems of Van Gogh Connoisseurship' in Kōdera, 1993, pp. 290 and 293. Surprisingly, Hulsker included the painting, unquestioned, in the 1996 edition of his catalogue (no. 2110, pp. 478–9) – yet another example of the experts in disagreement.

12. Jan Hulsker, The Complete Van Gogh: Paintings, Drawings, Sketches (Abrams, New York, 1978, p. 485) and Hulsker, 1996, p. 6. The Auvers works he put question marks against in 1996 were F754, F777, F814 and F822 (Hulsker numbers 2014, 2095, 2105 and 2107) – but these are now widely accepted as authentic.

13. Martin Bailey, 'At least forty-five Van Goghs may well be fakes', The Art Newspaper, July–August 1997, pp. 1 and 21–4. Hulsker wrote that his question marks meant he had 'very strong doubts about the authenticity' and only in one case was he simply questioning the dating (F524/JH1565) (fax from Hulsker to the author, 18 April 1997).

14. F457 (Sompo Museum of Art, Tokyo). Its authenticity was confirmed: Louis van Tilborgh and Ella Hendriks, 'The Tokyo Sunflowers: A genuine Repetition by Van Gogh or a Schuffenecker Forgery?', Van Gogh Museum Journal, 2001, pp. 16–43. See also Bailey, 2013, pp. 175–7.

15. Martin Bailey, 'Van Gogh: The Fakes Debate', Apollo, January 2005, pp. 55–63.

16. Ten Berge, Meedendorp, Vergeest and Verhoogt, 2003, p. 382.

17. Ten Berge, Meedendorp, Vergeest and Verhoogt, 2003, pp. 380–4.

18. Also entitled *Auvers Landscape* (F1589a).
19. There had been earlier problems over whether the painting could be exported from France, although this issue was not directly related to the question of attribution. In 1989 the French government declared *Garden at Auvers* to be a 'national treasure', prohibiting it from leaving the country and immediately reducing its financial value. Walter's heirs later put it up at auction (Binoche & Godeau, Paris, 6 December 1992, lot 7), but because the painting was unable to leave France, it fetched only about a quarter of its international market value. Walter's heirs later took legal action against the French authorities, successfully winning compensation for their loss.
20. Tajan, Paris, 10 December 1996, lot 1.
21. Claims that it was a fake were raised by Jean-Marie Tasset in *Le Figaro*. Landais also rejects the painting (*La fabuleuse Histoire du Jardin à Auvers*, self-published, 2014).
22. Inventory compiled by Andries Bonger in 1890, no. 298 (Van Gogh Museum archive, b3055). Emile Schuffenecker was an artist and his brother, Amédée, a dealer.
23. These include Pickvance, Feilchenfeldt and Françoise Cachin (Direction des Musées de France).
24. It was in exhibitions in Madrid (2007), Vienna (2008), Basel (2009), Philadelphia (2012), Ottawa (2012), Amsterdam (2013 and 2018), Cleveland (2015), London (2016), and Amsterdam/Paris (2023-4).
25. Information from the Vernes family, August 2020. The price and buyer have not been disclosed. The picture cannot be exported, so the new owner is likely to be French or with a base in France.
26. Letter from Hulsker to Landais, 10 May 2000, published long after his death (Landais, 2019, pp. 5–6). The rejected works are: F792 (H1987), F797 (H2003), F595 (H2009), F820 (H2010), F754 (H2014),

F821 (H2015), F758 (H2016), F786 (H2036), F598 (H2043), F599 (H2044), F764 (H2045), F764a (H2046), F783 (H2051), F822 (H2095), F812 (H2101), F777 (H2105), F814 (H2105), F814 (H2107), F796 (H2110), F563 (H2121) and F801 (H2123).
27. *The Lust for Life* book cover depicts a Wacker fake, dating from c.1925 (F523, National Gallery of Art, Washington, DC); *La Vie tragique de Vincent van Gogh* depicts a work by Judith Gérard, painted in 1897–98 as a tribute to Van Gogh and later passed off in 1911 as by the master (Bührle Collection, Zurich); *Vincent van Gogh, As seen by Himself* depicts a fake bought by William Goetz in 1948 (F476a, location unknown); and *Vincent van Gogh: The Lost Arles Sketchbook* depicts a drawing, possibly dating from the 1990s or early 2000s, which emerged in 2016 and was dismissed as unauthentic by the Van Gogh Museum (private collection).
28. Welsh-Ovcharov gives a detailed account of the sketchbook and her arguments in favour of authenticity (*Vincent van Gogh: The Lost Arles Sketchbook*, Abrams, New York, 2016, pp. 9-37 and 55-63). In February 2010 I was approached about the drawings, three years before Welsh-Ovcharov became involved. Suspecting they were fakes, I declined further involvement.
29. 'Found Sketchbook With Drawings Is Not By Van Gogh', museum statement of 15 November 2016. A statement by Welsh-Ovcharov's French publisher, Seuil, rebutting the Van Gogh Museum's view, was issued on 17 November 2016. Responding point-by-point, it concluded that the sketches are not forgeries.
30. Daniel Rosenfeld, *European Painting and Sculpture*, Rhode Island School of Design, Providence, 1991, p. 230.
31. Louis van Tilborgh and Oda van Maanen, 'Van Gogh's View of Auvers-sur-Oise Revisited', *Blue* (Rhode Island School of Design Museum review), spring 2015, pp. 23–34.

32. Works that were rejected and later accepted include F243, F278, F279, F285, F528 and two not in the de la Faille or Hulsker catalogues – *Still Life with Fruit and Chestnuts* (Fine Arts Museum of San Francisco) and *The Blute-Fin Mill* (Museum de Fundatie, Zwolle).

33. Excluding letter sketches and sketches either done as preparatory for a painting or after a painting.

CHAPTER TWENTY-TWO: HIDDEN PORTRAIT

(pp. 181–6)

1. Letter 879 (5 June 1890).
2. For an excellent study on the portrait, see Saltzman, 1998.
3. The photograph of Ruben-Faber was taken before giving birth to her son Eli on 22 June 1897. The only other very early photograph of a Van Gogh in a private collection shows *Three Sunflowers* (F453, private collection) and *Irises* (F608, J. Paul Getty Museum, Los Angeles) hanging in the dining room of Octave Mirbeau (*Revue Illustrée*, 1 January 1898, with the photograph probably taken in late 1897).
4. I identified the battered label when the empty frame was displayed in *Making Van Gogh: A German Love Story*, Städel Museum, Frankfurt, 2019. On the painting, see Eiling and Krämer, 2019, pp. 161–77 and 186–200.
5. Roger Fry, *The Nation*, 24 June 1911, p. 464. The first English museum to buy a Van Gogh was the National Gallery/ Tate (then a single institution) in 1924 – prices had become substantial, but nothing approaching those of Rembrandt.
6. Saltzman, 1998, p. 196. Berlin's version of *Daubigny's Garden* is F776 (July 1890, now Hiroshima Museums of Art). Although the sale of 'degenerate' art from German museums now seems ethically repugnant, this deaccessioning is still accepted by the German government and museums as legal.

7. Eiling and Krämer, 2019, p. 175. Göring sold two Van Goghs and a Cézanne, via the Berlin dealer Sepp Angerer on 18 May 1938. They were bought by the banker Franz Koenigs: 'shortly thereafter - the details of the transaction can no longer be reconstructed - they came into the possession of Siegfried Kramarsky of the Lisser & Rosenkrantz bank.'
8. Walter Feilchenfeldt Sr to Grete Ring, 11 August 1939 (kindly provided by Walter Feilchenfeldt Jr). See also Eiling and Krämer, 2019, pp. 175 and 177, note 74.
9. Prices are from Saltzman, 1998, p. xxiii. Her table includes the 1995 equivalent, from which I have extrapolated to 2024.
10. *Daily Telegraph* (London), 13 May 1991 and Saltzman, 1998, p. 324.
11. Podcast by Johannes Nichelmann, 'Finding van Gogh', Städel Museum, Frankfurt, 2019 and Nash telephone interview with the author, 12 November 2019.
12. *Kunst*, October 2019, pp. 46–52.
13. Podcast by Nichelmann, 'Finding van Gogh', Städel Museum, Frankfurt, 2019.
14. Christie's, 15 May 1990, lot 21 and Eiling and Krämer, 2019, p. 175.
15. Email from Christine Koenigs to the author, 10 November 2020.
16. It was hoped to show both portraits at the Van Gogh Museum in a 1990 exhibition and they are in the catalogue (Evert van Uitert, Louis van Tilborgh and Sjraar van Heugten, *Vincent van Gogh: Paintings*, Van Gogh Museum, Amsterdam, 1990, pp. 268–71), but the Christie's sale meant that the privately owned picture was never lent.

CHAPTER TWENTY-THREE: PILGRIMS TO THE INN

(pp. 187–194)

1. Letter 873 (20 May 1890).
2. For a short history of the auberge, go to: www.maisondevangogh.fr
3. *L'Intransigeant*, 14 December 1912. A similar story, but with slightly different details, had been earlier reported in *Gil Blas*, 24 November 1908.

4. 'Ravoux,1955, p. 11. On another occasion she named the buyer as Haranson (Tralbaut, 1969, p. 322). The name may well be a misspelling of Harrison. So far it has proved impossible to identify the mysterious American buyer.

5. Ravoux, 1955, p. 11. It is possible that the 'German' may have been Amédée Schuffenecker (brother of the artist Emile) who is recorded (de la Faille, 1970, F790) as having owned *La Mairie* in the early 20th century (his surname could have sounded Germanic). The 'German' could also have been Walter Brody, a Prague-born artist who worked in Berlin (1900-03) and then moved to Paris. He was a regular summer visitor to Meulan and seems to have owned *La Marie* by 1908

6. *La Mairie* was bought by Alfred Hagelstange, the director of the Wallraf-Richartz Museum, Cologne museum, apparently for his personal collection. The Paris dealer was Vollard.

7. *The American Weekly*, 12 August 1956.

8. For background, see Tagliana-Ullrich and Demory-Dupré, 2020.

9. Adeline had married Louis Carrié in 1895 and died in 1965. Her younger sister Germaine married Guilloux and died in 1969.

10. Published in *Paris Match*, 25 December 1954.

11. Adeline gave the following interviews: RDF/RTF radio, 2 April 1953, with her sister Germaine Guilloux (Veen, 2020, pp. 113–21); *Les Nouvelles Littéraires*, 16 April 1953; *Les Nouvelles Littéraires*, 12 August 1954; letter from Adeline to Morel, 18 August 1954 (Morel, 2012, pp. 85–7); *Les Cahiers de Van Gogh*, no. 1, 1955, pp. 8–11; and Tralbaut, 1969, pp. 320 and 322. See also the analysis in Obst, 2010, pp. 59–65. Since the 1955 text was written by her (or more likely assembled from an interview and published under her name with her approval), I have normally cited this as the most accurate account.

12. Kirk Douglas, *The Ragman's Son: An Autobiography*, Simon & Schuster, London, 1988, p. 266.

13. Tagliana-Ullrich and Demory-Dupré, 2020, p. 61.

14. Interview with Janssens, January 2021.

15. Letter 881 (10 June 1890). The published Letters translates '*à moi*' as 'of myself', but 'of my work' is clearer.

16. Theo had shown Chéret's posters in the window of Boussod & Valadon in 1888 (*La Revue Indépendante*, May 1888).

17. Interview with Janssens, January 2021.

18. *The Art Newspaper*, May 2003, see also press release, Institut Van Gogh, Auvers, 17 October 2007.

19. Offered at Sotheby's, New York, 7 November 2007, lot 9.

20. Interview with Janssens, January 2021.

CHAPTER TWENTY-FOUR: TODAY

(pp. 195–200)

1. Letter 864 (29 April 1890).

2. Jansen, Luijten and Bakker, 2009.

3. *Daily Telegraph*, 6 April 2009.

4. The Gachet ownership was suggested as 'probable' when it was auctioned (Sotheby's, New York, 4 November 2014, lot 17).

5. Knoedler stock books, 15 December 1926 and 22 October 1928 (Getty Research Institute, Los Angeles).

6. *South China Morning Post*, 7 December 2014.

7. Hans Ibelings, *Van Gogh Museum Architecture: Rietveld to Kurokawa*, Nai, Rotterdam, 1999, p. 4.

8. Max Osborn, who had written about both Van Gogh and Pissarro in the very early 1900s, recalled these words (*Der Bunte Spiegel*, Krause, New York, 1945, p. 37).

9. Letter 604 (4 May 1888).

10. Jill Lloyd, *Vincent van Gogh and Expressionism*, Van Gogh Museum, Amsterdam, 2006, p. 11.

BIBLIOGRAPHY

Alain Amiel, *Vincent van Gogh à Auvers-sur-Oise*, self-published, 2009

Autour du Docteur Gachet, Musée Daubigny, Auvers, 1990

Yves d'Auvers, *Les Impressionnistes d'Auvers-sur-Oise*, Auvers, c.1973

Martin Bailey, *The Sunflowers are Mine: The Story of Van Gogh's Masterpiece*, Frances Lincoln, London, 2013

Martin Bailey, *Studio of the South: Van Gogh in Provence*, Frances Lincoln, London, 2016

Martin Bailey, *Starry Night: Van Gogh at the Asylum*, White Lion, London, 2018

Nienke Bakker, Louis van Tilborgh and Laura Prins, *On the Verge of Insanity: Van Gogh and his Illness*, Van Gogh Museum, Amsterdam, 2016

Nienke Bakker, Emmanuel Coquery, Teio Meedendorp and Louis van Tilborgh (eds.), *Van Gogh in Auvers-sur-Oise: His final Months*, Van Gogh Museum, Amsterdam, 2023

Jos ten Berge, Teio Meedendorp, Aukje Vergeest and Robert Verhoogt, *The Paintings of Vincent van Gogh in the Collection of the Kröller-Müller Museum*, Kröller-Müller Museum, Otterlo, 2003

Robert Béthencourt-Devaux, *Montmartre, Auvers s/Oise et Van Gogh*, self-published, 1972

Carel Blotkamp and others, *Vincent van Gogh: Between Earth and Heaven, the Landscapes*, Kunstmuseum Basel, 2009

Jo Bonger, 'Memoir of Vincent van Gogh' in *The Complete Letters of Vincent van Gogh*, Thames & Hudson, London, 1958, vol. i, pp. XV–LVII

Amelle Bonis, Michel Jourdheuil and Elodie Perrault, *Le Docteur Gachet: Médicin, Collectionneur et Artiste Amateur*, Bonne Anse, Vaux-sur-Mer, 2021

Richard Brettell, *Pissarro and Pontoise: The Painter in a Landscape*, Yale, London, 1990

Albert Brimo, *Auvers-sur-Oise: Mémoire d'un Village*, Butte aux Cailles, Aurillac, 1990

Eduard Buckman, 'An American finds the real Vincent van Gogh at Auvers-sur-Oise', *De Tafelronde*, no. 8–9, 1955, pp. 46–53

Pierre Cabanne, *Qui a tué Vincent van Gogh?*, Voltaire, Paris, 1992

Camille Pissarro et les Peintres de la Vallée de l'Oise, Musée Tavet-Delacour, Pontoise, 2003

Fernande Castelnau, *L'Isle Adam et Auvers-sur-Oise*, Nouvelles, Paris, c.1960

Cézanne, Van Gogh et le Doctor Gachet, Dossier de l'Art, Paris, 1999

Le Château d'Auvers-sur-Oise à travers les Ages, Beaux-Arts, Paris, 2014

Pierre Le Chevalier, *Docteur Paul-Ferdinand Gachet: Catalogues des Estampes*, self-published, 2009

Gustave Coquiot, *Vincent van Gogh*, Ollendorff, Paris, 1923

'Daubigny's Garden' 1890 by Vincent van Gogh, Hiroshima Museum of Art, 2008

De Daubigny à Alechinsky, 20 Ans de collections, Musée Daubigny, Auvers, 2007

Marie-Paule Défossez, *Auvers-sur-Oise: Le Chemin de Peintres*, Valhermeil, Paris, 1993

Marie-Paule Défossez, *Les Grands Peintres du Val-d'Oise*, Valhermeil, Paris, 2000

Evelyne Demory, *Auvers en 1900*, Valhermeil, Paris, 1985

Anne Distel and Susan Stein, *Cézanne to Van Gogh: The Collection of Doctor Gachet*, Metropolitan Museum of Art, New York, 1999 (French edition: *Un Ami de Cézanne et Van Gogh: Le Docteur Gachet*, Réunion des Musées Nationaux, Paris, 1999)

Victor Doiteau, 'La curieuse Figure du Dr Gachet', *Aesculape*, August 1923–January 1924

Victor Doiteau, 'A quel Mal succomba Théodore van Gogh' Aesculape, May 1940, pp. 76-87.

Victor Doiteau and Edgar Leroy, *La Folie de Vincent van Gogh*, Aesculape, Paris, 1928

Victor Doiteau, 'Deux "Copains" de Van Gogh, inconnus, les Frères Gaston et René Secrétan', *Aesculape*, March 1957, pp. 39–58

Douglas Druick and Peter Kort Zegers, *Van Gogh and Gauguin: The Studio of the South*, Art Institute of Chicago, 2001

Ann Dumas and others, *The Real Van Gogh: The Artist and his Letters*, Royal Academy of Arts, London, 2010

René Dupuy, Maurice Jarnoux and Odette Valeri, 'Un petit Village entre au Louvre', *Paris Match*, 25 December 1954, pp. 45–55

Christophe Duvivier, *L'Impressionnisme au fil de l'Oise: L'Isle-Adam, Auvers-sur-Oise, Pontoise*, Selena, Paris, 2020

Alexander Eiling and Felix Krämer, *Making Van Gogh: A German Love Story*, Städel Museum, Frankfurt, 2019

Jacob-Baart de la Faille, *The Works of Vincent van Gogh: His Paintings and Drawings*, Meulenhoff, Amsterdam, 1970

Walter Feilchenfeldt, *By Appointment Only: Cézanne, Van Gogh and some Secrets of Art Dealing*, Thames & Hudson, London, 2005

Walter Feilchenfeldt, *Vincent van Gogh: The Years in France, Complete Paintings 1886–1890*, Wilson, London, 2013

Une Folie de Couleurs à Auvers-sur-Oise: Centenaire Gachet, Valhermeil, Paris, 2009

Viviane Forrester, *Auvers-sur-Oise*, Molinard, Auvers, 1989

Dr Paul Gachet, *Etude sur la Mélancolie*, Montpellier, 1858

Paul Gachet Jr, preface in Doiteau and Leroy, 1928, pp. 9–14

Paul Gachet Jr, 'Les Artistes à Auvers de Daubigny à Van Gogh', *L'Avenir de l'Ile-de-France*, 18 December 1947 (reprinted in Golbéry, 1990, pp. 181–92)

Paul Gachet Jr, *Souvenirs de Cézanne et de Van Gogh à Auvers*, Beaux-Arts, Paris, 1953a

Paul Gachet Jr, *Van Gogh à Auvers: Histoire d'un Tableau*, Beaux-Arts, Paris, 1953b

Paul Gachet Jr, *Vincent van Gogh aux 'Indépendants'*, Beaux-Arts, Paris, 1953c

Paul Gachet Jr, *Paul van Ryssel, le Docteur Gachet, Graveur*, Beaux-Arts, Paris, 1954a

Paul Gachet Jr, *Van Gogh à Auvers: 'Les Vaches'*, Beaux-Arts, Paris, 1954b

Paul Gachet Jr, *Le Docteur Gachet et Murer: Deux Amis des Impressionnistes*, Editions de Musées Nationaux, Paris, 1956

Paul Gachet Jr, *Lettres Impressionnistes au Dr Gachet et à Murer*, Grasset, Paris, 1957a

Paul Gachet Jr, 'Les Médecins de Théodore et de Vincent van Gogh', *Aesculape*, March 1957 (1957b), pp. 4–37

Paul Gachet Jr, 'A propos de quelques Erreurs sur Vincent van Gogh', *La Revue des Arts, Musées de France*, no. 2 (1959), pp. 85–6

Paul Gachet Jr (commentary by Alain Mothe), *Les 70 Jours de Van Gogh à Auvers*, Valhermeil, Paris, 1994

Christine Garnier, 'Auvers-sur-Oise et Van Gogh', *Revue des Deux-Mondes*, January 1959, pp. 40–50

Christine Garnier, *Auvers-sur-Oise*, Temps, Paris, 1960

Christine Garnier, 'Auvers-sur-Oise se souvient d'avoir été la Capitale de l'Impressionisme', *Plaisir de France*, October 1965, pp. 44–9

Martin Gayford, *The Yellow House: Van Gogh, Gauguin and nine turbulent Weeks in Arles*, Fig Tree, London, 2006

V.W. van Gogh, *Vincent at Auvers-sur-Oise*, Van Gogh Museum, Amsterdam, 1976

Roger Golbéry, *Mon Oncle, Paul Gachet: Souvenirs d'Auvers-sur-Oise 1940–1960*, Velhermeil, Paris, 1990

Nathalie Heinrich, *The Glory of Van Gogh: An Anthology of Admiration*, Princeton University Press, 1996

Wulf Herzogenrath and Dorothee Hansen, *Van Gogh: Fields*, Kunsthalle Bremen, 2002

Sjraar van Heugten, *Van Gogh and the Seasons*, National Gallery of Victoria, Melbourne, 2017

Cornelia Homburg, *Vincent van Gogh and the Painters of the Petit Boulevard*, Saint Louis Art Museum, 2001

Cornelia Homburg, *Vincent van Gogh: Timeless Country – Modern City*, Skira, Milan, 2010

Cornelia Homburg (ed), *Van Gogh Up Close*, National Gallery of Canada, Ottawa, 2012

Jan Hulsker, *The New Complete Van Gogh: Paintings, Drawings, Sketches*, Meulenhoff, Amsterdam, 1996 (first ed.: *The Complete Van Gogh*, Abrams, New York, 1977)

Inspiring Impressionism: Daubigny, Monet, Van Gogh, National Galleries of Scotland, Edinburgh, 2016

Colta Ives, Susan Alyson Stein, Sjraar van Heugten and Marije Vellekoop, *Vincent van Gogh: The Drawings*, Metropolitan Museum of Art, New York, 2005

Leo Jansen and Jan Robert (eds.), *Brief Happiness: The correspondence of Theo van Gogh and Jo Bonger*, Van Gogh Museum, Amsterdam, 1999

Leo Jansen, Hans Luijten and Nienke Bakker, *Vincent van Gogh – The Letters: The Complete Illustrated and Annotated Edition*, Thames & Hudson, London, 2009 (www.vangoghletters.org)

Dominique-Charles Janssens, *Van Gogh: Last Paintings, Last Home, Last Dream*, Institut Van Gogh, Auvers, 2023

Tsukasa Kōdera, *The Mythology of Vincent van Gogh*, Benjamins, Amsterdam, 1993

Stefan Koldehoff, *Van Gogh: Mythos und Wirklichkeit*, Dumont, Cologne, 2003

Benoit Landais, *L'Affair Gachet: 'L'Audace des Bandits'*, self-published, 2019a

Benoit Landais, *Jan Hulsker et les Van Goghs d'Auvers*, self-published, 2019b

Benoit Landais, *Vincent et les Femmes suivi de La Mort de Vincent*, self-published, 2019c

Alexandra Leaf and Fred Leeman, *Van Gogh's Table at the Auberge Ravoux*, Artisan, New York, 2001

Pierre Leprohon, *Les Peintres du Val-d'Oise*, Corymbe, Paris, 1980

Hans Luijten, *Jo van Gogh-Bonger: The Woman who made Vincent Famous*, Bloomsbury, London, 2023

Bert Maes and Louis van Tilborgh, 'Van Gogh's *Tree Roots* up close', *Van Gogh: New Findings*, Van Gogh Museum, Amsterdam, 2012, pp. 54–71

Henri Mataigne, *Notes Historiques et Géographiques sur Auvers-sur-Oise*, Pontoise, 1885

Henri Mataigne, *Histoire de la Paroisse et de la Commune d'Auvers-sur-Oise*, 1906, reprint by Valhermeil, Paris, 1986

Neil McWilliam (ed.), *Emile Bernard: Les Lettres d'un Artiste* (1884-1941), Réel, Dijon, 2012

Claude Millon, *Vincent van Gogh et Auvers-sur-Oise*, Graphédis, Pontoise, 1998 (first ed: 1990)

Jean-Marc Montaigne, *Eugène Murer: Un Ami oublié des Impressionnistes*, ASI, Rouen, 2010

Robert Morel, *Enquête sur la Mort de Vincent van Gogh*, Equinoxe, Saint-Rémy-de-Provence, 2012

Alain Mothe, *Vincent van Gogh à Auvers-sur-Oise*, Valhermeil, Paris, 2003 (first ed: 1987)

Alain Mothe and others, *Cézanne à Auvers-sur-Oise*, Valhermeil, Paris, 2005

Bernadette Murphy, *Van Gogh's Ear: The True Story*, Chatto & Windus, London, 2016

Steven Naifeh and Gregory White Smith, *Van Gogh: The Life*, Profile, London, 2011

Andreas Obst, *Records and Deliberations about Vincent van Gogh's First Grave in Auvers-sur-Oise*, privately published, Lauenau, Germany, 2010

L'Oise de Dupré à Vlaminck: Bateliers, Peintres et Canotiers, Somogy, Paris, 2007

Keiko Omoto, *Van Gogh, Pelerinages Japonais à Auvers*, Musée Guimet, Paris, 2009

David Outhwaite, 'Vincent van Gogh at Auvers-sur-Oise', MA thesis, Courtauld Institute of Art, London, 1969

The Painters at Auvers: Daubigny, Cézanne, Van Gogh, Beaux Arts, Paris, 1994

Les Peintres et le Val-d'Oise, Sogemo, Paris, 1992

Les Peintres et l'Oise, Musée Tavet-Delacour, Pontoise, 2007

Ronald Pickvance, Van Gogh in Arles, Metropolitan Museum of Art, New York, 1984

Ronald Pickvance, Van Gogh in Saint-Rémy and Auvers, Metropolitan Museum of Art, New York, 1986

Ronald Pickvance, 'A Great Artist is Dead': Letters of Condolence on Vincent van Gogh's Death, Van Gogh Museum, Amsterdam, 1992

Adeline Ravoux (Carrié), 'Les Souvenirs d'Adeline Ravoux', Les Cahiers de Van Gogh, no. 1 (1955), p. 11

John Rewald, Post-Impressionism: From Van Gogh to Gauguin, Museum of Modern Art, New York, 1978 (3rd ed.)

John Rewald, Studies in Post-Impressionism, Thames & Hudson, London, 1986

Alain Rohan and Claude Millon, Qui était le Docteur Gachet?, Office de Tourisme, Auvers, 2003

Alain Rohan, Vincent van Gogh: Aurait-on retrouvé l'Arme du Suicide?, Fargeau, Paris, 2012

Mark Roskill, Van Gogh, Gauguin and the Impressionist Circle, Thames & Hudson, London, 1970

Cynthia Saltzman, Portrait of Dr Gachet: The Story of a Van Gogh Masterpiece, Viking, London, 1998

Klaus Albrecht Schröder and others, Van Gogh: Heartfelt Lines, Albertina, Vienna, 2008

Guillermo Solana, Van Gogh: Los Ultimos Paisajes, Museo Thyssen-Bornemisza, Madrid, 2007

Timothy Standring and Louis van Tilborgh, Becoming Van Gogh, Denver Art Museum, 2012

Susan Alyson Stein, Van Gogh: A Retrospective, Park Lane, New York, 1986

Chris Stolwijk and Han Veenenbos, The Account Book of Theo van Gogh and Jo van Gogh-Bonger, Van Gogh Museum, Amsterdam, 2002

Régine Tagliana-Ullrich and Evelyne Demory-Dupré, Du Café de la Mairie à la Maison Van Gogh, self-published, 2020

Louis van Tilborgh and Teio Meedendorp, 'The Life and Death of Vincent van Gogh', Burlington Magazine, July 2013, pp. 456–62

Marc Tralbaut, Van Gogh: A Pictorial Biography, Thames & Hudson, London, 1959

Marc Tralbaut, Vincent van Gogh, Viking, New York, 1969

Henk Tromp, A Real Van Gogh: How the Art World Struggles with Truth, Amsterdam University Press, 2010

Van Gogh et les Peintres d'Auvers-sur-Oise, Musées Nationaux, Paris, 1954

Van Gogh et les Peintres d'Auvers chez le Docteur Gachet, L'Amour de l'Art, Paris, 1952

Wouter van der Veen and Peter Knapp, Van Gogh in Auvers: His Last Days, Monacelli, New York, 2010 (French edition: Vincent van Gogh à Auvers, Chêne, Paris, 2009)

Wouter van der Veen, Attaqué à la Racine: Enquête sur les derniers Jours de Van Gogh, Arthénon, Strasbourg, 2020 (English edition: online at www.arthenon.com)

Johannes van der Wolk, The Seven Sketchbooks of Vincent van Gogh: A Facsimile Edition, Abrams, New York, 1987

Marije Vellekoop and Roelie Zwikker, Vincent van Gogh Drawings: Arles, Saint-Rémy & Auvers-sur-Oise 1888-1890, Van Gogh Museum, Amsterdam, 2007, vol. iv

Marije Vellekoop, Muriel Geldof, Ella Hendriks, Leo Jansen and Alberto de Tagle, Van Gogh's Studio Practice, Van Gogh Museum, Amsterdam, 2013

Vivre en Val-d'Oise (bimonthly review), numerous issues, 1990–2010

Bruno Vouters, Vincent et le Docteur Gachet, Voix du Nord, Lille, 1990

INDEX

Page numbers in *italics* refer to illustrations captions. Endnotes are indexed selectively, with an 'n' number for the note.

A

Alexis, Paul (Trublot) (1847–1901) 208 n10
Anfray, Louis 167
Apollo 223 n39, 225 n4, 229 n15
Arcimboldo, Giuseppe (1526/7–93) 40
Arles 7, 8, 15–16, 17–18, 34, 68, 72, 127, 178,
 180, 199
 ear incident 7, 16, 17, 20, 22, 30, 83
 Gauguin and Van Gogh in 17, 82–83,
 85, 195
 Yellow House 15–16, 17, 83, 85, 195
Art Newspaper, The 175, 214 n 10, 229 n 13
Artaud, Antonin (1896–1948) 167, 222 n2
At Eternity's Gate film (2018) 123
Auberge Ravoux 7–8, *8, 26,* 27–30, 189, *192*
 Café de la Mairie *26,* 27, 188
 efforts to acquire a Van Gogh painting 193-4
 Institut Van Gogh 193, 209 n5, 210 n7
 Janssens, Charles-Dominique 8, 187, 192–4,
 208 n4, 209 n5, 232 n 14, 17, 20
 Van Gogh's bedroom 7–8, *8,* 32–4, *111,*
 193, 203
 Van Gogh's death 106–11
Aubert, Claude (?–1989) 10–11
Aurier, Albert (1865–92) 45, 86, *88,* 120, 132,
 143, 216 n4
Auvers-sur-Oise 7–9, 202–4
 A la Halte de Chaponval *61,* 213 n3
 Auberge Saint-Aubin 25, 50–1, 209 n3
 cemetery 8–9, 13, 29, 116, 121, 152–3, 204
 Chaponval, 24, *45,* 46, 48, *50, 61*
 road bridge 29, 50, 212 n8
 château 10, 92, 104–5, *105,* 203, 217 n2,
 218 n11, 219 n19
 church 8–9, *28,* 29, 62–3, *63,* 64, 71, 94-5,
 116, *119,* 121, 132, 204, 213 n9
 Cordeville 46, 165
 cottages 44-6, 48, 99
 graves of Vincent and Theo *9,* 9, 13, 152–5,
 156, 204
 Hotel du Cadran 216 n8
 Lilot jetty 212 n6
 mairie 28, 29–30, 116, 121, 202

Montcel 212 n7
population 30
railway 25, 49, 51, 61, 94
Saint-Martin 212 n10
Vessenots 68-9
Villa Ida 94, 217 n10
visit by Theo and Jo, 8 June 1890 60–5
wheatfields 9, 15, 47, 68–71, 81, 91–3, 95–6,
 104, 105
Avril, Pierre (?–1836) 40

B

Backer, Nienke 201
Ballin, Mogens (1871–1914) 182, 184
Balthus (1908-2001) 194
Bazin, Germain (1901–90) 164
Bazire, Emilienne (1879–1948) 160, 228 n53
Bernard, Emile (1868–1941) 103, 104, 106,
 118, 120, 121, 132–3, 138, 191, 218 n3
 cover of *Les Hommes d'Aujourd'hui,* 225 n9
 exhibition of Van Gogh's work 144–5
 Funeral 119, 191
 Lettres de Vincent van Gogh 145
 Portrait of Paul Gachet Jr 158
 Self-portrait for Vincent 221 n23
Bernard, Michel-Ange (1906-92) 191
Bernheim Jeune 148
Bever, Adolphe van (1871–1927) 105
Bing, Siegfried (1838–1905) 22
Boch, Anna (1848–1936) 143
Bois, Johannes de (1878–1946) 148
Bondy, Walter (1880-1940) 232 n5
Bonger, Andries (1861–1936) 22, 88, 99–100,
 119, 137–9, 217 n18
Bonger, Jo (1862–1925) 17, *19,* 20–3, 25,
 30, 34, 38, 45, 71, 97, 110, 114, 146, 160,
 172, 217 n18
 death 168
 informed of Vincent's death 111–12
 marriage to Gosschalk 154
 portrait by Gosschalk *145*
 promotion of Van Gogh's work 99,
 145–9
 sale of works by Van Gogh 177, 181
 Theo and Jo's visit to Auvers 60–5
 Theo and Vincent's graves 153–5
 Theo's illness and death 139–41
 Vincent's death 117–21, 136–8
 Vincent's visit to Paris 86–91, 129

Bonger, Mien (1858–1910) 89
Bonjean, Louise (Antonia) 221 n30
Bonnard, Pierre (1867–1947) 198
Bourges, Léonide (1838–1909) 120
Boussod, Etienne (1857–1918) 89, 130
Boussod & Valadon 18, 22, 60, 62, 82, 88–9,
 109, 120, 129–30
Brabant 44–5, 64
Brooke, Edmund Walpole (1865–1938)
 216 n8
Brücke, Die 198–9

C

Café de la Mairie 26, 27, 188
Caffin, Alexandre (1836–1901) 116, 132,
 133
Cardin, Pierre (1922–2020) 192
Cassirer, Paul (1871–1926) 148, 174, 183
Cézanne, Paul (1839–1906) 12, 13, 32, 37,
 38, 40, 41, 48, 72, 160–1, 164–5
 Auvers, Panoramic View 48, 48
 Bouquet in a small Delft Vase 214 n3
 Bouquet with Yellow Dahlias 214 n3
 Dahlias in a large Delft Vase 214 n3
 *Geraniums and Coreopsis in a small Delft
 Vase* 214 n3
 House of Dr Gachet at Auvers, The 32, 33
 works inherited by Gachet Jr 160, 164–5
Chaponval 48, 50, 61
 Houses at Auvers 46
 Thatched Cottages and Houses 46
Charpentier, Michel (1927–2023) 192
Chéret, Jules (1836–1932) 193, 232 n16
Chevalier, Louise (1847–1904) 39, 42, 62,
 119
Cohen, Steven 196
Coquery, Emmanuel 201
Coquiot, Gustave (1865–1926) 210 n8,
 220 n4
 Graves of the Van Gogh brothers 154
Corot, Camille (1796–1875) 171, 210 n16
cottages 44–6, 48, 99
Crohin, Numa (1859–?) 213–14 n4, 218–19
 n12
Crohin, Laure (1884–1958) 218–19 n12
 see Liberge, Laure

D

Daubigny, Charles-François (1817–78) 30,
 49, 92–3, 120, 121, 203
 The Track on the Plain of Auvers 31
Daubigny, Marie (1817–90) 94, 107, 202
Daumier, Honoré (1808–79) 210 n16
Degas, Edgar (1834–1917) 13, 89
Denis, Maurice (1870–1943) 120, 181, 198,
 221 n24
 Maternité à la Pomme 182
Derain, André (1880–1954) 198
Derousse, Blanche (1873–1911) 152, 167,
 170
 Van Gogh's First Grave 154, 226 n3
Deroy, Auguste (1825–1906)
 View of Auvers from the Oise 28
Detrez, Ambroise (1811–63) 212 n3
Distel, Anne 12, 169, 210 n3
Doiteau, Victor (1892–1960) *La Folie de
 Vincent van Gogh* 124–5, 210 n8
Douglas, Kirk (1916–2020) 98, 191
Druet, Eugène (1867–1916) 182
Dumollard, Martin (1810–62) 41
Dumoulin, Louis (1860–1924) 213 n20
Durand-Ruel, Paul (1831–1922) 138
Duret, Théodore (1838–1927) 149

E

Eeden, Frederik van (1860–1932) 97–8
Eiling, Alexander 186
Eisen, Keisei (1790–1848) 214 n9, 228 n41
Engineer, The *see* Gogh, Vincent Willem
 (1890–1978)
Epiphane, Sister (Deschanel, Rosine)
 (c.1842–1932) 127, 223 n34

F

Faille, Jacob-Baart de la (1886–1959) 168–9,
 174, 201
fakes and questioned works 165, 167-70,
 171–80
Fauves 198–9
Flöttl, Wolfgang 185–6
Fry, Roger (1866–1934) 150, 182
Fugère, Henry (1872–1944) 212 n3
Le Fur, Rémy 9–11

G

Gachet, Blanche (1843–75) 36, 39, 79
Gachet, Emilienne, *see* Bazire, Emilienne
Gachet, Louis (1825–1905) 166
Gachet, Marguerite (1869–1949) 38, 39, 62, 66, *81*, 119, 160, *162*, 162–4
 portraits by Van Gogh 53, 79–80, 87, 93–4, 158–9
Gachet, Paul, Dr (1828–1909) 11–15, 18–20, 23, 25, 31, 37, 51, 54, 115–16, 137, 163
 appearance 54–5
 art collection 39–40, 158–9
 assessment of Van Gogh's medical condition 36–7, 60, 65–7
 care of Van Gogh's grave 152–5
 character 35–6, 38–9
 death 159–60
 collection of bones and skulls 12–13, *41*, 41–2
 collection of plaster casts of guillotined heads *40*, 40–1, 208 n12
 diary 14–15, 131
 garden 42, 52, 54, 57, 58, 61–2, 72, 74, 167, 196, 203
 homeopathy 39, 54, 57
 house *36*, 37–8
 Japanese art 37, *37*
 Madame Gachet at the Piano 79, *80*
 medical records 124–5, 157–8
 memoir of Van Gogh 155–8
 Night 79
 phrenology 12–13, 39, 41
 Pig, The 62
 portrait by Van Gogh 52–9, 77
 Société d'Autopsie Mutuelle 13–14, 115, 116, 159–60, 208 n14 and n18
 Société des Eclectiques 12, *38*, 38, *40*, 41
 Van Gogh's death 107–11, 131–2, 133
 Van Gogh's first impressions of 35–6, 42–3
 Van Gogh's funeral 119, 121
 Vincent van Gogh on his Deathbed (drawing) 113–14, *114*
 Vincent van Gogh on his Deathbed (oil on board) 114, *115*
 visit by Tho and Jo 60–6
 works by Van Gogh owned by 57, 158–9
Gachet, Paul, Jr (1873–1962) 13, 14, 39, 64, 80, 116, 151, *156*, *158*, *160*, *161*, 167–9, 190
 account of Van Gogh's death 124–6
 art collection 160–2, 164
 collection donated to French state 164–5
 character 161–2
 death 165–6
 Deux Amis des Impressionnistes: Le Docteur Gachet et Murer 165
 exhumation of Van Gogh's first grave 153–4
 Les 70 Jours de Van Gogh à Auvers 166
 Lettres Impressionnistes au Dr Gachet et à Murer 165
 marriage 160, 164
 Medallion of Van Gogh 154, *155*
 Place where Vincent van Gogh committed Suicide, The 105, *106*
 Portrait of Dr Paul Gachet 41, *157*
 Souvenirs de Cézanne et de Van Gogh à Auvers 163, 165
Gambetta, Léon (1838–82) 13
Garnier, Christine (1915-87) 161
Gauguin, Mette (1850–1920) 215 n8
Gauguin, Paul (1848–1903) 16, 17, 55, 58–9, 69, 89, 120, 166
 Bathers 198
 Dogs Running in the Grass 216 n12
 Oranges and Lemons with a View of Pont-Aven 216 n12
 relationship with Van Gogh 82–5, 132, 145, 195
 Self-portrait with Halo 83 (plate 35)
Gautier, Amand (1825–94) 42, 161, 212 n3
 Dr Paul Gachet in the Pose of St Francis of Assisi 43, *42*
Gérard, Judith (1881–1954) 230 n27
Ginoux, Marie (1848–1911) 53, 65, 127
Ginoux, Joseph (1835–1902) 65, 127
Godard, undertaker 116, 220 n8
Goeneutte, Norbert (1854–94) 55
 Portrait of Dr Paul Gachet 37
Goetz, William (1903–69) 230 n27
Gogh, Anna van (1819–1907, Vincent's mother) 71, 72, 89, 111, 119, 130, 137
Gogh, Cor (Cornelis) van (1867–1900) 128, *129*
Gogh, Theo van (1857–91) 8, 14, 16, *19*, 25–6, 30, 39, 85, 94, 104, 158–9, 181, 197
 Boussod & Valadon 18, 22, 60, 62, 82, 88–9, 109, 120, 129–30

chronology 205–7
exhumation and re-burial 153–5
grave 9, 9, 141, *156*
ill health 65, 89
illness and death 139–41, 147
letters from Vincent 34, 35, 36, 42, 45,
 52, 55, 57, 70–1, 77–8, 101, 126–7,
 193
Vincent's death 107–12, 113–16, 130–4,
 135–8, 144–5
Vincent's visit to Paris 17–23, 86–91
visits Vincent in Auvers 60–7
Gogh, Vincent van (1853–90) 7–16
chronology 205–7
cottage paintings 44–6
death 107–12
double-square canvases 92–6
first impressions of Auvers 25–34
first impressions of Dr Gachet 35–43
flower paintings 72–6
funeral 113–21
Gauguin, Paul 82–5, 145
last pictures 97–101
painting the Auvers landscape 47–51
portraits in Auvers 77–81
portraits of Dr Gachet 52–9
posthumous rise to fame 143–51
suicidal tendencies 126–8
suicide 103–6
suicide weapon 9–11, 10, 103–4, 123–6,
 218 n10
visit from Theo and Jo 60–7
visits to Theo and Jo 17–23, 86–91
wheatfield paintings 68–71
works
Almond Blossom 21
Arlésienne, The 21, 53
Baby in a Pram 65
Bank of the Oise at Auvers 49–50 (plate 14)
Blossoming Chestnut Branches 73, 214 n7
 (plate 28)
Bridge in the Rain 217 n12
Blute-Fin Mill, The 230 n32
Child with Orange 78 (plate 31)
Church at Auvers 15, 62–4, 98, 164
 (plate 20)
Cottages 217 n17
Cottages at Cordeville 46, 164 (plate 6)
Cows 159, 164, 228–9 n66–7
Cypresses 86, 216 n4

Daubigny's Garden (first version) 94, 174–5,
 183, 202, 214 n10, 216 n20 (plate 41)
Daubigny's Garden (second version) 98,
 174–5, 183
Dr Gachet's Garden 42, 52, 153, 158, 164
 (plate 4)
Ears of Wheat 69 (plate 24)
Farmhouse 46, 217 n17 (plate 7)
Farms near Auvers 96, 99 (plate 46)
Field with Wheatstacks 95 (plate 43)
Fields, The 71, 194 (plate 26)
Fritillaries 221 n26
Garden of the Asylum 168
Garden at Auvers 176–8, 194 (plate 53)
Girl against a Background of Wheat 81, 196,
 198 (plate 33)
Girl in White 81 (plate 32)
Green Wheatfields 69 (plate 23)
Harvest, The 21
Houses at Auvers 46 (plate 8)
Irises 196
Japanese Vase with Roses 73, 74, 159, 164
Landscape at Auvers in the Rain 95 (plate 42)
Landscape at Twilight 92–3, 104 (plate 38)
Landscape with Train 50–1, 193–4 (plate 16)
Mairie, La 187, 188, 231–2 n5 (plate 3)
Marguerite Gachet at the Piano 38, 79–80, 87,
 93–4, 95, 158–9, 162–4 (plate 30)
Marguerite Gachet in the Garden 53, 79, 158
Oise at Auvers, The 50 (plate 15)
Old Tower, The 213 n11
Old Vineyard with Peasant Woman 47, 64
 (plate 9)
People in a Café 29
Plain of Auvers, The 93, 148 (plate 40)
Plain near Auvers, The 70, 93, 99 (plate 25)
Poppies and Daisies 75, 76, 196, 197, 199
Poppy Field 49 (plate 13)
Portrait of Adeline Ravoux (first version) 78,
 187
Portrait of Adeline Ravoux (second version)
 78–9 (plate 29)
Portrait of Dr Gachet (first version) 52–7,
 150, 167, 181–6, 196 (plate 18)
sketch of 55
Portrait of Dr Gachet (second version) 57, 62,
 162, 164, 167, 169 (plate 19)
Portrait of Père Tanguy (plate 2)
Portrait of Dr Gachet (The Man with the
 Pipe) 56, 57–8

Potato Eaters, The 21, 173
Red Vineyard, The 143
Road in Auvers 99, 148 (plate 47)
Road with Cypress and Star 59
Self-portrait (Detroit) 225 n9
Self-portrait for Laval 221 n23
Self-portrait for Gauguin 83 (plate 34)
Self-portrait with Bandaged Ear and Pipe 83
 (plate 36)
Self-portrait with Swirling Background 38, 56,
 162, 164, 228 n60, 228–9 n66 (plate 1)
Sheaves of Wheat 95 (plate 44)
Stairway at Auvers 49, 175 (plate 12)
 unauthenticated version 172, 175, 180
Starry Night 16, 195
Still Life with Fruit and Chestnuts 230 n32
Still Life with Plaster Statuette 212 n5
Sunflowers 72, 175, 183, 195, 196, 229 n14,
 231 n3
Thatched Cottages and Figures 98
Thatched Cottages and Houses 46, 182 (plate 5)
Three Sunflowers 231 n3
Tree Roots 95–6, 99–101, 203 (plate 48)
 last painting 99–101
Trees 217 n19
Two Children 164, 228 n60, 228–9 n66
Undergrowth with two Figures 93, 96, 217 n19
 (plate 39)
Van Gogh's Chair 8, 38, 208 n1
Vessenots, Les 68–9 (plate 21)
View of Auvers 51, 179, 182, 230 n31 (plate
 17, plate 51)
Vineyard and Houses 47–8 (plate 10)
Vineyards with a View of Auvers 48 (plate 11)
Wheatfield 69 (plate 22)
Wheatfield under Thunderclouds 95 (plate 37)
Wheatfield with Crows 96, 97–8, 150, 216
 n20, 217 n3 (plate 45)
Wheatfields after the Rain 70, 98–9, 174, 182
 (plate 50)
Wheatfields with Reaper 71, 176, 226 n18
 (plate 27)
 unauthenticated version 176, 177
Wild Flowers and Thistles 74, 74, 76
Young Woman against a Pink Background
 215 n23
Gogh, Vincent Willem (1890–1978) 17, 19,
 65, 141, 155, 168, 168, 197, 225–6 n16
Gogh, Wil (Willemien) van (1862–1941)
 21, 51, 52, 55, 62, 64, 71, 72, 77, 111,
 128, 129, 130, 134

Golbéry, Roger 165–6
Goncourt, Edmond and Jules
 Germinie Lacerteux 53–4
 La Fille Elisa 54
 Manette Salomon 54
Goodyear, Conger (1877–1934) 196
Goodyear, George (1906-2002) 196
Göring, Hermann (1893–1946) 183
Gosschalk, Johan Cohen (1873–1912)
 154–5
 Portrait of Jo Bonger 145
Guillaumin, Armand (1841–1927) 40, 90,
 210 n16, 227 n33
 Self-Portrait 164
gun which killed Van Gogh 9–11, 10, 103–4,
 104, 123–6, 218 n10

H

Hagelstange, Alfred (1873–1912) 232 n6
Harronson, Harry 188
Heckel, Erich (1883–1970) 198
Hérouville 104, 214 n8
Hiroshige, Utagawa (1797–58)
 *Sudden Evening Shower on the Great
 Bridge near Atake* 95
Hirschig, Anton (1867–1939) 80–1,
 109–10, 113, 116–17, 120, 132, 192,
 203, 210 n8
Hoornik, Sien (1850–1904) 195
Hoschedé, Ernest (1837–91) 120
Hulsker, Jan (1907–2002) 169, 175, 178,
 229 n12
Huyghe, René (1906–97) 164

I

Impressionists 12, 18, 22, 27–8, 31–2, 37,
 40, 62, 120, 138, 161, 184, 197, 203,
 204
Isaäcson, Joseph (1859–1942) 224 n9
Israëls, Isaac (1865–1934) 224 n9

J

Jacquin, Léon (1872–1944) 105, 219 n15
Janssens, Charles-Dominique 8, 187, 192–4,
 208 n4, 209 n5, 232 n14

Japanese art 22, 32, 66, 73, 74, 95, 162, *163*, 165
Jawlensky, Alexej von (1864–1941) 198
Jordaens, Jacob (1593–1678)
 Study of Five Cows 227 n24
Justi, Ludwig (1876–1957) 174–5

K

Kessler, Harry (1868–1937) 182
Kirchner, Ernst (1880–1938) 198
Koenigs, Franz (1881–1941) 183, 184, 186, 231 n7
Koenigs, Christine 186
Kohn, Marc-Arthur 178
Koldehoff, Stefan 185–6, 226 n3
Kramarsky, Siegfried (1893–1961) 183, 186, 231 n7
Kramarsky, Lola (1896–1991) 183
Kröller-Müller, Helene (1869–1939) 148, *149*, 162, 176

L

Lacenaire, Pierre (1803–36) 40–1
Lamarck, Jean-Baptiste (1744–1829) 208 n14
Landais, Benoit 169, 178
 L'Affaire Gachet 169
Lauzet, Auguste (1865–98) 120
Laval, Charles (1862–94) 120
 Self-portrait for Vincent 221 n23
Leboeuf gunshop, Pontoise 103–4, *104*
Leboeuf, Augustin (1825–95) 104
Leboeuf, Pierre 218 n8
Lefaucheux firearms 9–10, *10*, 104
Leroy Edgar (1883–1965) *La Folie de Vincent van Gogh* 124–5, 210 n8
Lescure, Arsène-Raymond (c.1828–55) *40*, 41
Levasseur 224 n3
Levert, Vincent 117, 119
Liberge, Fernand 218–19 n12
Liberge, Laure (1884–1958) 163–4, 218–9 n12
Lieser, Heinz *Vincent Van Gogh, As Seen By Himself* (plate 52)
Lignereux, Hélène 219 n15
Los Ríos, Ricardo de (1846–1929) 121

Loving Vincent film (2017) 123
Lust for Life (1934 novel and 1956 film) 98, 103, 122, 190–1

M

Maio, Vincent di 125–6
Maes, Bert 100
Manet, Edouard (1832–83) 12–13, 151
Matisse, Henri (1869–1954) 198
Matton, Charles (1931–2008) *192*
Mazery, Joseph (1850–1920) 107, 116, 124
Meedendorp, Teio 125, 134, 201
Meester, Johan de (1860–1931) 98, 100, 217–18 n20
 The Desolation of the Fields 98
Meier-Graefe, Julius (1867–1935) 149–50
Menucourt 209 n4
Méry-sur-Oise 29, 50, 116, 121, 217 n11
Mesdag, Baukje van (1853–1920) 120
Millet, Jean-François (1814–75) 77
Millon, Claude (1910–2009) 211 n19
Minnelli, Vincente (1903–86) 191
Mirbeau, Octave (1848–1917) 119
Monet, Claude (1840–1926) 12, 40, 120, 144, 164, 195, 200
Montcel 212 n7
Monticelli, Adolphe (1824–86) 120
Mothe, Alain (?-2015) 166
Murer (Meunier), Eugène (1841–1906) 120, 160, 165, 215 n8
Musée d'Orsay, Paris 74, 158, 165, 169, 170, 204

N

Nabis 198–9
Naifeh, Steven 11
 Van Gogh: The Life 122–6
Nash, David 185
Nichelmann, Johannes 185
Nolde, Emil (1867–1956)198
Norbert, Joseph (?–1843) 41
Nuenen, Netherlands 44, 64, 213 n11

O

Obst, Andreas 220 n11
Osborn, Max (1870–1946) 232 n8

P

Pearce, Charles Sprague (1851–1914)
 120–1, 221 n30
Pearce, Louise (Antonia) (1856–1925) 221
 n30
Pechstein, Max (1881–1955) 199
Penel, Félix 213 n3
Peyron, Théophile (1827–95) 19–20, 127
Picasso, Pablo (1881–1973) 183, 195, 199, 200
Pickvance, Ronald (1930–2017) 178
Piérard, Louis (1886–1951) *La Vie Tragique
 de Vincent van Gogh* 223 n34 (plate 52)
Pissarro, Camille (1830–1903) 12, 18, 31–2,
 62, 89, 120, 139, 144, 198, 216 n2
 Gachet, Paul, Dr 39, 40
 Gachet, Paul, Jr 160, 161, 164
 Rue Rémy, Auvers 31, 32
Pissarro, Lucien (1863–1944) 18, 120
Pont-Aven, Brittany 82, 84–5, 91
Pontoise 29, 31, 84, 103, 107, 116, 164
Poradovska, Marguerite (1848-1937) 37
Post-Impressionists 150, 182, 184, 197, 204
Postcard of Rue Daubigny (plate 49)
Poulet, Jean-François (1863–1954) 127
Puvis de Chavannes, Pierre (1824–98)
 Inter Artes at Naturam 22

Q

Quost, Ernest (1844–1931) 216 n8

R

Raffaëlli, Jean-François (1850–1924) 22
Ravaud, Elisabeth 169–70
Ravoux, Arthur (1849–1914) 26, 27, 48,
 78, 103, 106–9, 113, 116, 123, 132–3,
 187–8, 193, 209 n4
Ravoux, Léonie (1881–?) 27
Ravoux, Louise (1855–98) 26, 27,
Ravoux, Victor (1879–79) 27
Ravoux family, photographs 209 n5, 210 n7

Ravoux-Carrié, Adeline (1877–1965) *26, 27,*
 78, 105, 118, 132, 158, 188, *190,* 190
 portrait by Van Gogh 78–9, 187
Ravoux-Guilloux, Germaine (1888–?) 26,
 27, 78, 210 n7
Renoir, Pierre-Auguste (1841–1919) 12, 13,
 40, 164
 Bal du Moulin de la Galette 184
Rewald, John (1912–94) 123, 143, 171,
 222 n6
Rey, Félix (1867–1932) 220 n7
Rigaumont, Emile (1850–1929) 133
Rivière, Georges (1855–1943) 12–13
Robin, Léopold (1877–1939)
 Dr Gachet's Salon 36
Rohan, Alain 125
Roulin, Joseph (1841–1901) 126
Ruben-Faber, Alice (1866–1939) 181–2,
 182, 184
Ryssel, Louis van, *see* Gachet, Paul, Jr
Ryssel, Paul van, *see* Gachet, Paul, Dr

S

Saint-Martin 212 n 10
Saint-Paul-de-Mausole 7, 16, 18, 20, 86,
 127, 191
Saint-Rémy-de-Provence 7, 16, 18, 20, 86,
 127, 191
Saito, Ryoei (1916–96) *184,* 184–5
Schnabel, Julian 123
Schoebel, Bernard 192
Schuffenecker, Amédée (1854–1935) 162,
 177, 228 n40
Schuffenecker, Emile (1851–1934) 162,
 177, 228 n40
Schuliar, Yves 125
Secrétan, Gaston (1871–1943) 122–4
Secrétan, René (1874–1957) 11, 122–4
Seurat, Georges (1859–91) 223 n53
Signac, Paul (1863–1935) 127, 132
Singer-Polignac, Winnaretta (1865–1943)
 228 n46
Sisley, Alfred (1839–99) 12, 40, 164
Smith, Gregory White (1951–2014) 11
 Van Gogh: The Life 122–6
Société d'Autopsie Mutuelle 13–14, 115,
 116, 159–60, 208 n14
Société du Dîner Lamarck 208 n14

Société des Artistes Indépendants 39, 62, 99, 143, 161
Société des Eclectiques 12, *38*, 38, *40*, 41
Société Nationale des Beaux-Arts 21–2
Société Protectrice des Animaux 62
Somei, Yûki (1875–1957) 227–8 n36
 Portrait of Gachet Jr 159
Stein, Susan 169, 210 n3
Stone, Irving (1903–89) *Lust for Life* 98, 188, 188 (plate 52)
Swart, Sara de (1861–1951) 88

T

Tagliana, Roger and Micheline 10–11, 188–93
Tanguy, 'Père' Julien (1825-94) 22–3, 90, 119, 138, 159
Ten Cate, Siebe (1858–1908) 120
Tessier, Henri 116, 132–3
Thorigny, Félix (1824–70)
 Panorama of the Oise Valley 28
Tilborgh, Louis van 100, 125, 134, 201
Toulouse-Lautrec, Henri de (1864–1901) 86–7, *88*, 144
 Mademoiselle Dihau at the Piano 87
 Portrait of Vincent van Gogh 87
Tralbaut, Marc (1902–76) 163
Trublot, *see* Alexis

V

Valdivielso, Nicolás Martínez (1840–1925) 121
Valk, Maurits van der (1857–1935) 120

Van Gogh family *see* Gogh
Van Gogh Museum, Amsterdam 10, 99–100, 125, 169, 170, 178–80, 197
Vandenbroucke, Ursula and Gilles (both ? – 1963) 166
Veen, Wouter van der 100
Vernes, Jean-Marc (1922-96) 177–8
Vernes, Pierre 178
Vernes-Karoglan, Edith 178
Vernier, Félix (1822–92) 80–1
Vexin plateau 47, 70
Voerman, Jan (1857–1941) 209 n20
Vollard, Ambroise (1866–1939) 148

W

Wacker, Leonhard 174
Wacker, Otto (1898–1970) 174
Wang Zhongjun 197, *199*
Wellcome Collection 208n12, 228 n50
Welsh-Ovcharov, Bogomila 178, 230 n28
 Vincent Van Gogh: The Lost Arles Sketchbook 178 (plate 52)
Wickenden, Robert (1861–1931) 121
Wilmotte, Jean-Michel 193
Wynn, Steve 196, *198*

Z

Zadkine, Ossip (1890–1967) 191, 202
Zurbarán, Francisco de (1598–1664) 42, 211 n25

ACKNOWLEDGEMENTS

Once again my deepest thanks to go Onelia Cardettini, who has generously assisted me on all of my Van Gogh books. Based in Provence, she has provided invaluable help in deciphering difficult handwriting in archival documents and helping with the translation of complex passages in French. I am extremely grateful for her assistance in responding to a constant stream of queries.

Writing on Auvers, I am very grateful for the publications by my distinguished predecessors – particularly Ronald Pickvance, Alain Mothe, Claude Millon, Roger Golbéry, Anne Distel, Susan Stein and Wouter van der Veen. It was Madame Millon who first got me interested in Van Gogh's period in Auvers. She had been born in the village in 1910, just 20 years after the artist's death, and lived there right up until her death in 2009, aged 98. She was a real link with the past: recalling the sight of Dr Gachet's daughter Marguerite alighting off the train from Paris in about 1920 and remembering a rosehip plant tumbling over the graves of Vincent and Theo some three years later.

Anyone researching Van Gogh is so fortunate to have access to a museum dedicated to the artist. I would like to thank my colleagues there, past and present: Milou Bollen, Isolde Cael, Fleur Roos Rosa de Carvalho, Alain van der Horst, Maite van Dijk, Zibi Dowgwillo, Emilie Gordenker, Monique Hageman, Ella Hendriks, Anita Homan, Sjraar van Heugten, Fieke Pabst, Teio Meedendorp, Renske Suijver, Louis van Tilborgh, Lucinda Timmermans, Marije Vellekoop, Anita Vriend and Roelie Zwikker. Much of this book was written during the 2020–21 Covid-19 pandemic and the library and documentary staff were

extremely helpful in emailing material at this difficult time. As always, the three editors of the 2009 edition of Van Gogh's letters deserve the highest praise – Leo Jansen, Hans Luijten and Nienke Bakker.

I am especially grateful to two historians who have published detailed and serious studies (which are not as well known as they deserve to be) on different aspects of the artist's death: Alain Rohan, who has written on the Lefaucheux gun, and Andreas Obst, who has researched Vincent's original grave. It has been fascinating to exchange numerous emails with them.

The Wildenstein Plattner Institute in New York has recently opened up its archive of the Paul Ferdinand Gachet and Paul Louis Gachet Papers, taken over from the Wildenstein Institute. These documents represent an invaluable resource on the doctor and his son and this will probably be the first Van Gogh book to make use of the material since it has become publicly available. I am very grateful for the assistance of Elizabeth Gorayeb and Sandrine Canac.

I would like to thank other individuals who helped in very various ways: William Boyd, David Brooks, Christophe Duvivier, Pascal Gaillard, Charlotte Hellman-Cachin, Walter Feilchenfeldt, Martin Gayford, Jantine van Gogh, Stefan Koldehoff, Felix Krämer, Remy Le Fur, Fred Leeman, Jean-Marc Montaigne, Richard Munden, Bernadette Murphy, David Nash, Sonja Poncet, Chris Riopelle, Agnès Saulnier, Régine Tagliana, Gina Thomas, Willem-Jan Verlinden, Yves Vasseur, Piet Voskuil, Bogomila Welsh-Ovcharov and Tom Wickenden. I also acknowledge the ever-helpful staff at the London Library.

Dominique-Charles Janssens, owner of the Auberge Ravoux, has always welcomed me to Auvers, ever since my first visit in 1988, soon after he acquired the inn. Since then on a series of trips he has generously invited me to share the patron's table with him in the dining room, where Van Gogh would take his meals. Without his commitment and energy, it is doubtful that Vincent's last home would have been properly preserved and enjoyed by well over a million visitors. I am extremely grateful for all his assistance. Van der Veen, the scientific

director of the auberge's Institut Van Gogh, has generously responded to a stream of queries.

For this 2024 edition, I would also like to draw attention to the excellent catalogue of the exhibition *Van Gogh in Auvers-sur-Oise: His final Months*, held at the Van Gogh Museum in Amsterdam and the Musée d'Orsay in Paris in 2023–24.

At my publisher, Frances Lincoln (an imprint of the London-based Quarto Group), I would like to thank Nicki Davis, the senior commissioning editor, who had also overseen my earlier volumes on Arles and the asylum. These two books have now become part of a trilogy on Van Gogh's greatest years, along with this one on his last weeks at Auvers. *Van Gogh's Finale* was edited by Joe Hallsworth, who very skillfully handled the text, images and production – it was a great pleasure working with him. I would also like to thank the designer, Emily Portnoi, and Melody Odusanya, Quarto's campaigns manager. For this updated edition I would like to thank the publisher Philip Cooper and editor Izzy Toner.

Last, but not least, I am extremely grateful to my wife Alison for her help in editing the text – and her constant support on my journey on the Van Gogh trail.

PICTURE CREDITS